WOMAN
LIFE
FREEDOM

Voices and Art from the
Women's Protests in Iran

Edited by Malu Halasa

SAQI

Contents

Introduction

On 13 September 2022, twenty-two-year-old Jina Mahsa Amini was detained outside a metro station in Tehran by Iran's Morality Police. Despite her attire – a headscarf and robe – she was accused of breaking the law, which requires women to cover their hair with a hijab and their arms and legs with loose clothing. The young Kurdish-Iranian was beaten inside a police van. Three days later, she died in hospital. The authorities blamed her death on a heart attack, even though hospital sources said her wounds were indicative of a brain injury sustained as a result of trauma to the head.

The murky circumstances of her death reverberated with ordinary Iranian women, who have been no strangers to the tactics and threats of the *Gasht-e ershad*, the Morality Police, also known as the Guidance Patrol. This 7,000-strong national police force began issuing more warnings, fines and arrests after hard-line president Ebrahim Raisi introduced a new 'chastity and hijab' law in the summer, months before Jina was stopped. Now in cities across Iran, CCTV surveillance cameras regularly identify women 'improperly' dressed. Government offices and banks deny entrance to these women. When the protests started, not wearing a hijab on social media meant the 'guilty' faced a mandatory prison sentence.

After Jina's funeral, protests led by women spread to 139 cities in all of Iran's thirty-one provinces. Videos on social media showed women in the streets with their hair uncovered and, in some cases, burning headscarves or cutting their own long hair – traditionally a sign of mourning or to voice dissent. Men joined the demonstrations. There was footage on Twitter and Instagram of spontaneous night protests where people danced around makeshift fires. The most popular anti-government chant – '*Zan, Zendegi, Azadi*' in Persian, or in Kurdish '*Jin, Jîyan, Azadî*', 'Woman, Life, Freedom' – echoed in the mass uprising. However, the movement quickly changed from one demanding women's rights to one demanding regime change. A nascent revolution was born.

One photograph in particular, which appears on page 80, revealed the scope of the solidarity inside the country. It shows a young woman standing on top of a car in Saqqez, arms to the sky. In front of her, as far as the eye can see, thousands of people walk or drive towards Jina's grave, to mark the fortieth-day anniversary of her burial. Groups that normally favoured the regime sided with the women, from striking Abadan oil refinery workers to the notorious religiously conservative bazaar.

Schoolgirls were also drawn into the protests. In video clips posted on social media they taunted government officials and ripped an official photograph of Iran's supreme leader Ayatollah Khamenei off a wall. Internet footage, verging on black humour, captured Iranians flipping turbans off clerics' heads.

The response of the regime was swift and brutal. Protesting women were shot in the eyes or in the genitals. There were reports of sexual violence against those arrested and detained. The numbers inside Evin Prison swelled. Executions began, in the first instances of men accused of killing security officers, of helping wounded female protestors, or of being in the wrong place at the wrong time and picked up during general police sweeps around the demonstrations.

Inside Iran, female journalists who first reported the events surrounding Jina's death were arrested, detained and accused of 'collaborating' with foreign authorities and 'colluding against national security', charges that could result in the death penalty. Elite Iranian athlete Elnaz Rekabi disappeared from public view once she returned to Iran after participating hijab-less in an international climbing competition in South Korea. Prominent Iranian actress Taraneh Alidoosti was arrested after she expressed solidarity online with one of the executed men. The rapper and outspoken critic of the regime, Toomaj Salehi, last seen on the state-run IRNA news agency's social media channels, gave a forced confession. He too has been threatened with execution. Fearful of retribution, yet another talented Iranian took the decision not to return home. After playing in a tournament in Kazakhstan without a hijab, chess master Sara Khadem moved to Spain.

During the 2009 Green Movement demonstrations, photojournalists targeted by the Islamic government retreated

from the streets and became artists in studios. Thirteen years later, during the women's protests, the government's firing line has widened to include artists as well as cultural and sports figures. The stories of these courageous people have not gone unnoticed inside the country, in the diaspora and in the wider international community.

At the time of writing, the nationwide women's protests have quietened, but they may well return. The authorities are still dealing with the aftermath of the uprising. Despite the threat of execution – just last week three men arrested during the protests were hanged and demonstrations erupted in Isfahan, Karaj, Gohardasht and Tehran – and 24/7-government surveillance of the populace and a spate of unresolved poisonings of schoolgirls, among many other dangers, resistance continues in ways both small and large. Women leave home without the hijab, even if it means having abuse or yoghurt hurled at them, although the general public consensus appears supportive of those unveiled. In the country's capital, at certain times, usually under the cover of darkness, people go to their rooftops and call out for the end of the regime.

Overcoming Fears

When I first began looking for material for this anthology, some people were hesitant to appear in a book that took its title from the battle cry of the protests – 'Woman, Life, Freedom'. Initially many of the contributors wanted to be anonymous.

A week ago, I sat with someone who had sent me material for the book from Iran, through friends of friends. She had spent one month in solitary confinement in Tehran's feared Evin Prison, knew she was on the regime's radar and as a result was understandably cautious. While I was keen to have her contribution in the book, I also wanted her to see its contents so she could judge for herself whether it was safe for her to participate.

I brought my laptop to our meeting and we went through the by-now-finished anthology, story by story, image by image. She paused at one of the art cards by Alexander Cyrus Poulikakos and

Niloofar Rasooli's 'Revolution of the Anonymous', which draws its imagery and inspiration from the internet. The card in question was a series of portraits of Iran's religious leaders in drag; they had been defaced with women's makeup.

'Can you remove this?' she asked.

On hearing I was unable to – the art card is part of the artists' selection – the young woman stated plainly: 'Then I can't be in the book.'

Of course, I was going to respect her decision. However, I insisted that we go through the rest of the manuscript. Her decision should be, at least, an informed one.

She lingered in the file of artwork from the open access drive that Iranian Women of Graphic Design (IWofGD) maintain on the internet. One poster, 'Brave' by Milad Nazifi, shows the climber Elnaz Rekabi. 'A Mirror' by Mansooreh Baghgaraei, was embroidery made with real hair. It depicts the naked back of a woman, her body riddled with holes where she had been shot by a weapon used by the regime against demonstrators – a pellet gun. Artists from inside Iran and the diaspora, joined by a global artistic community, had uploaded their artwork to IWofGD's open access drive so that protestors could download the images, print them and take them on demonstrations.

The young woman looked up from my computer screen and said, 'I have to be in the book. I must stand with these women.'

'And if the authorities call you in?' I asked.

She shrugged. 'I will have to talk to them.'

Rapid Change

Woman Life Freedom opens with first-person accounts of life of people inside Iran. An anonymous writer reflects in 'The Girl of Revolution Avenue' on a pivotal day in 2017 when a young woman stood on top of an electricity substation box on Enghelab (Revolution) Avenue, removed her headscarf in protest and was immediately arrested. The spirit and bravery of human rights campaigner Vida Movahed pervade the anthology, which includes an essay by the translator Farnaz Haeri about walking without a hijab through Maidan Valiasr, Tehran's busiest square and

roundabout. Forthright members of Iran's Gen Z – 'The Smarties' – with their dyed hair and rejection of headscarves as early as 2019, stare out of portraits by the photographer Shiva Khademi.

Although the mandatory hijab is symbolic to the regime, the revolution is much bigger than a piece of cloth. It is a fight for the rights of women, men and children as well as the different communities in the country. Alongside the Baha'i, the Arabs, Baluch and Azeri, the Kurds are another discriminated minority in Iran. The Iranian-Kurdish journalist Kamin Mohammadi writes about Jina's Kurdish identity and the importance of their community in the women's protests. The range of themes in this collection shows the intersectional violence at play, whether directed against the human body, queerness, clothing, environment, diaspora, media and technology.

Just as social media has played an important part in disseminating news and images, art's role in this historic moment has been indispensable. It has sustained the uprising in the public eye and given it continued energy and potency. The centrality of art is discussed in an interview with Dr Pamela Karimi, a historian of art, architecture and visual culture of the modern Middle East. She also makes telling observations on other pertinent topics, such as feminism, the Western gaze and the positions artists have long held within Iranian society.

Life in Iran has always elicited a strong reaction in the Iranian diaspora. Since Roshi Rouzbehani left her country eleven years ago, she has been a vocal advocate of Iranian women's rights in her editorial illustrations for *The Guardian* and *The New Yorker*. The protest art featured in the anthology draws on traditional iconography from calligraphy and tapestry to cutting-edge digital illustration. The selection, curated by Emilia Sandoghdar, includes established artists collected by the British Museum and the Victoria and Albert Museum, alongside lesser-known artists, who are equally passionate.

Just as the photographs taped onto city walls during the 1979 Islamic Revolution were an important way of conveying news of the anti-Shah protests that rocked the country, so today graffiti also spreads the word. Despite real threats to their lives, street artists go out and brave government surveillance cameras and facial

recognition technology to spray-paint the streets. The collective Khiaban Tribune follows their efforts and dodges the same cameras as this socialist youth group photograph and document graffiti in Tehran.

The regime's manipulation of technology has had real and dangerous ramifications for dissent inside the country. When the government closes the internet down and activities inside the country are no longer visible to the rest of the world, people are arrested or, worse yet, killed. In '"Fighting VPN Criminalisation Should Be Big Tech's Top Priority", Activists Say', Ashley Belanger provides a full picture of the resistance by ordinary people behind their computer screens in Iran, aided by tech-savvy activists elsewhere.

Today, media outlets beyond Tehran's control, from websites to satellite channels and dissident radio stations, deliver unfiltered news and views to millions of Iranians at home. News can be transmitted in other ways too. For the book, the editorial cartoons of Mana Neyestani provide a potted history of the women's

protests since Jina's murder. When Neyestani was living in Iran, the authorities told the cartoonist that it would be better if he concentrated on drawing for children. A conversation he drew between a cockroach and a child landed him in jail. He fled the country as soon as he was able to.

To understand Iran's present, one must be cognisant of its past. The artist Soheila Sokhanvari's portraits of the country's pre-revolutionary feminist icons give an indication of what women lost (and what they were blamed for), once the new Islamic Republic of Iran seized power. Those women, cultural movers and shakers of their time – film stars, musicians, dancers and poets – were left to fend for themselves. By contrast, Niloofar Rasooli's essay about the death of protestor Ghazaleh Chalabi, 'In Her Voice, We Are All Together', demonstrates the power of today's collective action.

A Q&A with Steffi Niederzoll, the director of the documentary, *Seven Winters in Tehran*, reveals the shocking legal status of women in that religious society. Reyhaneh Jabbari was executed for the murder of a man who attempted to rape her. In addition to women protecting themselves or walking unencumbered and unveiled in public, other seemingly innocuous global activities that thousands do every day have also been outlawed by Iran's Shi'a clergy. Women there have long lived bifurcated lives, one public, the other private. In 'High Fashion', for instance, photographer Tahmineh Monzavi documents illegal, clandestine runway shows in Tehran.

International luxury fashion has also shed light on injustice in Iran. Milad Ahmadi paid homage to those killed during the demonstrations by writing their names on a rosette, designed by Amir Taghi and worn by actress Sepideh Moafi on the red carpet of the 2023 Golden Globes Awards. Marzieh Saffarian's pop art collages, available on clothing and in prints sold by Urban Outfitters, propose a sunnier future for Iranian women.

For music critic Clive Bell, inspirational music like 'Baraye' by Shervin Hajipour – performed the world over, even in the White House – has provided the soundtrack of dissent. Radio broadcaster and sound artist Fari Bradley became a full-time activist after she received a phone call from Iran, with the instruction: 'Be our voice'.

The experiences of queer artist Tasalla Tabasom growing up in Tehran were multi-faceted and divided, as she reveals in her essay 'Fragmentation', about her art of the human body. However, for some, the pressure of living in the country was too much to bear. In her memoir piece, the poet Shokouh Moghimi writes about her sister's suicide and madness in 'Big Laleh, Little Laleh'. These women and others don't want our pity. Iran's foremost nonfiction essayist Habibe Jafarian describes the resilience of her mother in 'The One Who Must Walk on Foot.' It is a difficult path to follow, confirms filmmaker Sara Mokhavat in her essay, 'On the Pain of Others, Once Again'.

Sometimes in a religiously conservative society, it is traditional women who upend their families for the sake of the daughters they love and want to educate. Vida Zarkeshan recalls the hard-won lessons of her grandmother passed down through the female generations of their family. Meanwhile the doyenne of Iranian photography, Hengameh Golestan, captures the strength and outrage of the first women who demonstrated en masse against compulsory veiling in 1979, after the Islamists came to power. In Golestan's black and white imagery, the women are rightfully resentful. They had fought against the Shah and lost even more freedoms under the mullahs. A year later, Golestan went to the Ministry of Islamic Guidance to apply for a permit to cover the Iran–Iraq War (1980–1988). Officials told her the frontline was no place for a woman. They said she should stay home and make 'pickles and jams' for the men at the front.

As society decays, ecology also falls victim to ideology. Maryam Haidari tells of the environmental degradation of the traditional wetlands named Hoor-al-Azim, which have meant so much to her Iranian-Arab family from Khuzestan. Under circumstances like these, the imagination becomes a place of both refuge and defiance. The photographs in the series 'A Changing Dreamscape' reveal Mehri Rahimzadeh as one of the most intriguing photographers of her day. She also pushes the boundaries in her commercial work, all shot in Iran, with magazine covers showing pregnancy tests and women's hair.

It is against this varied, surprising, remarkable backdrop that the women's revolution has taken place. Vali Mahlouji's essay 'In the

Time of Eros' examines how totalitarian states curtail and control the human body. Simple ancient arts, such as dancing, singing, even a brief kiss in the street, which dare to envision a different way of life, have perhaps already defeated the mighty Islamic state. Another letter from the anonymous writer who opens the book closes it with the thought that, hope against hope, there might be no going back.

Homecoming

A friend of mine recently returned from Iran. He had been visiting his family in one of the smaller cities. Around the dining room table, his brother talked about the traffic surveillance cameras and the drivers who transport unveiled women in their cars. First, a warning comes via the car owner's mobile phone. The second time, a fine is threatened. The third time, you could end up in court, with the car confiscated. He and his wife, the parents of three girls, expressed concerns about sending their daughters back to school after the Nowruz break for Persian New Year. Too many schoolgirls had been poisoned.

My friend told me he worried about 'the future of smart girls in a country like Iran.' He said he took his nine-year-old niece into the city for a day out. She was testing a pen he wanted to buy her in a stationery shop. He watched her write three words on a pad of paper: 'Woman, Life, Freedom'.

She looked up at him and said, 'I want everyone to see this.'

Malu Halasa
London, May 2023

The Girl of Revolution Avenue

Letter from Tehran

Anonymous

Dearest _____,

In the heart of Tehran, on Revolution Avenue and a stone's throw from the University of Tehran, there is an electricity substation that found itself suddenly in the spotlight almost exactly five years ago. This box has a lot to do with the upheavals that have beset Iran in recent months. On 27 December 2017, a young woman named Vida Movahed climbed up the large grey gadget, took off her white hijab, stuck it on a wooden stick and waved it in the air as a sign of protest. She drew an immediate crowd, and in under ten minutes was arrested by security officers and taken away.

Movahed came to be known as the Girl of Revolution Avenue. She was subsequently sentenced in court to a year's imprisonment for her act of defiance. A few days after her arrest, workers from the national power company were sent to solder a triangular metal piece on top of the rectangular box so that no other woman would be tempted to climb up there and become the next Girl of Revolution Avenue. It was a superficial solution to a deep sociopolitical divide within the country.

Five years on, if you were to stand at the counter inside the France Pastry Shop, one of Tehran's oldest cafés, and look outside at the substation that Movahed climbed up, the very first thing you'd notice is that a significant number of women who pass by are not wearing the hijab.

By now, the world knows the story of Mahsa Amini whose death, following her arrest by the Morality Police in September 2022, impelled the youth of Iran to take to the streets, catching the entire country off guard. In the subsequent months, much has been written and said – especially outside Iran – about a momentous reckoning taking place in the life of the Islamic Republic. There is an element of wishful thinking here (as often happens with regard to Iran), but there is also a good deal of truth. Iran is a complicated nation, and people in Tehran joke that every six months this sprawling plateau of so many identities and languages transforms into a different country altogether.

And yet the Islamic Republic endures.

The change which has occurred in recent months is certainly acute. Walking through the capital will reveal that a significant portion of the female population willingly continues to wear the hijab and does so insistently. However, a visible number of women also walk the streets with their heads entirely uncovered. This shift is unprecedented in the life of the Islamic Republic. Women with a variety of hairstyles and colours go about their business boldly, without revealing, at least on the surface, any fear of the security forces occupying the corners of the major thoroughfares.

The Woman, Life, Freedom movement that evolved following Amini's death, and the appearance of women on the streets of Iran not wearing the hijab, is not unlike a sprint relay, with the baton first passed on the day Movahed climbed the substation. A lot of women whose basic motto is now 'a normal life' do not necessarily know what happened on Revolution Avenue five years ago – and how fateful it turned out to be. The same goes for the young men who go out of their way to show solidarity by waving victory signs and smiling widely at the women who refuse to cover their heads. In the busy Haft-e ('Seventh') Tir Square in the heart of the city, a young woman not wearing the hijab articulates her view, saying: 'I want to dress freely. My mother hardly ever removes her hijab, but I'm not my mother. Respect for difference and diversity is what makes life beautiful.'

And yet, on the other side of the equation, the Islamic Republic has considered the hijab a red line, and an ideological foundation, for the last forty years. Many within the regime consider losing

this fight synonymous with surrendering, and surrender has never been part of the Islamic Republic's playbook. But what to do when so many young women in towns large and small across Iran are rejecting the hijab? One strategic option – the one that the regime seems to have adopted for the time being – is to do nothing. This has led to scenes that would have been unimaginable in this country half a year ago: young women (but not only the young) passing directly in front of security police, who make no effort to arrest them. And while in Friday prayers, and other platforms connected to conservative factions, the cry for a harsh crackdown continues unabated, the highest echelons of power appear to be tacitly endorsing the maxim 'live and let live'.

Young women and men of school and university age are the flagbearers of the movement and paid a heavy toll during the earlier street confrontations with the security forces. More recently, prison terms and a handful of summary executions (not to mention the winter chill) have brought a hiatus, for now, to the streets of Tehran and other cities.[1]

While the streets are quiet, the youth are still busy in the virtual world, and Iran's Generation Z is as internet savvy as youth anywhere. The regime's filtering and control of the virtual world may be able to slow internet access, but it cannot put a stop to it altogether. A teacher at a Tehran girls' school says: 'My students stand up in the middle of class, shouting that they don't want to follow the lesson plan; they want to talk about the problems the country faces. These kids are angry.'

'Taking off my hijab is the least I can do,' says a young woman, who has not worn a headscarf for the past three months. She continues: 'The government must understand that even guns aren't

1 Translator's note: The connotation is dual: on the one hand the authorities have laid off bothering people on the street, on the other hand incarcerations and executions from the time of the violent demonstrations have subdued the population from wanting to go out there again. The live-and-let-live basically says this: do what you want, as long as you don't go out there and start demonstrating and turning violent towards the regime itself again, like you did in the autumn. We don't care if you don't wear the hijab, or we'll pretend for now not to care. This approach of theirs is not really at variance with how a dictatorship operates. It's sticks and carrots.

enough to force women to cover their heads anymore. If one day I have to go back to wearing the hijab, I'll have betrayed Mahsa and all the others who've already died for us. Every day, I spend hours on YouTube and other websites. I see what's going on outside Iran. Why should there be such a divide between us and the rest of the world? Why does the government have to control our private lives? Why are Iranians so poor when our country has so much natural wealth?'

It's a little past noon on Revolution Avenue, a weekday. I decide to spend half an hour inside the France Pastry Shop, which is more than enough time to get a sense of the women who pass by the celebrated substation. In the thirty-minute interval, sixty-one women pass by. Thirty-two of them have their heads completely uncovered. Sixteen wear their headcovers reluctantly, the hair easily showing. Thirteen either wear a full chador or the *maqnaa* (one-piece head covering) often worn by women in government offices and schools.

Inside the café, the numbers are similarly telling – several university-age women wearing no hijab are busy ordering hot drinks and pastries. Leaning on the café's window, a young couple stares out at the pavement. The young woman, with no headscarf, points to the platform and says, 'You know, that's exactly where Vida took her hijab off for the first time ever and waved it on a pole.' As if on cue, at that moment a big black van, accompanied by a force of twenty motorcycles belonging to the special anti-riot police, passes the spot on Revolution Avenue.

Nowadays, Tehran's streets are relatively calm – despite the exaggerated and often out-of-context claims of imminent revolution that opposition television channels tiresomely broadcast into the country. As Generation Z will tell you, Woman, Life, Freedom is on pause right now. They liken the movement to an active volcano that erupts now and then, but whose eruptions are far smaller than the major one which is expected to happen some day. One of them says, 'We're the embers under the smouldering ash; any day, we could catch on fire.' The regime and its shock troops need to get it into their heads once and for all that Iran will never go back to how it used to be.

Interestingly, the regime and its young people may have the same objective in mind: not going back to what once was. Why else

would the sight of women not wearing the hijab have become so commonplace here? One could argue that, rather than a volcano awaiting a 'great eruption', the Islamic Republic – after more than four decades of practice – has not necessarily perfected, but rather learned the art of allowing for seismic activity (sometimes even tectonic in scale) in order to pre-empt something of far larger magnitude.

This story is still unfolding.

Yours always,

A.

Translated from Persian

Queering of a Revolution

On reappropriation

Alexander Cyrus Poulikakos

This revolution is an act of claiming. This revolution as an act itself is reappropriating a term that has been tainted since the Islamic Revolution in 1979. Just see how quickly the meaning of '*Enghelabi*' ('the revolutionary') has metamorphosed from the image of a man in a tie-less white-collar shirt into a young woman, unveiled. This is performed through a queering of existing articulations, mirroring and distorting languages of the regime. These languages veil everyday life in public spaces and practices in order to impose an ideological facade, an ultra-violence on anybody who enters public life.

The regime has made use of the walls of the cities to spread propaganda and impose its theocratic ideology through slogans and imagery. Sieving through their facade in opposition, anonymous authors spray their own slogans on the walls of the cities, exposing unspoken truths, often by warping the governmental propaganda words and weaving them anew. After being painted over by the authorities, the newly blank wall is re-sprayed and reclaimed by protestors with writings such as, 'Blood can be erased with nothing.' The spilled blood is the pen of these anonymous authors. These writings are shared over social media, predominantly Instagram and Twitter, and serve as the unidentified collective script that multiplies and calls on each other, creating recurrences unrelated to physical boundaries and linear time.

Likewise, the authority's instrumentalisation of the dead has been reappropriated. Images of martyrs and the so-called

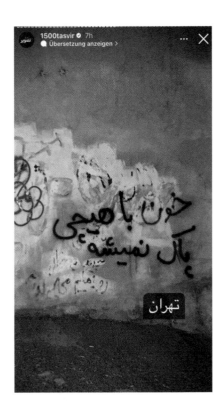

← 'Blood can be erased
with nothing', a wall
that had been repeatedly
painted over; writing
over writing. Anonymous,
Tehran. Image: Instagram
story by @1500tasvir, 27
October 2022.

Supreme Leaders have been omnipresent on the walls of the cities in Iran, in shops, schools and any form of public or semi-public space. Their faces are installed to instill fear and surveillance and to remind us of their permanent power. In this revolution, their stoic permanence is being unspun and the pulsating blood of the innocent they have shed is leaking through the cracks of lies. The martyred faces of those who have been murdered for protesting, with Jina Mahsa Amini as the conveyer, are replacing the icons imposed by the government. The faces of the new revolutionaries are sprayed over the walls of the cities anonymously and turned into art, shared over social media. Jina and her fallen sisters have become the true signifiers for the uprisings, omnipresent through the directionless acceleration of flow and multiplication in the digital realm. Therefore, a unity of places has become possible, temporarily, without unity of time and physical space.

This reconstruction of the signifiers has empowered fearless Gen Z schoolgirls to take down images of the Supreme Leaders in their classrooms, tear them apart as well as paint makeup on the grim faces depicted. The power of the dead has been set on fire by Gen Z, using social media, their space of escaping the normative theocratic oppression.

What has truly made this revolution unprecedented is the queering of the masculine articulation by reappropriation. The epitome of this can be seen in the reconditioning of the most feared and politicised subject of the regime: the female body. Female bodies have set this revolution on fire, by rising and transforming into each other. This revolution is led by young women defining their bodies as signifiers, weaving a mesh impeding patriarchal systems and activating a decentralised revolution.

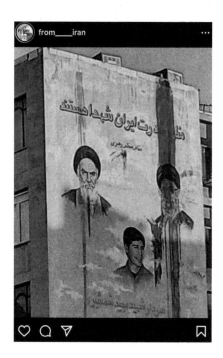

→ Red paint spilled over propaganda wall images of dictators. Anonymous, Tehran. Image: Instagram post by @ from__Iran, 15 November 2022.

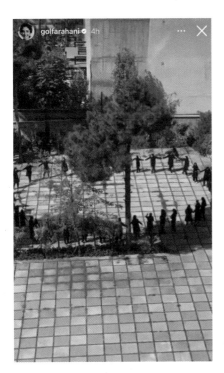

In a country with an average age of thirty-two,[1] the power of the young is at a climactic level. Gen Z is rupturing the enclosed walls they live behind, to infinite openings. Through these digital openings, a space and a language have been able to leak out of Iran. A diasporic community of more than four million documented people has been invited to join the streets of the *Enghelabi* in their distant home, with further uprisings being sparked in Afghanistan. Through the digital windows defying physical obedience and the reigning forces of ultra-violence, the female body has become a metaphysical thread burning down the walls of woman's oppression.

1 'Iran Demographics Profile', Index Mundi 2021.

The Smarties

Hair colour as protest

Shiva Khademi

← 'No one's born with this kind of hair colour, so I dye mine.' Shiva (b. 1998, Tehran)

In Mashhad, where I grew up, women typically dress in black. When I moved to Tehran four years ago, the young women with dyed hair immediately caught my eye. I remember being moved by the flashes of red, green and pink on the city's crowded underground.

While I have never coloured my own hair, I was amazed by the bravery of these young women, and I wanted to find out more. I was also struck by the fact that these women did not cover their hair. Back in 2019, it was compulsory to wear headscarves in public and few women removed them.

For these photographs, I went out each day in search of a certain type of woman. And each day I managed to find a suitable subject. In my experience as a photographer, strangers often refused my requests if I asked to take their photo, but these women were different. They were eager to pose in front of my camera. One young woman told me she was grateful someone had noticed her and taken her seriously.

← 'With colours I can find
myself or, in other words,
I invent myself.' Aida
(b. 1996, Tehran)

↓ 'It's about the
character that I create
with each colour. I'm made
of colours.' Azin,
(b. 1999, Tehran)

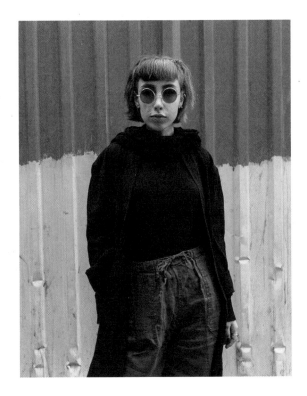

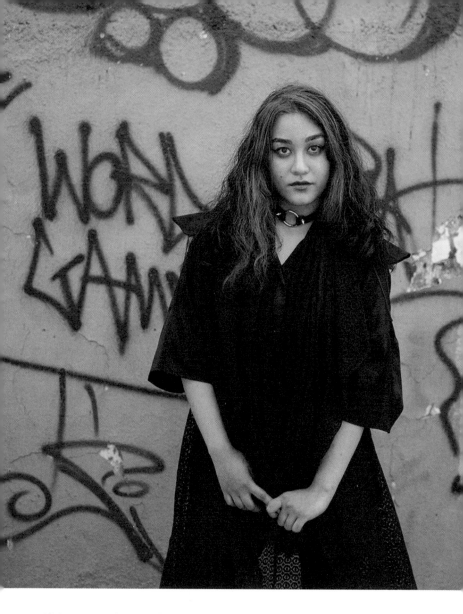

↑ 'Colours are interesting to
me when they can change the
nature of things.' Hamta
(b. 1994, Tehran)

When I approached the subjects for this series, I usually opened the conversation by saying they were one of the Smarties. They didn't mind the label; in fact it made them laugh. I told them I admired their courage in being seen when women were under constant observation. I told them I preferred to keep my appearance simple, and I asked them why they changed their looks. Some of the women I spoke to dyed their hair a different colour every month. The women I met were as diverse and complex in personality as in appearance. For them, their hair colour was not superficial; it represented a freedom they were willing to fight for.

I met each of the women three or four times, and our conversations led to friendship. If the subject of one of my photographs is a stranger to me, there's no story – and ultimately no photo. We wandered through the streets together, talking about their favourite colours. I asked them what colour wall would suit their style as a backdrop. I didn't tell them what to do during the photoshoots; I just asked them to be themselves. They knew where and how to look. Some of the women are visibly angry about what's happening in their lives; others stare calmly into the camera. Mostly, the women are still.

→ 'For me, colours are equal
to power and energy.' Marzieh
(b. 1997, Tehran)

When I was walking with one of the Smarties, a police officer stopped and warned her against not wearing a hijab, or scarf, in public. Mahla immediately told him she was transgender. Shocked, he let us go. After a few minutes of silence, I asked her if she really was trans. She told me it wasn't true and she had said it so he would leave her alone. I felt the stares from others on the street whenever I was with one of the Smarties. Once, when I was photographing a woman named Hedieh, a man started harassing her about her uncovered hair. Things grew heated, and I told Hedieh we should leave. All the women had similar stories – but they would not be dissuaded. They were never bothered by the astonished looks they received from strangers. By contrast, I was the opposite: always terrified of being noticed.

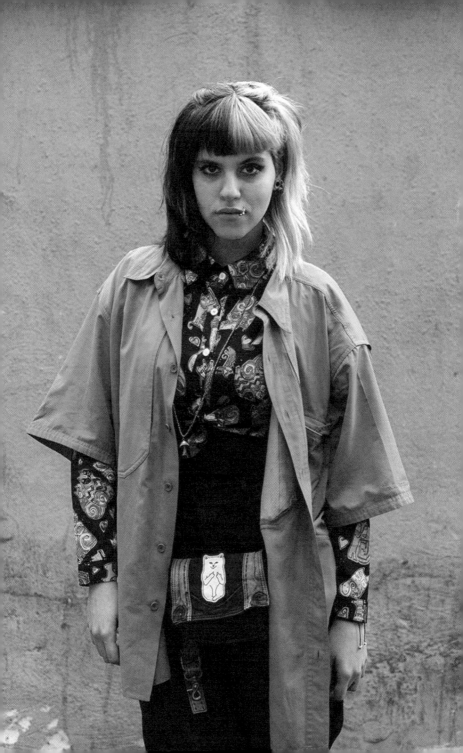

Another of the Smarties told me the first time she dyed her hair pink and red, her father refused to let her back into the house. She had to stay with a friend for a week until her father relented and let her come home. Another said her mother had promised her a holiday if she never dyed her hair orange and yellow again. Many of them faced rejection from their parents and siblings and were considered outcasts but no matter the threats or promises they received, the Smarties refused to concede.

I ran into a few male Smarties in Tehran as well. But there weren't many of them. Compared to women, men are less restricted and controlled in Iran. They can wear what they like, while the young women I photographed knew that removing their scarves and colouring their hair came at a price.

→ 'I always wished my hair was pink. When I saw Japanese anime, this passion grew stronger.' Anita (b. 1997, Tehran)

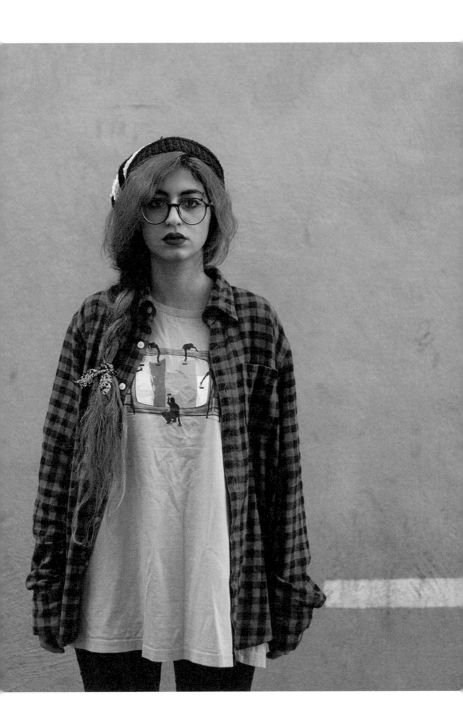

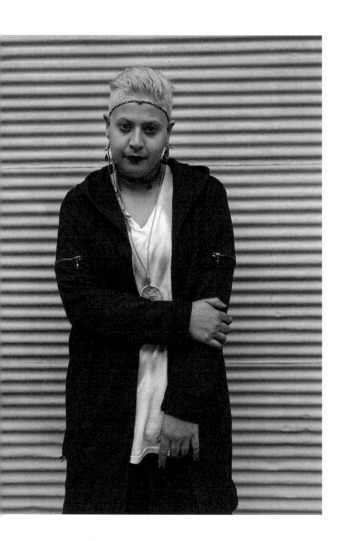

↑ 'The world is colourful,
and so am I.' Setareh
(b. 1995, Tehran)

→ 'I always change my
identity at the exact moment
I begin to feel empty.'
Marjan (b. 1995, Tehran)

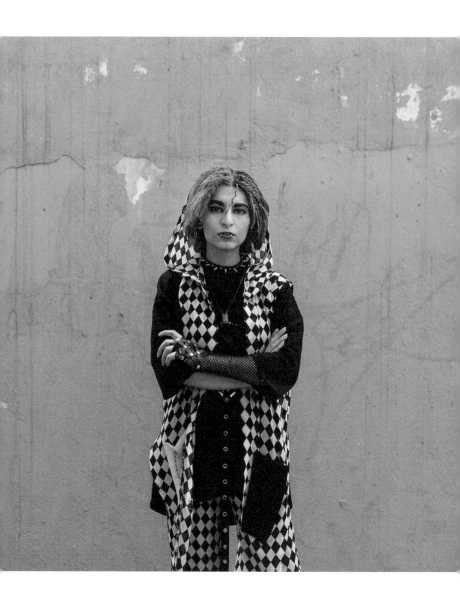

It is now six months since the Woman, Life, Freedom movement began – and everything looks different. The face of Tehran and other cities across Iran has changed. It has become common to see women and girls out in public – on the underground, in streets and shops – choosing not to wear a headscarf. I think the Smarties were the pioneers of the shift we're now witnessing, and their numbers have increased too. We walk alongside one another, showing hair of all shades and colours.

↓ 'I love colours. I love
their limpidity and the
happiness which lives in it.'
Mahtab (b. 1988, Tehran)

'Jin Jîyan Azadî':
The Kurdish Heart of Iran's Female-led Uprising

Kamin Mohammadi

'Kurdistan, Kurdistan, the graveyard of fascism!' Of all the chants to ring out over Iran since mid-September 2022, this one, invariably accompanied by the massive mobilisation of Kurds, catches my attention. Kurdistan is the region where the protests now exploding across Iran first caught flame, and in the past few weeks, Kurdish cities have seen the most brutal crackdowns by a regime not shy about killing its own people.

These protests were ignited because of the death of a Kurdish-Iranian girl on 16 September 2022 in Tehran. Jina Mahsa Amini came from Saqqez, where ethnic Kurds have long experienced discrimination. Her real name, Jina, is Kurdish, and as such could not be registered on her birth certificate in the Islamic Republic of Iran, where only Persian and Islamic names are lawful. There is some speculation that the brutality of her treatment at the hands of the Morality Police was in part due to her ethnicity. The protests at her funeral began when attending Kurdish women took off their headscarves and began chanting '*Jin Jîyan Azadî*' over her grave. These words – 'Woman Life Freedom' – have long been at the heart of Kurdish protests.

Soon the words could be heard echoing throughout the mountainous region. In the first two days of the protests, 250 people were reportedly arrested and five killed, including a child. Still the protests continued to spread to the rest of the country, with the Kurdish freedom cry of 'Woman Life Freedom' the dominant chant. As of February 2023 the number of demonstrations, according to the Human Rights Activists News Agency (HRANA), has been recorded at 1,280, in at least 309

locations. The agency calculates that 522 people have been killed and 19,763 arrested,[1] although the real numbers are likely much higher.[2]

What started as a protest against the mandatory hijab has become a full-throated demand for freedom. This is appropriate, as the chant of 'Woman, Life, Freedom' comes from a wider Kurdish struggle in which the equality of women is understood as a prerequisite of liberty for all. Indeed, '*Jin Jîyan Azadî*' was first used in the Kurdish feminist resistance movement that forms a wing of the Kurdish Workers' Party (PKK). Its roots lie in the anti-patriarchal, anti-capitalist, Marxist-Leninist ideology of the PKK's imprisoned founder, Abdullah Ocalan, who declared, 'A country can't be free unless all women are free.'

The Kurds are the fourth-largest ethnic minority in the Middle East, and their origins are shrouded in legend. One of the original Aryan tribes, their traditional homeland falls across the borders of Turkey, Syria, Iraq and Iran. In Iran, Kurds constitute about ten per cent of the eighty-four million population, and constitute a Sunni minority in a predominantly Shi'a country.

In their long struggle for self-determination and some degree of autonomy, the Kurds have been repeatedly used and manipulated by stronger powers, valued for their fighting prowess and knowledge of their native mountain terrain. They have invariably been betrayed by those outside powers, bearing out the truth of an old saying, 'The Kurds have no friends but the mountains.'

As an Iranian Kurd, brought up in exile in Britain since 1979, I have always been proud of my Kurdish roots. Part Persian, part Kurdish, I consider myself entirely Iranian, an identity that encompasses many regional ethnicities. But it is the Kurdish component of my identity that seems to most enchant, fascinate and terrify people. Once, on meeting a Turkish man in London, he visibly blanched and stepped back on being told of my Kurdish origins.

1 HRANA, 'Iran Protests – Daily Update'. Twitter, 20 February 2023.
2 The numbers of arrests were higher according to the head of Iran's judiciary, Gholamhossein Mohseni Ejehi. He said that 22,000 had been arrested since the protests in September 2022. AP's Jon Gambrell, 'Iran Announces Pardoning of More than 22,000 Arrested during Protests', PBS News Hour, 13 March 2023.

I had my first encounter with the myth around the Kurds in Tehran, in a travel agency while buying an aeroplane ticket to Sanandaj, the capital of Iranian Kurdistan and my father's hometown. The woman behind the counter looked at me, and her eyes widened. 'You're going *there*?' she exclaimed. 'Are you sure it's safe?' By way of explanation she told me, 'They cut off heads there, you know.'

The Kurds are descended from the Medes, an early Iran-based dynasty that conquered Nineveh in 612 BCE and were, in turn, conquered by the Persians sixty years later. For millennia, Kurds' strong culture has motivated various Shahs to attempt to weaken Kurdish identity by moving them out of their traditional homelands. In 1732, Nader Shah moved Iran's Kurds to Khorasan, but they fought their way back to their portion of the Zagros mountains. Modern Kurdish nationalism begins with Sheikh Ubeydullah's revolt in 1880 against the Ottoman empire and Iran's Qajar dynasty.

After the First World War, the Kurds were promised their own independent state by the Allies. Woodrow Wilson's fourteen points of January 1918 suggested that sizable ethnic minorities within the Ottoman empire be given their own states. The Treaty of Sèvres in 1920 guaranteed the establishment of a Kurdish state within a year, but it was rejected by Ataturk, the founder of modern Turkey, and never went into effect. In 1923, the final draft of the Treaty of Lausanne ignored the Kurds altogether. In 1946, as the Russian–British occupation of Iran was ending, Kurds established the short-lived Kurdish Republic of Mahabad. But when the foreign armies moved out, Iranian troops moved in. They promptly hanged Kurdish leaders, including the founder of the Kurdish Democratic Party of Iran (KDPI), Qazi Mohammad.

During the revolution of 1979, the Kurds gave their support to the revolutionaries and in return were promised self-rule. However, on his victory and return to Iran in February 1979, Ayatollah Khomeini, instead of retiring to a seminary in Qom as promised, moved to the Tehran suburbs and took absolute power. Like his predecessors, Khomeini brutally suppressed the Kurdish rebellion that ensued, sending not only troops but bombers to quell the uprising. The struggle lasted until 1980 and claimed some 10,000 Kurdish lives; around 1,200 political prisoners were

executed without trial. Since then, the Kurds of Iran have lived with routine discrimination, unable to register their own names, teach their language in schools, or hope to rise to positions of power. As Sunni Muslims in the religious dictatorship of the Shi'a Muslim Islamic Republic, the Kurds are subject to double discrimination.

This history informs the position of Iranian Kurds today. With regional ties to the Kurdish struggle in neighbouring Turkey, Iraq and Syria, Iranian Kurds watched with pride in 2014 when Kurdish female resistance fighters in Syria, known as the Women's Protection Units (YPJ), actively defended their homeland against ISIS as allies of the US and Europe. But the rise of Kurdish autonomy in north-eastern Syria and in Iraq served to increase the brutality of suppression in Iran. As the recent protests have intensified, Kurdish cities like Mahabad have seen the most robust protests and drawn the most savage response from the regime.

In the towns of Kurdistan, the regime's security forces not only use bullets and gas in the streets, but shoot people inside their homes and cars. They are making arbitrary arrests of citizens, breaking down their front doors in the middle of the night, and tracking the movements of artists, filmmakers, activists, students, actors and musicians through delivery apps. Gruesome beatings are meted out to protestors, including school-children in their schoolyards (children as young as seven have died this way). The regime has stolen and desecrated the bodies of dead protestors, conducted secret burials, and pressured the families not to reveal the mutilated state of the bodies handed back to them.

On the occasion of Jina Mahsa Amini's fortieth-day memorial – in Iran an important ceremony to mark a death – thousands of Kurds in their traditional clothes converged on the cemetery in Saqqez. The regime filled the area with security forces and roadblocks from early morning, so people walked long distances across open country to reach her grave. Jina's family, in spite of direct threats from the regime, defiantly held the ceremony to serve as a focal point for the biggest show of protest yet. (There are reports they have since been placed under house arrest.) After the ceremony, when the security forces attempted to ambush protestors in an area near the town's army barracks, soldiers

opened the barracks' doors to people seeking shelter. They could not help them in any other way, since the crackdown is in the hands of the Iranian Revolutionary Guard Corps (IRGC), an ideological militia that is sworn to protect the revolution, not the country, and which answers directly to Supreme Leader Khamenei. (There are reports that the IRGC has de-armed local army units on the suspicion they are on the side of Kurdish protestors.)

As the rest of the country comes out to chant 'Woman Life Freedom', Kurdish towns such as Javanrud, Bukan and Mahabad suffer the heaviest presence of security forces. There are tanks and truckloads of troops on the streets, and reports of vehicles with Iraqi plates carrying members of the Hashd al-Shaabi forces, an Iraqi Shi'a militia with close links to the Islamic regime. Water, electricity and the internet are regularly cut off, with many areas placed under a strict 9 pm to 9 am curfew. During these hours, security forces roam the streets, often singing religious songs, or announcing over loudspeakers that they are coming to get protestors. They break into people's homes, rob, vandalise and kidnap. They leave intimidating graffiti on walls, promising to return.

Moving into December, arrests and disappearances are at an all-time high. One investigation into the treatment of disappeared protestors carried out by CNN revealed how systematic rape is used to torture men and women and force them to make false confessions. Often these overwhelmingly young victims ask their parents to bring them abortion pills. Many commit suicide within days of being released.

Strikes, which are taking place in waves across the rest of the country, have roiled Kurdistan. In a sign of the resilience of the Kurdish people, communities are helping each other with basic foods and medicines. A truck drivers' strike now sweeping across the country – seen by activists as one of the most effective ways to cripple the Islamic Republic – has been in effect in Kurdistan. Since the regime uses hospitals and ambulances to arrest protestors, Iranian medics all over the world have begun to offer remote consultations to those injured by tear gas, truncheons and bullets (rubber, pellet and live rounds are all routinely used). Since September 2022, at least fifty Kurdish citizens have been

killed under torture by government institutions, according to human rights groups. The Hengaw Organization for Human Rights Group estimates that more than 7,500 Kurdish citizens have been arrested and abducted by security agencies and 134 Kurds have been killed.[3]

The Kurds are embracing their reputation for fearlessness and show no sign of backing down. As images of the regime's brutality circulate around the world through social media, respect for the Kurds and their struggle – which is at the heart of the Iranian female struggle – is higher than ever. Other ethnic regions being pounded by the regime, notably Baluchestan and Khuzestan, have come out to publicly praise the Kurds for their bravery, resilience, deep commitment to gender equality and their tendency to speak out eloquently even as they bury their children. Their singing and dancing during protests manifests the enduring strength of their culture and identity. The regime's counter-narrative – that the Kurds are separatists seeking to turn Iran into another war-torn Syria – is failing to stick.

While there is the danger that foreign actors will manipulate the Kurds into waging a separatist struggle, this uprising is defined by a nation embracing Iran's diversity – ethnic, generational and otherwise. The protests have brought into the streets not only women who do not wish to wear the mandatory hijab, but also LGBTQ people, students and everyday *bazaaris*. Without an apparent leadership or central organisation, they are primarily led by young women, but also others who cut across gender, age and socio-economic status.

Since September, the simple demand for human rights, equality and democracy at the heart of these protests has led to powerful scenes of civil disobedience that, until recently, were beyond our wildest imaginings. Schoolgirls with their hair loose stamping on

3 'Hengaw statistical report on the killing of at least 134 Kurdish citizens during the Jina revolution + PDF file'. Hengaw Organization for Human Rights Group, 11 March 2023. Of the more than 7,500 Kurdish citizens arrested and abducted by security agencies, Hengaw verifies the identity of 2,167 of them. Two hundred and twenty are women and 191 are children and teenagers. The detailed report includes a breakdown of abductions and arrests in Kurdistan Province, Iran.

pictures of ayatollahs and chasing regime representatives from their schoolyards. Women quietly going about their daily business without a loose coat or head covering. We have seen the retaking of public spaces by women using their physical bodies, hair included, to take back the streets, the squares, the schoolyard, the university campus. These women are overwhelmingly young, but their cries of 'Woman Life Freedom' carry the voices of all Iranian women who have been silenced and suffered indignity, humiliation and erasure at the hands of 'God's own government'.

This cry, even amid horrible suffering, gives us hope.

A first version of this essay, published by Truthdig (www.truthdig.com) on 7 December 2022, was nominated for two awards, 'Writing on Gender and Society' and 'Foreign Correspondence', by the LA Press Club for its 2023 SoCal Journalism Awards.

Braving Tehran's Roundabout, Maidan Valiasr

New encounters in the city

Farnaz Haeri

My head is uncovered, so is my neck. As soon as I meet the eyes of the policeman standing near the bus stop, my hands automatically reach for my hijab. Then I remember that, of course, I'm not wearing one. A minute later, when I get on the bus, people who still aren't used to seeing women without a headscarf glance at me and quickly turn away, their eyes full of questions. At the next station, an austere-looking woman wrapped in her black chador, prayer beads in hand, gets on. She fingers her prayer beads and repeats an invocation under her breath. There's bound to be a fight between us, I think to myself. Instead, what does she do? She asks me for directions, and I tell her she needs to get off at the next stop. Her gratitude is a wave of kindness: 'May you always be safe, my daughter. Please take very good care of yourself.'

I hadn't expected this. Nor did I expect it yesterday at the photocopy shop when the man stood up, bowed in my direction, and said, 'Long live our courageous women!' Nowadays, instead of being pestered on the streets by young men, women are met with the refrain of the movement: Woman, Life, Freedom. This, too, is as unexpected as it is beautiful.

I get off the bus at Maidan Valiasr, in the heart of the city. I have to pass through the eastern end of the circle, which is where

the undercover agents and the Basij militia are assembled. So far, the entire city has paid my curls nothing but respect. But not these guys. As I pass by them, one of them says to the man next to him, 'I bet if I hit her over the head she'd pass out.' He laughs as he says this, loud enough that I can hear it. My heart is in my mouth. I expect a baton to collide with my head at any moment. As I continue walking, looking directly ahead, someone hits me in the ribs – maybe with the butt of a gun – and shouts at me to cover my head. I don't have anything to cover my head with, and I wouldn't do it even if I did. My hands stay by my side and I press on ahead. Another one of them shouts, 'Dirty Bahai, cover that head.' The next man adds, 'Bahai slut'. I hadn't realised until now that, to these men, calling someone a 'Bahai' – a member of a much-abused religious minority that started in Iran in the nineteenth century – is the ultimate insult. In the meantime, I'm still waiting for that baton to hit my head as I finally march past the end of the line-up of street thugs.

The *maidan* at Valiasr has for many years had a gigantic billboard space on its north-west quadrant. I still don't dare look up, expecting that at any moment something, anything, is going to knock me flat to the ground. When I finally muster enough courage to look, I notice that, on the several-stories-high billboard, there's nothing but a vast blank space and below it the words: '*The Women of My Land*.' The absurdity of seeing these words in reference to nothing and no one is as strange as hearing paid street thugs call you a Bahai slut. The billboard looks orphaned with just those words serving as signifiers to something non-existent. When it was first put up, the faces of real Iranian women, heads of course properly covered, had been up there – supposedly the regime's way of fighting back against the Woman, Life, Freedom refrain of the street demonstrations. But there was such an outcry by the people featured and their relatives that the regime was forced to remove their photos, leaving only a string of forlorn words on a massive vacant poster.

I keep on walking. Walking without that dreaded piece of cloth they've forced on us since the first year in school. The piece of cloth that clawed at my throat throughout my younger years would often slip off without me realising it. That piece of cloth is

gone. Gone from my head and from those of many others. For us it's as if the Berlin Wall has finally come down.

I've run a gauntlet and a fire of insults and I'm still in one piece. The fear is still with me, but it's only lurking in the background. Our world here has shifted. Those militia goons can say what they want; the truth is that not wearing a hijab no longer means being a loose woman or a 'slut' in this country. It no longer creates a feeling of us-versus-them. We Iranians are all in this together. And no one is going to hang us from our hair in hell anymore. In primary school, the religious studies teacher insisted this is what would befall us if we were seen outside in public without our hijabs. The image of being strung up by my hair in hell was so traumatic that I begged my parents to take me to the barber and cut off all my hair like a boy's. I figured no one would be able to hang me from my hair if I didn't have any in the first place.

Nowadays, loose hair – without a forced casing of fabric around it – is simply hair. Nothing more, nothing less. This hair is not going to lead any young man astray with desire. At the very least, the people on the streets of my city have realised this. Maybe one day the country's religious studies teachers will get it too.

Translated from Persian

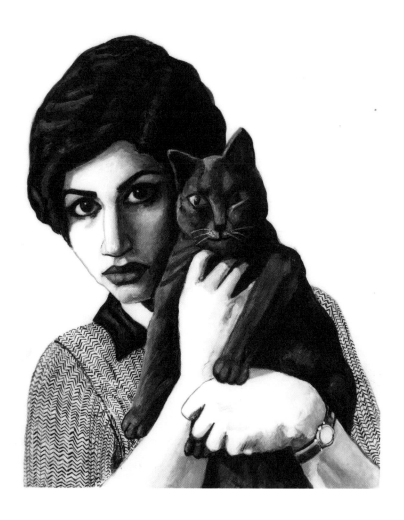

Rebel Rebel

Exhibition of Iran's pre-revolutionary feminist icons

Soheila Sokhanvari
Reviewed by Malu Halasa

A towering mirrored 'Monolith' stands at the entrance to Soheila Sokhanvari's exhibition *Rebel Rebel*. The over thirteen-foot-high sculpture, made from wood, metal, Perspex mirrors and glitter, casts brilliance and shadow on the hand-painted Islamic geometric murals covering the floors and walls of the Curve Gallery in London's Barbican Centre, encasing twenty-eight portraits of feminist icons from pre-revolutionary Iran. At the base of the 'Monolith', sharp, sparkling shadows blur and fade into chaotic amorphous patterns, an apt allegory for the lives of important female Persian cultural figures from before Iran's Islamic Revolution.

Prior to 1979, poets, actresses, academics, pop stars, film directors and ballerinas – women from all walks of life and professions – fuelled the rich tapestry of Persian arts, culture, language and literature. There were those whose work didn't come to a complete stop after Ayatollah Khomeini took power forty-four years ago. Some were arrested and sent to Evin Prison. After they were forced to write letters repudiating their former lives – the experience of many of the actresses – they continued some semblance of their careers. Others left public life entirely, descended into addiction or died in obscurity. A small minority fled the country and continued working abroad, never to return.

The eyes of Iran's tragic poet Forough Farrokhzad (1934–1967) and her cat stare, searching and accusatory, peer out of Sokhanvari's portrait. Farrokhzad was the nation's best-known poet. After she published under her own name what was considered sexually frank poetry for its day, her son was taken away from her after her divorce. She died in a car crash at the age of just thirty-two. Her painting is named 'Let Us Believe in the Beginning of the Cold Season' after her posthumous collection of late poems. Each of the other twenty-seven portraits has been given a title inspired by the creative lives of its subjects.

Faegheh Atashin (b. 1950) has many names. One of them is 'the Love Addict', though she is better known as Googoosh, the famous Iranian singer renowned for her emotional ballads of heartache and loss. In 1979, Googoosh was travelling outside Iran. She returned to the country and, like all women performers, was banned from singing until the so-called 'reformist' presidency of Mohammad Khatami in 1997. Three years later she was finally given a passport and left the country. She now lives in Los Angeles and performs to adoring Iranian fans in the diaspora. In her portrait, an older version of the singer sits in front of a framed picture of her younger self. Both are dressed in the style of clothes evocative of their respective eras. Googoosh's heavily made-up younger version of herself wears a distinctive 1960s bob, while a couple of decades later she appears more subdued. Time has passed, to never return.

Found Photographs

For source material, the artist trawled through internet search engines for photographs of her subjects. She painted egg tempera on calf vellum, with a squirrel-hair brush, which suggests art rooted in both the aesthetics and working practices of the past. The resulting portraits were influenced by conflicting art history traditions. In the ornate settings of Persian miniatures, more attention is often paid to the background. The stylised figures in the miniatures show little or no emotion. This is the opposite of Catholic martyr paintings of sad, tortured saints. Iranian Shi'as also have their own version of visual culture: popular religious posters, sold in Iranian bazaars, often celebrate Husayn's martyrdom at the battle of Karbala.

Another singer, Farhdokht Abbasi Taghany (1934–1991), known as Pouran Shapoori, appeared in films and television and sang more than thirty-two hit songs. Like all but two of the interior settings of the portraits in the *Rebel Rebel* series, Pouran and Googoosh sit amidst a kind of patterned splendour. The exception is Farrokhzad's white backdrop and the grey behind 'The Lor Girl', Roohangiz Saminejad (1916–1997), the first unveiled Iranian woman to appear in a Persian-language film, in 1933.

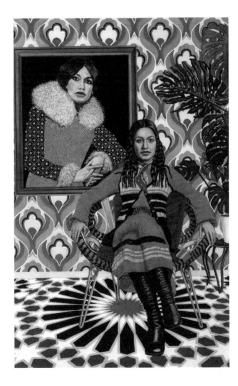

← Soheila Sokhanvari,
The Love Addict (Portrait
of Googoosh), 2019. Egg
tempera on calf vellum.
Painting size: 40 × 27 cm.

The floor of Googoosh's portrait resembles the Islamic geometric shapes that cover the entirety of the Curve Gallery. Barefoot Pouran in 'Wild at Heart' dangles her legs on a decorative red sofa. The wallpaper behind her is ornate, the flowers of which seem to fall onto the singer's dress. It is an optical illusion of sorts; the flowers are corsages.

The clothes the women wear, as in the portrait of Filmfarsi superstar Forouzan, Parvin Kheirbakhsh (1937–2016), enhance the subject's story. Forouzan, considered one of Iran's most alluring actresses, worked on sixty films. During her career she was objectified by men, both secular and religious. In a 1972 interview she said, 'I am sick, sore, and exhausted. I am tired of standing in front of the camera listening to the director telling me to "be a

little sexier, a little more lustful, bring your skirt higher, be a little more inciting and provocative".[1]

In her portrait, 'Hey, Baby, I'm a Star', she wears a modestly revealing pink flowered dress, her expression forthright and open. After the Islamic Revolution, once she signed a letter of repentance, the authorities released her from prison. However, her money and property were confiscated and she died in obscurity.

← Soheila Sokhanvari, *Wild at Heart* (Portrait of Pouran Shapoori), 2019. Egg tempera on calf vellum. Painting size: 14 x 17.8 cm.

Sartorial Upheaval

The decorations and shapes in the women's clothing and interiors – in some cases landscapes – where they sit, as well as in the physical space of the gallery itself, are key to Sokhanvari's visual vocabulary, which stems from family culture. Her father,

1 'Portrait Biographies', PDF Exhibition Guide to *Rebel Rebel* (London: The Curve Gallery, Barbican Centre, 7 October 2022 to 26 February 2023), p11.

Ali Mohammed Sokhanvari, was a tailor during a period of great sartorial upheaval in Iran. In 1936, the first Pahlavi king, Reza Shah, issued the *Kashf-e hijab* edict, which ordered women not to veil or wear the chador. It was part of new and evolving laws, which replaced female and male traditional attire with Western clothing, including the 'Chapeaux Hat' for men.[2]

In the 1940s, Sokhanvari's father taught himself about new clothing styles by going to the cinema. At the cinema in Shiraz, which showed Western films, he spent the whole day sketching the outfits of Hollywood film stars, which he then reproduced at home. Sokhanvari recalls her mother's version of the black dress and yellow coat, with black buttons, worn by Audrey Hepburn in the 1961 film, *Breakfast at Tiffany's*.[3]

———

2 Elahe Saeidi and Amanda J Thompson, 'Using Clothing to Unify a Country: The History of Reza Shah's Dress Reform in Iran', ITAA (International Textile and Apparel Association) Proceedings, No. 70, 2012.

3 'From *Breakfast at Tiffany's* to Opiated Adjacency, Soheila Sokhanvari in Conversation with Eleanor Nairne', in *Soheila Sokhanvari Rebel Rebel*, ed. Eleanor Nairne, with Hilary Floe (London: Barbican, 2002), p20.

↑ Soheila Sokhanvari, *The Lor Girl*
(Portrait of Roohangiz Saminejad),
2022. Egg tempera on parchment.
Painting size: 12.45 x 15.3 cm.

The artist reveals, 'I used to float about my father's office, where there would be tons of sketchbooks with fabric samples and rolls of fabric resting against the walls. I imagine that's why patterns and colours play a major part in my works. He taught me how to draw and paint – I owe him that too.'[4]

Like many Iranians abroad, Sokhanvari is a dual national. She was unable to return to Iran and therefore did not see her father before his death in 2021. Fabrics and Islamic geometries may be part of reconstructing memory and home, but the politics of dazzle is not lost on the artist.

'By patterning the walls and floor of the gallery, I'm inviting the viewer to step into one of my paintings. I'm inspired by Islamic aesthetic philosophy, in which architectural surfaces are intensely ornamented. What you could call an "over-beautification" creates a delirium for the viewer so that they lose their sense of self and encounter God.' As influences, she references Simone Weil's experience of beauty as 'radical decentring' and Elaine Scarry's 'opiated adjacency'.[5]

Sokhanvari admits, 'My intention is to create a space to dazzle the onlooker so that they can contemplate these women.'[6]

Psychedelic Social Reality

Art historian Dr Jordan Amirkhani sees Sokhanvari's intense patterning as a kind of caging of women. She cites as one example the portrait 'Only the Sound Remains' for Azar Mohebbi Tehrani (1946–2020), the singer Ramesh from the golden age of Iranian pop. Amirkhani writes, 'These patterns seem to pin the women in place, reflecting the ways in which women were indeed "caught" within a web of conflicting social practices; this was a web that reproduced oppressive gender roles and derailed pathways to activism and emancipation for Iranian women, many of whom were eager to fulfil the liberatory potential of the state's progressive social mandates

4 *Ibid.*
5 *Ibid.*
6 *Ibid.*

… [It was] glamorous on its surface but disorienting in reality …
In a society unable to negotiate the clashes between clerics and
culture-makers, women's freedom to create and express was
rendered precarious.'[7]

Amirkhani also discusses Sokhanvari's deployment of 'the
histories of geometric patterns found in Islamic art alongside the
campy, stylized aesthetics adopted in Iranian popular culture of the
1960s and 1970s, acknowledging a truly psychedelic social reality.'[8]

The artist experienced this reality first-hand after she left Iran.
Months after the 1979 Revolution, feeling unwell in a UK school, she
waited for the nurse, while a television next door showed images
of violent protests in Iran. The volume had been turned down at
the same time as music from the school's dance class filled the air.
'From that moment on,' writes Harriet Shepherd, 'Sokhanvari's
every memory of the revolution has been recalled to the beat of
"Boogie Wonderland."'[9]

Music is an important component of the exhibition, which was
named after David Bowie's 1974 song, 'Rebel Rebel'. In the Curve
Gallery, a chill-out area with cushions has been provided for those
who wish to immerse themselves in a poignant soundscape by
Marios Aristopoulos. It features the voices of Iranian women and
music by Ramesh and Googoosh at a time when women singers
are still banned from performing live or being broadcast inside
Iran. Above the cushions hanging from the ceiling is the sculpture,
'The Star'. Fashioned from Perspex two-way mirrors, wood,
metal, plastic and electronics, within its see-through interior a
monitor plays videos of the singers of the day. Sokhanvari's use
of mirrors recalls the glass-cut sculptures of Monir Shahroudy
Farmanfarmaian (1924–2019), who revitalised the Persian folk art
tradition of Āina-kāri.

7 Jordan Amirkhani, 'A Constellation of Stars', in *Soheila Sokhanvari Rebel Rebel*,
 ed. Eleanor Nairne, with Hilary Floe (London: Barbican, 2002), p33.

8 *Ibid*.

9 Harriet Shepherd, 'Woman Life Freedom: Soheila Sokhanvari Honors the Untold
 Stories of Iran's Feminist Icons', *W Magazine*, 10 July 2022.

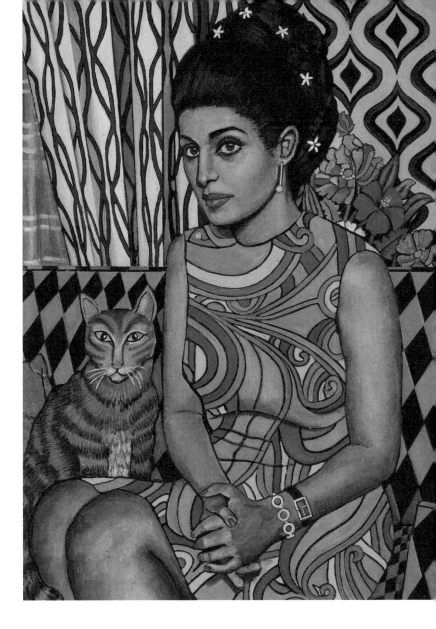

↑ Soheila Sokhanvari, *Only the Sound Remains* (Portrait of Ramesh), 2021. Egg tempera on calf vellum. Painting size: 17.3 × 12.8 cm.

Cosmic Dancers

While some of the careers didn't last, the influence of these women and their work did – at times in disturbing ways. The portrait, 'Baptism of Fire' of the actress Nosrat Partovi (b. 1944), tells one such story. In the 1974 film *The Deer*, directed by Masoud Kimiai, she plays the character of a cabaret dancer who lives with a drug addict. The film is set in the 1960s, a time when unskilled workers were leaving the countryside for urban destitution.

The Deer was playing in the Cinema Rex in the port city of Abadan, on the night of 19 August 1978, when a terrible fire broke out inside the cinema, where the doors had been locked. Over 400 people perished in the tragedy. Many believed it was a terrorist attack by radical Islamists who considered cinema a symbol of Western immorality and corruption; others blamed the Shah's secret police. The attack – and the social unrest which followed – was the beginning of the end of the Pahlavi dynasty. Within months, the new Islamic Republic began. Actress Nosrat Partovi was never heard of again.

Not every woman in Sokhanvari's *Rebel Rebel* series ends up a victim. Pouri Banaaei (b. 1940), a star in early Filmfarsi and later in Iranian New Wave classics, stands, hands on hips, gazing confidently towards a distant horizon in 'The Immortal Beloved'. She towers above the tree line of a mountainous landscape. Banaaei had notoriously refused to sign the regime's letter of repudiation, saying she had done nothing wrong, and returned to ordinary life.

Sokhanvari plays with women's visibility/invisibility in 'Cosmic Dancers I and II', octagon installations viewing boxes constructed from wood, metal, PVA, acrylic sheet, car paint, emulsion paint and electronics. Looking into the boxes from one side, a figure of a woman can be seen dancing inside. Peering in from the opposite side, the figure has all but disappeared.

One of Sokhanvari's feminist icons who did completely disappear from Iran after the 1979 Revolution was classical ballerina Haydeh Changizian. Sokhanvari painted her portrait, 'A Dream Deferred', and joined Changizian in conversation with SOAS

← Soheila Sokhanvari, *Baptism of Fire* (Portrait of Nosrat Partovi), 2022. Twenty-three-carat gold and egg tempera on calf vellum. Painting size: 13.37 x 17.3 cm.

academic Katy Shahandeh.[10] It was a rare appearance. Changizian, now in her late seventies, had been seen as a child dancing at a wedding in Tehran. Her parents were told she should be classically trained, and they sent her to one of the country's few ballet schools, that belonging to Madam Yelena Avedisian.

As a teenager, Changizian convinced her father she needed dance tuition abroad to realise her dream. He allowed her to study in Germany, where her brother attended university. She entered the Institut für Bühnentanz in Cologne, and in 1964, was offered a contract with Cologne Opera Ballet. Instead she continued her studies in Leningrad at the Vaganova Choreographic School of the world-renowned Kirov Ballet. Afterwards, she joined the Frankfurt Opera Ballet and it was there that the Iranian Minister of Culture

10 Haydeh Changizian, Soheila Sokhanvari and Katy Shahandeh, 'Woman, Life, Art: In Conversation with Haydeh Changizian and Soheila Sokhanvari', SOAS (School of Oriental and African Studies), Brunei Gallery, London, 9 February 2023.

← Soheila Sokhanvari, The
Immortal Beloved (Portrait
of Pouri Banaaei), 2022.
Egg tempera on calf
vellum. Painting size:
16.95 x 12.4 cm.

and Arts saw her dance and asked her to return to Iran to perform
with the Iranian National Ballet. In her mid-twenties, she was
the company's prima ballerina. By 1978, she planned to establish
her own Niavaran Cultural Dance Company, and bring Persian
literature, history and mythology to classical ballet. However,
a year later after the Islamic Republic banned women from
performing on stage, she left the country for the US and continued
her dance career in California.

During their conversation, Changizian and Sokhanvari traded
stories from their lives and others belonging to women cultural
practitioners from pre-1979 Iran. Their reminiscences and
observations inspired an audience of students, young artists and
performers who only knew the Islamic Republic. The two women
had followed their dreams in spite of their estrangement and exile
from their country.

In Iran, the experiences of generations of Iranian women, young and old, have once again become visible, as many take to the streets. In Sokhanvari's portraits, the compelling dark eyes of her rebellious women are a timely reminder of one of the regime's tactics used against women during the protests: shooting demonstrators in the eyes,[11] and the call to ophthalmologists across the world to lend their aid and expertise to wounded Iranians too scared to go to state hospitals for fear of arrest.[12]

Sokhanvari's *Rebel Rebel* exhibition ensures that the faces and stories of these inspiring cultural icons are not lost. Their spirit will inspire the women who come after them.

→ 'A Dream Deferred' (Portrait of Haydeh Changizian), 2022. Twenty-three-carat gold and egg tempera on calf vellum. Painting size: 7.7 × 5.7 cm.

11 Cora Englebrecht, 'Hundreds of Protesters in Iran Blinded by Metal Pellets and Rubber Bullets', *New York Times*, 19 November 2022.
12 'Call Out for Eye Specialists', *IranWire*, 20 January 2023. See also Katherine Hignett, 'Blinding as a Weapon: An Ophthalmological Review', *IranWire*, 3 March 2023.

In Her Voice, We Are All Together

The death of a protestor

Niloofar Rasooli

'Don't be afraid, don't be afraid. We are all together,' she chants, then is shot in the head.

These are the final words of Ghazaleh, a protestor, thirty-three years old, de-veiled, standing on a utility box, taking a video of people and, a few seconds later, of her own death. We see her death through a surprisingly intact video on her mobile phone. We see a record of a death, a moment, over and over again. It is the evening of 21 September 2022. It is in Amol, a city in northern Iran (see page 106).

We happen to be there when her camera starts shooting the video. We see the crowd, we see the fire. It is night. It is cold. The orange flames of the fire illuminate the crowd. The yellow shine of the moon absorbs the voices. People are shouting. People are angry. People are tired. Our body, our history, reminds us that a bullet could strike us any time; we cannot see, but we believe we see a black guard nearby. It should be somewhere, somewhere close, somewhere far, somewhere. We tremble, she looks around. She raises her voice, loudly chanting, 'Don't be afraid, don't be afraid. We are all together.' We come together. Her voice surrounds us, we stay in it, we stay in it for just a moment. Reading it again and again, we take shelter in her voice for just a moment. And then she is fatally shot. We are all fatally shot.

When she falls, her mobile phone falls from her hand. We fall from her hand onto the ground. We can only see the ceiling.

There is a big, doomed gap, a concrete wound. The wound divides the ceiling, the world and us into two never-meeting parts. People rush into the frame. They see us dead, they see her dead, they scream. Their words are drowning in the background screams, we are drowning in the wound in the ceiling. Is somebody repeating, 'Don't be afraid, don't be afraid. We are all together'? We do not know, we never know, we die when the camera dies.[1]

In the recent history of Iran, there are numerous people who have documented their own death, the moment of receiving a bullet in their face, chest and heart. What remains are their voices, their final words. Their sentences become the voice of a history. A voice stretches the history. A history is condensed in a voice.

1 Tweet on @ManotoNews, 20 October 2022. Accessed 5 January 2023.

← The only photo from Ghazaleh's funeral, which shows her grave. Retrieved from the anonymous photos published on Twitter @GFakhari, 27 October 2022.

Ghazaleh's self-recorded death haunts and stops the continuity of time. She is killed to be erased, to be stopped, to be done. Her video, however, achieves the opposite.

Who was the first to save the video from her mobile phone? How did it survive? How many other voices have narrated their own death, but were erased after the inspection of the authorities? We do not know, we only know that Ghazaleh's voice does not end with her death, it just rises.

After Ghazaleh's death, her voice went viral. Her chanting of 'Don't be afraid, don't be afraid. We are all together' gave another rise to the uprising. The authorities refused to deliver the body to her family. It is reported that her mother cut a vein in her hand; she bled so much that the authorities fearfully returned the body to her.[2] Blood comes to save a dead body.

2 Maryam Foumani, 'Ghazaleh Chalabi, a Woman Who Wanted to Multiply Her Courage', *Asoo*, 5 November 2022. Accessed 5 January 2023.

Ghazaleh's story does not finish here, as it may never finish, like many other histories of flesh wounds that will never finish.

'They only let her be buried in a one-metre grave. The poor girl could not even fit in there, they had to bend her legs.'[3]

Ghazaleh's grave is the location of pain, is the soil that if you dig, you will find nothing except boiling blood. The grave is enclosed within two walls, and stairs. The walls that once were coming as slaps on her face, the walls that once were muting her voice, concealing her body, and stealing her dreams and hopes. These muting walls come one more time on her corpse, on her grave. So, no big crowd can come together over her grave. But a big crowd came together there, somewhere around her grave. Forty days after Ghazaleh's death, people gather in the same cemetery, de-veil, burn their headscarves, hold hands, dance and chant what Ghazaleh was chanting. 'Don't be afraid, don't be afraid. We are all together.' This is her voice, chanting even after her death. In her voice, we shall come together.

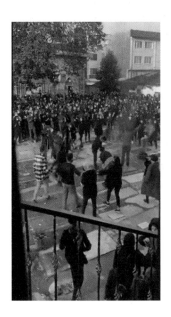

→ Forty days after Ghazaleh's death, people gather in the same cemetery and protest against her brutal murder. Retrieved from the anonymous videos published on Twitter @1500tasvir, 4 November 2022.

3 Tweet on @GFakhari, 27 October 2022. Accessed 5 January 2023.

Seven Winters in Tehran

Q&A with the director of a documentary about Reyhaneh Jabbari, executed for the murder of a man who attempted to rape her

Steffi Niederzoll

A model of an Iranian prison was filmed for Seven Winters in Tehran. Photo: Julia Daschner, courtesy of Made in Germany Filmproduktion.

As monolithic and all-powerful as the Islamic Republic of Iran is, its secret vulnerabilities were revealed by the troubling but illuminating documentary *Seven Winters in Tehran,* directed by Steffi Niederzoll.

The film recounts the tragic story of a near rape victim who murdered her perpetrator in self-defence, the failed campaign of a mother to save her daughter from execution and the determination of ordinary people in facing down a corrupt system. There is no happy ending, yet *Seven Winters* still inspires and empowers.

In 2007, 19-year-old Reyhaneh Jabbari was studying Software Engineering. In earlier times, as shown from home video footage featured in the documentary, she was a happy, bubbly young woman who had a bright future ahead of her. She worked part-time as an interior decorator, and was approached and befriended by Morteza Sarbandi, purportedly a plastic surgeon. He had plans, he said, to renovate a new clinic space and he invited her to an empty apartment.

Reyhaneh was making measurements and taking notes when Sarbandi accosted her. To defend herself, she grabbed a knife on a nearby table. He goaded her, daring her to stab him – he said he could take it. She did, in his shoulder. Reyhaneh fled after a friend of Sarbandi's came to the apartment. Later that evening, Sarbandi died from his wounds.

In the middle of the night Reyhaneh's mother, Shole Pakravan, woke to find policemen in her house. They took her eldest daughter away. For fifty-eight days her family was not allowed to see or talk to Reyhaneh. The police tortured her and threatened to arrest and torture her mother and Shahrzad, her younger sister. Reyhaneh gave a false confession, which was used as evidence against her in court.

'You Should Have Been Raped'

The first judge who heard the case was sympathetic to the young woman's plight. His replacement, a hardline religious judge, told Reyhaneh it would have been better if she had been raped to avoid the situation she was now in. Reyhaneh was convicted of Sarbandi's murder. Under the Islamic state's *qisās,* an antiquated law of blood revenge or retribution, the family of the murdered victim can

determine whether Reyhaneh's sentence (in this instance, blood revenge by hanging) is carried out or not.

During the seven and a half years she spent in prison – the seven winters in the title of the film – her mother Shole waged a campaign to uncover the truth of what had happened to her daughter. It came out that Morteza Sarbandi was not a plastic surgeon after all. He trained people in self-defence in the Quds Force, a militia headed by Qasim Soleimani, who was assassinated in 2020 in Iraq. Sarbandi had many businesses. His work for the Quds Force, formally part of the IRGC (Islamic Revolutionary Guard Corps), in part explains why Reyhaneh was vilified in the Iranian press, with a campaign of disinformation, rumour and conjecture that darkened her character. Shole's campaign to save her daughter went viral on Facebook. Iranian officials were asked about Reyhaneh's case whenever they made state visits to Europe.

Relatives kept vigil outside the final prison to where Reyhaneh had been taken and filmed Shole covertly, as she waited to learn if Reyhaneh had been granted clemency or was going to be executed. This was the initial footage seen by Steffi Niederzoll. It was shown to her by Reyhaneh's relatives, who were refugees in Turkey. Niederzoll, who was away visiting her partner at the time, had known of Reyhaneh's case from news reports in Germany. An artist and film school graduate, she was writing her first fictional film treatment. On repeated trips to Turkey, she and Reyhaneh's relatives became friends. They wanted her to make a film about the case. Although she wasn't sure if she was the right person to do it, she still wanted to help them.

Meanwhile in Iran, after Reyhaneh's death in 2014, Shole had become a well-known human rights campaigner openly critical of the country's death penalty. After a state interrogator threatened her, she and one of Reyhaneh's youngest sisters, Shahrzad Jabbari, fled Iran for Istanbul.

Niederzoll was at Reyhaneh's relatives' house, copying materal that she planned to take to Germany and get translated. She looked out of the window and recognised Shole. Their chance meeting convinced Niederzoll that she should make the film. In time, Shole and her daughter settled in Germany. Several years later her second daughter, Sharare Jabbari, was able to join them,

although Reyhaneh's father, Fereydoon Jabbari, was denied a passport and remains in Tehran.

Seven Winters in Tehran took five years to complete. Niederzoll had wanted to go and shoot in Iran, but was warned off by Iranian friends. The film could not have been made without the extensive archive Shole smuggled out of the country. Nor would it have been possible without the Iranian production team, and other anonymous people, who secretly filmed in Iran for the documentary.

Reactions to the Film

Steffi Niederzoll spoke to *Woman Life Freedom* over Zoom, between the film's European premiers. After the Berlin Film Festival, *Seven Winters in Tehran* was screened at London's Human Rights Film Festival, at the Barbican. It also debuted in Paris at the same time.

Q: *What has the reaction been to* Seven Winters in Tehran*?*

SN: People have been so touched by the movie. After every screening we had such strong Q&As. Some Iranians especially opened up. One said, 'I never spoke about it but my father was executed.' Another said, 'I never spoke about it but my brother was killed.' Or 'I never spoke about it but I was raped by a mullah.'

I get goosebumps because it's so – [the director's words fail her and her voice wavers] – I don't know, we always think that art can change something. I always had this idea that art can connect people. I'm crying because it's really touching. People want to take action.

Q: *The second trial judge's statement, that it would have been better if Reyhaneh had been raped, was a clear indication of what Iranian women face in their country.*

SN: This was the trickiness of the disastrous blood revenge law. In the case of Reyhaneh, Sarbandi's eldest son, Jahlal, 'owns' his father's blood. He can forgive or not forgive. As soon as Shole started to speak to Western media and said that Reyhaneh

was nearly raped, the chances that Jahlal might forgive Reyhaneh grew smaller. The more Reyhaneh's family fight for her mercy and life, the less she will be forgiven by Jahlal's family. That's the super-weird aspect of all of this.

Q: *The story seems one of conflicting honours. In the film, it's obvious that Jahlal wants to make a deal. He says he won't call for Reyhaneh's execution if she withdraws her charge that his father tried to rape her. That's the honour of his father and his family. Then there is Reyhaneh's honour, which she's not allowed the agency to protect in the Islamic justice system.*

SN: Shole wanted Reyhaneh to erase [take back] the rape charge. Shole begged her daughter, 'Save your life.'

Q: *Understandably.*

SN: However, Reyhaneh wanted to stay with the truth. I think she could not stand that someone so powerful could just get rid of what had happened. She thought: 'This is my truth, my dignity. This is the only thing I have.' She had lost everything. She wanted to get married and have children. She also knew that if she came out of prison, everything would be different. The only thing she had left was her dignity. That was her strength and why she became such a hero.

Q: *In such a fraught situation, it's easy to see people in stark terms, black or white, right or wrong, good or evil. Yet* Seven Winters *is a nuanced film, and one gets the sense that for Jahlal and the rest of the Sarbani family, calling for Reyhaneh's execution will not bring them peace.*

SN: It was always important for me to not enter this 'black and white' terrain. I don't want to say Jahlal's a victim – because he's also a grown man, and could have made a different decision. But for me, he is a victim of this patriarchal society. He has to fulfil *something*. I find this decision the state forces on him quite horrible. I feel sorry for everyone who is put through this. However, he can also

be seen to be doing wrong when he says he forgives. There is a whole system that will approve of him. When he's not forgiving, there is another part of society that will claim him.

I didn't read the whole SMS conversation between Shole and Jahlal because part of it was lost. Of course, we showed only a tiny bit in the movie. At one moment I had the feeling, wow, okay, he is really considering pardoning her. Then in another moment we see how his speech changes. He becomes very strict. I think he was also under pressure.

Q: *In the film, one gets the impression he is wavering.*

SN: He cries, 'What should I do?' If a guy like that cries in front of people, it is quite strong. I wrote a book with Shole, so I'm deeply involved in this case. Both families got all this wrong information. The Sarbandis were so sure that Reyhaneh was a sex worker. Of course, if you hear that she is a bad woman, you assume that she must have no morality and is capable of killing your beloved father …

Q: *A wealth of documentation must have been smuggled out of Iran.*

SN: Shole has a massive archive because she collected everything she could find. We're speaking about police reports, investigation reports. I read over 100 investigation reports from the time Reyhaneh was tortured. And, of course, Shole paid money for every little piece. She always found someone who maybe knew someone who could perhaps get a copy of this document or the other. She collected everything she could get over the years. Shole even still has everything that was in Reyhaneh's bedroom. The first time she gave any of Reyhaneh's clothes away was to the Ukrainians because we're seeing so many refugees in Berlin.

Beyond Terabytes and Gigabytes

Q: Seven Winters *couldn't have been made without mobile phone footage, which includes intimate moments of the*

family together when they were allowed to visit Reyhaneh in prison. You also included home movies that were shot when Reyhaneh and her sisters were growing up. How much material did you have?

SN: Normally, there are so many terabytes or gigabytes, so many hours. But I really can't say because much of it was in different formats. I had very old footage on VHS, Beta SP, mini-discs, cassettes, photographs and images, but mainly from 2007 onwards, when the near rape took place.

I also had amazing audio recordings from the prison visits. For example, in 2007, Shole started to research what happened. She referred to it as the 'Parents' Investigation'. You can tell that this one recording of Reyhaneh's voice in the film is from this time. Shole says to her, 'I record now, speak now.' Then you hear Reyhaneh describing the incident in detail and how it happened.

Q: *You built a model of an Iranian prison, which was reconstructed with help from former inmates who shared their memories from Evin and Shahr-e Rey, prisons where Reyhaneh was incarcerated. The model was filmed for the documentary. Because of this element of fictionalised reality, I erroneously assumed the photographs showing Reyhaneh's court case were also a reenactment of sorts.*

SN: Those were documentary photos by the official court photographer, in Iran. She took those pictures. They are from the courtroom. There was one moment in 2014 when this photographer sent those pictures to Shole, and Shole started to use them in her campaign. Because of this, these pictures were widely available.

Two of them became iconic, so I contacted the photographer and officially requested the use of them. She sold them to us, but of course she wrote in an official statement, 'In the name of God, I have to tell you I was witnessing this court and Reyhaneh was claiming …' It was a disclaimer, or that's how I interpreted it. So the government can't go back to the court photographer and say, 'You supported a movie that was against us.'

Corruption on Earth

Q: *Since you didn't go to Iran, you relied on the production company Zebra Kroop. Surreptitiously they shot film footage in Tehran for the documentary. If they had been caught, they would have been charged with* efsad-fil-arz *(corruption on earth). This is the same charge that has been brought against people who were arrested during the Woman, Life, Freedom protests, like the rapper and outspoken regime critic Toomaj Salehi. Some of the protestors who were accused of this 'crime' were executed. You must have been aware of the risks Zebra Kroop faced?*

SN: Of course, it was super-dangerous what people were prepared to do for me. A lot of people took great risks for this movie. Zebra Kroop are specialists in smuggling out material and shooting illegally in Iran. They didn't go *into* the apartment where the alleged rape had taken place, but they were just outside. That was dangerous because the apartment was next to a government building.

Q: Seven Winters *was started years before the women's protests, yet the film amplifies the grievances of women on Iranian streets and the difficulties they face, living under a hardline Islamic regime.*

SN: In this movie, I think you can see the tragedy because Reyhaneh is not a special case. Before her, women had the same destiny as her. Now, afterwards, a lot of people share her destiny, and not just women. Even so, there are layers [of complexity] when we speak about being a woman in Iran. I think you can see behind them a system of oppression that doesn't change. Women were protesting for their rights since the Islamic revolution began, but the oppression was strong. I have a feeling now that the women fighting for their freedoms in Iran see light on the horizon.

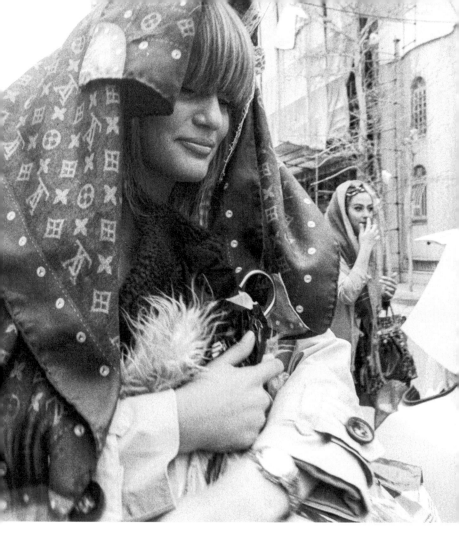

High Fashion

Women take control on the runway

Tahmineh Monzavi

The photographs in 'High Fashion' convey the twinned themes of power and women's clothing in Iran. Once official government permission was withheld and fashion shows were outlawed, women fashion producers in the industry began organising their own – from high-end to experimental. A graduating class, taught by a designer, staged one of the catwalk shows, included here.

In the wider Middle East, men are in charge of women's apparel and its means of production. In many Arab countries, men sew and sell to women. In Iran, because of sanctions, foreign clothing from well-known, even moderately priced Western brands has become too expensive. A new, younger generation of women designers has stepped into the breach. They create, manufacture and market clothes to a female clientele, in effect making decisions about their lives and the styles they want to wear.

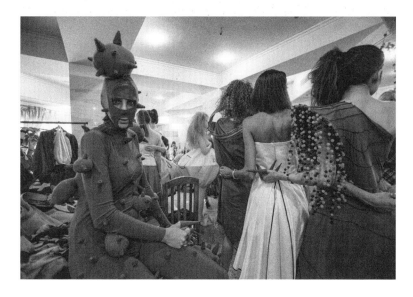

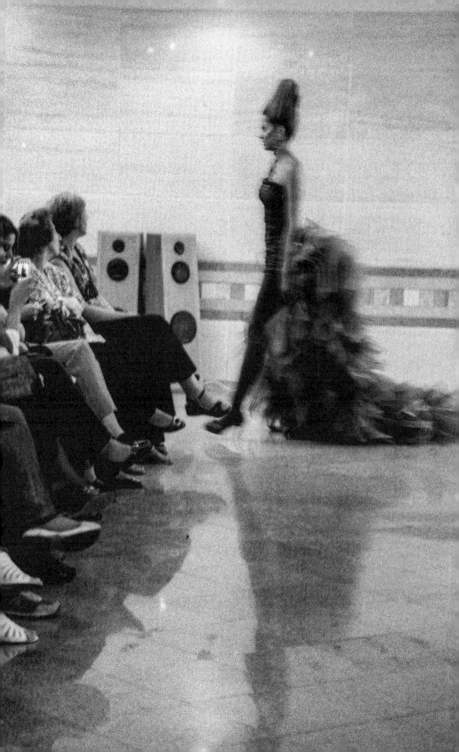

Big Laleh, Little Laleh

On madness

Shokouh Moghimi

Everyone thought Laleh was *majnoona* – crazy, mad, not quite right in the head. Everyone, that is, except our father, Baba, and me. They wondered why my older sister always carried a book in her hand and never stopped reading. 'Why is she always alone?' they'd ask. 'Why is she always muttering things to herself and to the walls?'

I was five years old when Laleh's 'madness' started to cause tensions in the house. She was a decade older, and it seemed liked besides Baba, the whole world wanted me to steer clear of Laleh or else her spirit of strangeness would enter my body too. But how could I stay away when everyone in our household was already calling me 'Little Laleh'? We looked too much alike.

I loved it when 'Big Laleh' would read to me from her books of poetry, even if I understood almost nothing of what she read. Other times, when she strolled by herself in the dark maze of our basement and held conversations with invisible beings, I would quietly follow and watch her. I was completely fascinated by Big Laleh.

The neighbourhood had its share of the mad. Often, they'd hide behind the ubiquitous myrtle trees and suddenly jump out at you making faces, or they'd find the fattest lizards they could in our boiling hot southern province and throw them at passing cars. Whenever our mothers were fed up with us, they'd threaten to hand us over to someone like Reza Salaki or Crazy Ferdows. But

Laleh, my Laleh, was not like any of these people. She was quiet. So what if she gazed at the sky rather than watch where she was going when she walked? She wasn't bothering anybody.

Mama would say, 'Laleh's strangeness comes from her childhood fevers when Saddam was bombing the city.' Whenever I heard her say this, I wanted to experience Laleh's fevers. Apparently, I'd had a lot of fevers too at one point. I always imagined a black-clad woman when I thought of these fevers. Fevers made me happy because I could then pretend I was becoming more and more like Big Laleh.

Our grandmother, who hailed from Bushehr, a city even further south on the Gulf, was certain that the jinns had made a nest in Laleh's mind and body. 'The mad see the devil,' she'd say, 'the *majnoon* see the jinns. Laleh talks to the jinns because the jinns want a sacrifice from us. We have to take this girl to Mamazar, the exorcist.'

Remarks like this turned Laleh more and more solitary and inward. Baba and I were her only friends. Baba couldn't always be there though. He worked for the National Oil Company and was often away on assignment. When he was around, those were the best of times for me, because then I could ride on the back of Laleh's bicycle without anyone giving me a hard time. We'd ride by the Karun, the beloved river that split our city, Ahvaz, in half, and I would wave at the water buffaloes wading about on the other side. Laleh and I had another name for the river too; we called it Naneh, a more rustic word for 'mother'. Laleh would always say, 'If it wasn't for Naneh, Ahvaz would have been done for during the war. Naneh washed all the filth of the war away. That's why we can still breathe here.' When she said these things, I'd let go of her on the back of the bicycle and breathe as deeply as I could. The river was life. She would say, 'Do you know why people throw themselves off the White Bridge into Naneh's waters? Because they know there's nowhere safer than her embrace.'

One day I found a bloody shawl among Laleh's things. I was in my first year of school and more curious about my older sister than ever. I'd go through her things all the time. The sight of that blood terrified me. But I kept my mouth shut, even when I finally realised that she'd tried to cut her wrist. Months later, Laleh was caught having poured gasoline all over her clothes. Our mother would not

stop crying while Laleh kept asking for forgiveness. This episode caused the jinns to retreat for a while and there was some calm for a change.

Then one day leading up to the Persian New Year, our mother took us girls shopping for new fabric at the bazaar so she could sew new dresses for us from the designs she was periodically sent from Kuwait. I loved listening for the different accents in our melting pot of a city and would whisper people's origins back to Laleh – 'The fava bean merchant is from Dezful, the incense seller is Arab, the flower guy is Persian, the one hawking dates is from Behbahan, and the Samanu dealer has to be a Lor. Am I right?'

We had just passed through the section mostly run by ancient Arab women who sold women's underwear. Inside the fabric shop our mother began picking out cloth and haggling in her broken Arabic with 'Uncle Adel'. Laleh stood apart, her usual disconnected self, while my other sister and I remained mesmerised by all that sequined fabric with the gold threads lining them. Mama's sudden screams made me jump. Laleh was disappearing in the throng outside. 'Grab her. She's unwell. Don't let her get away!' Laleh was running and Mama was running after her. Mayhem ensued, and all I heard inside the shop was Uncle Adel repeating '*Majnoona, majnoona*' under his breath.

After that episode, the jinns seemed to come at our house with a vengeance. All of Laleh's books and cassette tapes were confiscated and she was no longer allowed out on the street. Soon she stopped going to school altogether. The only thing I could do was watch her walk barefoot day and night on the steaming hot mosaic of the courtyard without ever exchanging two words with anyone.

On the morning of my tenth birthday, the jinns finally broke us. A loud thud made me jump. Our father went to the window and then immediately ran outside. Mama and my brother followed. There it was, Laleh's broken body on that same courtyard mosaic. They tried stopping me from seeing what was going on, but I saw it all – Laleh with cotton balls stuffed in her nose and ears, a piece of cloth shoved into her mouth. She had done all that to herself and then taken the jump from our rooftop. Was it possible the jinns had really done this to her, as our grandmother always said they would? My

eyes automatically went to the rooftop. There was no one there.

It was a Friday when this happened. My other sister and I stayed home. I had a lump in my throat, but I was also angry. Mama had promised to bake me a birthday cake. Now my birthday was forgotten. What a birthday gift Laleh had given me! I was resentful. The only good thing that came out of it was that our father stayed put and didn't go on one of his usual assignments for the oil company. I kept thinking: Dad will be back from the hospital, and everything will be alright.

There were no mobiles back then. We kept waiting for someone to call. No one did. In the afternoon our brother finally showed up. 'She's paralysed.'

It took a moment and then I started to laugh and I couldn't stop laughing. From that day on, every time I heard horrible news I would start laughing uncontrollably. In truth, after that day every one of us became *majnoon* in their own way. It was the madness that turned Baba's hair and Mama's hair utterly grey in no time at all, and the madness of the silence which blanketed the house so that I could virtually see the jinns of silence, but not of calm, dancing forever after on our walls and ceilings, and making faces at me.

Yet it was Laleh's own silence that was more spine-chilling than anything. Her only refrain: 'Don't be upset. Before you know it, I'll be up and running again.' She had become the very symbol of *jonoon*, madness, for me. Why did she have to turn the day of my birth into ashes?

They ended up keeping her in hospital for three weeks. During that time I barely saw our parents. Once in a while Mama would call and say, 'You didn't tell anyone at school about this, did you?' A lot of this had to do with saving face. One's child doesn't just go and throw themselves from a roof. I would come home from school and food would be ready, but no Mama or Baba. They'd leave us dinner and lunch and hurry back to the hospital. Maybe they didn't like me anymore … Maybe all this was because it had happened on my birthday. I wanted them to hug me and tell me it would be alright, but they weren't there.

I withdrew into myself.

Baba sounded like the saddest man on earth when he finally asked me to come with him for a visit to the hospital. At first, I

wanted to show my bitterness and not go. But I didn't have the heart for it. Laleh's eyes shone when she saw me. She apologised and said a belated happy birthday. I forgave her, but not completely. Not deep down anyway. Slowly though, once she had returned home, I came to love her as I had before.

Not so, however, with my other sister and my brother. It was as if everything Laleh did, or mostly didn't do, bothered them. My brother was convinced that no one in the city of Ahvaz would have him for a husband after what had happened in our household, and my sister kept saying that our connections with the larger family were permanently destroyed because of Laleh.

The scolding and rebukes were endless. Every other day my brother would threaten to send Laleh to the asylum if she didn't stop pissing and shitting on herself. Laleh would quietly weep and say nothing. I had no other weapon but to laugh. Amid that sick laughter, I would try to remind everybody that Laleh's spine had been severed. 'You'd piss on yourself too if your spine was gone.' I wanted to help her, but I didn't know what to do. Her eternal friends, Baba and I, went back to buying her all the books and cassette tapes we could find so she'd have something to do. I'd sit next to her and ask her to read to me for hours on end. 'Flower of suffering, read! Read to me.'

Meanwhile, Mama had become addicted to medical news. Every day at 9.00 in the morning and 7.30 in the evening she'd sit listening to the news and grow old. She was waiting for the day when the news would tell us they'd found a way to put spines back together. She'd say, 'That none of our neighbours heard or saw what happened is a miracle in itself. Now there's sure to be a second miracle and my dear daughter will walk again.'

After a few months Laleh was able to gain control of her bladder and bowel movements. Mama and Baba seemed to grow wings from happiness. Was the miracle really happening? Hope returned to the house. A pair of young doctors came by and made a cast of her feet to make braces. One of the doctors had the strangest last name we'd ever heard, 'Birds of Flight'. Dr Birds of Flight! Laleh and I couldn't stop laughing afterwards. Some weeks later, Dr Birds of Flight and the other doctor returned with their gadget. The first time they stood her up it truly seemed like a

miracle. But Laleh got tired quickly and begged them to leave her alone. After a while the contraption disappeared.

On my eleventh birthday we were all out of sorts. An entire year had passed since the tragedy. A year during which we had hidden Laleh from everyone. None of our friends or family had a clue what had happened to Laleh. We'd say things like, 'She's shy. She won't leave the house or even her room.'

This secret life was hardly easy in a midsize city like Ahvaz. Our years slowly turned into one long bout of concealment. I could no longer have friends over to the house. Friendships began and ended at school. And at school there were lies after lies that I had to tell my classmates about what a happy family we were. Every time some new pain arrived in Laleh, we'd spend days at the hospital where I learned to occupy myself in its busy corridors. At least the hospital visits brought Laleh out of the house, and I too could escape that afflicted place for a while.

At some point I mustered enough courage to go up to the roof. I would take my homework and sit there watching the tall palms and the jujube trees. The trees had been the last witnesses to Laleh's decision. I'd gaze at what I imagined was what Laleh had seen before jumping. The roof was now my refuge. The final place that Laleh actually climbed to on her own two feet. Every day I would imagine Laleh leaping off that roof. I'd imagine invisible hands pushing her off, those jinns. Pushing her and laughing with their hideous opened maws bigger than the roof of the house from which she fell.

Then Mama slowly gave up hope. My two other siblings wouldn't be found dead walking past Laleh's room. As for Baba, the oil company would not stop sending him on assignments around the country. None of us talked about Laleh. Meanwhile, besides the walls and her jinns, I was the only one Laleh would talk to. As soon as I arrived home from school, I'd go to her room and make her do her stretches so she wouldn't get bedsores. She got bedsores anyway. Her room smelled terrible. But I pretended nothing was wrong and we'd talk about our river. 'Naneh has been asking for you. The migrant birds have arrived too, you know. They fly all over Naneh. I told her you'd be coming to see her on your own two legs any time now.'

Laleh listened intently. I told her about the goings-on at the bazaar – what the Dezful merchants were up to, what the

Arab people were doing, the scent of incense and the Ameri neighbourhood with its brickwork that must have been taken right out of the pages of *The Thousand and One Nights*. We'd imagine that one day we'd go to Baghdad together and walk through the city gates with the words our Arab neighbour had taught us, '*Iftah ya simsim* (Open sesame)!' I'd describe the *majnoon* guy who suddenly showed up one day in Kianpars not long after Laleh's fall. People said he'd been a masseur for the national football team before the revolution. He would put henna on his hair and he wore mismatched sandals and carried with him a plastic tarp with an assortment of useless knick-knacks in it. He spoke to the grass while opening his legs wide as if he were about to start doing warm-ups. I'd wave at him each time under the bridge, and he'd just laugh hysterically and make faces.

My stories made Laleh laugh. She'd say, 'You know, every person is *majnoon* in their own way. I guess the masseur too must have fallen from a bridge.' But was the former masseur a jinn or a *majnoon*? I'd wonder. How could he so easily relax by our river without a care in the world when Laleh had to stay here like this?

By the time I turned fourteen, Laleh's behaviour had taken a turn for the worse. She would spend hours staring at the flower patterns on the carpet. Her face changed expression constantly and she was always mumbling under her breath. I'd find torn-up pieces of paper scattered around her mattress. I wasn't sure if she was writing things and then destroying what she'd written. I never asked about it. The same way I never asked her, 'Why did you kill yourself, Laleh? Why did you allow those jinns inside you when Little Laleh loved and cared for you so much?'

Soon her behaviour towards me too turned odd. One day she'd be kind, the next day she wouldn't even look at me. She would withdraw, and I could tell she was frustrated and tired. She'd go days without eating. She stopped reading and at some point she destroyed all of her cassettes. In retaliation they took her room from her. Now she had to live and sleep in the hall so they could always keep an eye on her. What they really wanted was to be able to upbraid her at every turn.

'That bedroom is yours now,' they said. 'Take it.'

'I don't want the bedroom,' I'd answer. 'I prefer the hall. I'm more comfortable here.'

'Take the bedroom!' they commanded.

Home had finally turned into hell. The only escape was to focus on school as much as possible. When classmates encouraged me to reach for the stars because of my perfect grades, I wanted to pull them aside one by one and tell them, 'Listen, my sister committed suicide.'

I'd sit in the hall and read in front of Laleh. I'd turn the music up loud to get some kind of reaction out of her. Nothing. The storyteller Laleh had once been had gone mute. She'd turn to the wall and suddenly start screaming at nothing and no one. Her body was declining fast. Her kidneys were failing. Some days she'd piss on herself on purpose. It was as if she hungered for the constant condemnations from the rest of the family. Laleh was ending and I could do nothing about it.

It was on the fifth anniversary of Laleh's fateful decision that my relationship with her finally snapped. I had just arrived home from school carrying the little gifts my classmates had given me for my birthday. Laleh sat in her wheelchair behind the window. Seeing me, her face turned full of longing, then sadness. That look was a kick in the stomach. Suddenly I could no longer stand her. I couldn't stand her regret for what she had done five years ago. Until then, I'd respected her choice because she'd believed in what she was doing. But that look of regret seemed to end whatever reserve of forgiveness I still had for her. Instead, there was anger and resentment for seeing five years of my childhood scorched in the bonfire of grief over what she had done to herself and to us. I stopped speaking to her altogether.

Laleh died. Apparently, it was hepatitis that killed her. One winter night she wailed and groaned until morning like a wounded animal. The next afternoon when I came back from school no one was home. They'd taken her to the hospital. In the evening Baba called.

'Why aren't you sleeping, little one?'

'I can't sleep.'

'Give the phone to your brother, please.'

After talking to Baba, my brother came and stood over me. 'Doctors say Laleh won't last the night. She's been asking for you.'

'I'm not going to the hospital. I want to sleep.'

Sleep never came.

At dawn my sister came into my room. 'Laleh's dead.'

I pulled the blanket over my head. 'Leave me alone. I want to sleep.'

The jinns had finally extracted their sacrifice from us. Laleh was dead. But why? Was it because I'd stopped talking to her? But I loved her …

We went to the cemetery. I couldn't cry. I saw her stretched out on the surface of the platform where they washed the bodies. She seemed no different than years ago. Only her legs had shrunken into themselves. Otherwise, it was the same Laleh who was always looking up at the sky rather than ahead of her. I was speechless but wore that same dumb smile as always. When they lowered her into the grave I started laughing maniacally. Then I said: 'Leave me alone. I want to get back to school. I don't want to get an absence mark.'

Now I had two roles to play in our house: I had to be Little Laleh as well as Big Laleh – but without her craziness. When Mama kissed me, I wasn't sure if it was me she was kissing or Big Laleh. Whenever I looked up while watching TV or reading a book, I'd catch Baba looking at me intently with tears in his eyes. I hated mirrors, hated anything that hinted at our resemblance. In the mornings when I woke up and saw that the books I'd fallen asleep on had been removed, I didn't complain. Often they were books Laleh had read at one time. I knew what was happening. They were all worried for me. My brother and sister would suddenly barge into my room and ask if I was all right. I'd say nothing. Sometimes I'd talk to a neighbourhood cat that I imagined carried Laleh's soul inside her. It was a game of push and pull between me and the family to make sure I hadn't gone over the edge, and it became my daily routine to prove to everybody that no, the jinns had not yet taken over my body like they had once taken over Laleh's.

One day when we all were pretending nothing was amiss and ours was not a house of hurt, Baba called from across the room, 'Laleh dear, come let's play a game of backgammon.' He hadn't meant anything by it. People called me Laleh by mistake nearly all the time. But that day my patience finally gave out and all the jinns

inside me came screaming out. I demanded to have my books back, and all of Laleh's too which they had hidden from me. I didn't want to be Laleh anymore. I'd been nothing else since my tenth birthday. I was sick of it. I escaped outside. Not just that day, but all the time from then on. In the fabric sellers' market where I'd seen Laleh on her own legs for the last time in public, I found a little bookstore. It carried most of the banned books in the country. The owner let me come every day, sit in a corner and read to my heart's content. I devoured those books, mostly because I didn't want grief to sink me. At nights I'd return to the jinn-stricken silence of our house and fall sleep without saying a word to anyone. And when my schooling was finished in Ahvaz, I made a beeline for the capital, Tehran, the huge metropolis that could, and can, take in all the crazies of the world – a city where you wouldn't have to make yourself and others suffer for five years and then regret jumping from a balcony, because, well, you really needed to make that jump.

I hung out in parks with strangers in Tehran. Whenever someone asked about the dark circles under my eyes, I'd give them one of my stock lies – my twin sister had just died … I had cancer … my mother was in jail …

Other times I'd tell people I only had one brother and one sister. I hid Laleh from the world and tried purging her jinns.

But the jinns do return, at least once a year on my birthday. For me, birthdays will never be anything but a funeral, while for those jinns they'll always be a feast on madness.

Translated from Persian

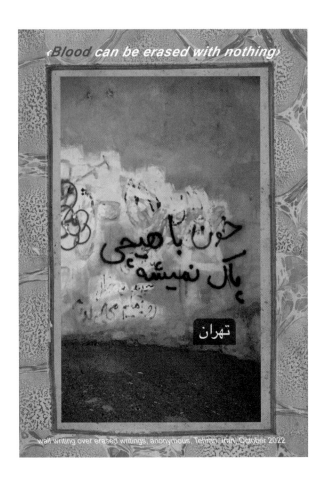

‹Blood can be erased with nothing›

تهران

wall writing over erased writings, anonymous, Tehran, Iran, October 2022

Revolution of the Anonymous

Cards from the streets

Alexander Cyrus Poulikakos and Niloofar Rasooli
Text by Niloofar Rasooli

In the recent history of Iran, walls of gender apartheid have appeared one after the other, but all scratched up, by women living behind them. The walls, the walls, the walls. The walls have sprung up like mushrooms in the recent history of Iran, from the tangible and intangible segregating walls of the public arenas, concealing women's bodies and muting their voices, to the heavy walls of Sakhteman-e Vozare, the centre of the so-called Morality Police in Tehran, where the engine of muting works, where Jina Mahsa Amini, our beloved sister from Saqqez, Kurdistan, was murdered on 16 September 2022. We know these walls by heart; we have all been kept behind them, scratched them, and resisted by imagining the impossible, revoking the hidden stories, and desiring this apartheid's otherwise.

In the recent history of Iran, the built environment has coexisted with hegemonic power, muzzling voices, veiling bodies, defining forbidden territories and policing dreams and hopes. The other side of this story, however, is a long history of women, not lending their hands to these walls, but curling their fists; the other side of this story is the story of breaking the walls; the other side of this story is the story of the radical transgression and uprising of those, in the words of Audre Lorde, 'who never meant to survive'.

Questioning, arresting, beating and murdering the body of Jina have sparked the fire of Woman, Life, Freedom. All over Iran, it has aroused voices

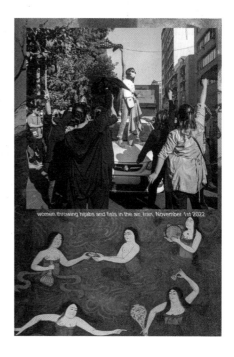

women throwing hijabs and fists in the air, Iran, November 1st 2022

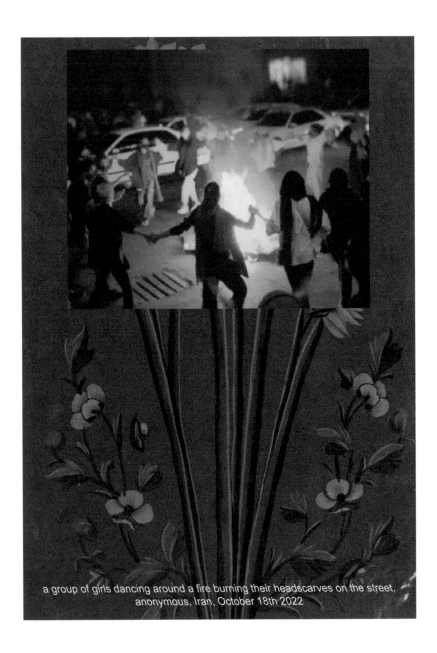

a group of girls dancing around a fire burning their headscarves on the street, anonymous, Iran, October 18th 2022

and brought oppressed bodies on the street to reclaim the rights of women over their own, attacking and destroying the concrete walls of tyranny. Now in Iran, tears are falling from one of our eyes, and blood from the other. These tears and blood bring burning questions to our conception of feminism under the shadow of neo-Orientalism; once again calling us to think whose voice matters and whose voice is constantly being interrupted, misunderstood, silenced and erased.

This revolution is revolutionising the masculine and straight grammar of a revolution. It does not have – and resists having – the male leader, the male saviour, the male winner. It resists following a well-trodden path, conforming to any orientation or determined destination or settled ideological conclusion. It is collectively kept anonymous and anonymously kept collective. Anonymity is a collective disobedience, and it is disobediently being a collective.

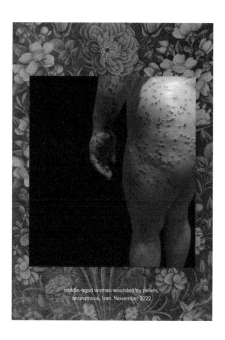

middle-aged woman wounded by pellets, anonymous, Iran, November 2022

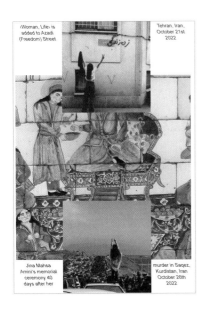

‹Woman, Life› is added to Azadi (Freedom) Street

Tehran, Iran, October 21st 2022

Jina Mahsa Amini's memorial ceremony 40 days after her murder in Saqez, Kurdistan, Iran October 26th 2022

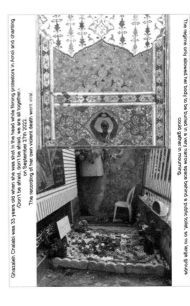

Ghazaleh Chalabi was 33 years old when she was shot in the head while filming protestors in Amol and chanting ‹Don't be afraid, don't be afraid, we are all together.› On September 27th on September 27th 2022. The recording of her own violent death went viral.

The regime only allowed her body to be buried in a very narrow space behind a public toilet, so no large groups could gather in mourning.

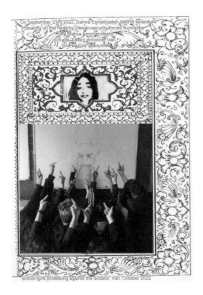

On September 23rd 2022, Sarina Esmailzadeh died of severe beating on the head by Iranian security forces during the Jina Mahsa Amini protests in Karaj, Alborz province, Iran. She was 16 years old.

school girls protesting against the dictator, Iran, October 2022

photo of Khomeini doodled in drag, anonymous, Iran, November 2022

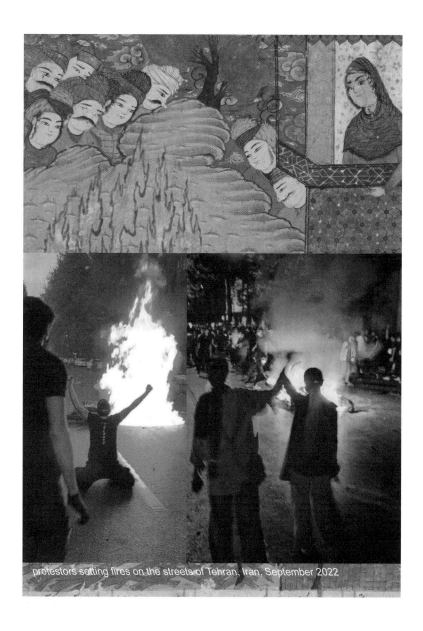

protestors setting fires on the streets of Tehran, Iran, September 2022

hacking of Iranian State Television, Hackers Anonymous, Iran, October 9th 2022

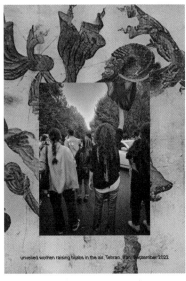

unveiled women raising hijabs in the air, Tehran, Iran, September 2022

burning of Image of Khamenei, Iran, October 2022

wall writing, anonymous, Iran, 2022

‹Zan Zendegi Azadi›

آزادی

زندگی

زن

wall writing of ‹Woman Life Freedom› in front of the Faculty of Fine Arts
University of Tehran, anonymous, Iran, October 31st 2022

A Revolution Made by Art

Interview with Pamela Karimi

Dr Pamela Karimi spoke with hundreds of artists, curators and theatre experts for her book *Alternative Iran: Contemporary Art and Critical Spatial Practice*. In this interview with *Woman Life Freedom*, she discusses how dissident art has amplified protesters' voices and how Telegram, Instagram and open-sourced social media offer new, nimble ways to subvert regime censors and internet morality police. Dissident art in the Islamic Republic, she observes, often blends centuries-old indigenous motifs with contemporary global memes, such as the *Handmaiden's Tale*. Above all, an authentic, local, healthy feminism has become for both genders the uprising's fulcrum. Karimi considers how shock and humour can deliver powerful, often disturbing messages. She contrasts the gaze of insiders towards the emerging revolution with that of diaspora practitioners, Western progressives and art-market tastemakers. The lines between art and activism have been blurred, she argues. Art is now part of everyday life in Iran. It champions the individual and bravely defines a vision of a freer society. Artists, whether named and famous, or, more commonly, anonymous, as well as poets, video-makers, singers and collectives, are concretely engaging with vital social issues. They challenge the system. And often directly inspire the ongoing protests on Iranian streets.

Q: *The intersection between arts and activism has almost uniquely characterised the Woman Life Freedom revolution. What is the function of art in this movement?*

PK: From its inception in the early 1980s, post-revolutionary Iranian art has consistently embodied the merging of artistic expression and political activism. However, the political views have not been overtly expressed. Whether in the realm of visual arts, theatre or film, Iranian artists have employed subtle and indirect means of protest and activism. The Ministry of Culture and Islamic Guidance, which has monitored art in Iran since the 1980s, operates much like a 'Morality Police' and censors any work deemed subversive or critical of the regime. To circumvent these restrictions, for four decades Iranian artists have developed creative tactics such as subversive appropriation, distancing, parody, pastiche and even operating in disguise. These tactics have even given rise to new styles and genres, such as 'apartment theatre', and have led to exceptional works of cinema that use allegory to express deeper meanings beyond the surface narrative.[1] So, despite the challenges posed by state censorship, Iranian artists have found ways to use their craft as a means of social and political critique.

 Compared to the body of art produced in the past four decades, the Woman, Life, Freedom revolution has sparked a rebellious and zealous character in Iranian art. Although the art itself is bold, artists have adopted inconspicuousness, anonymity and obscurity. These strategies are not just used for protection; many creative agents remove themselves from the centre of attention to amplify the political message in their work. This widespread anonymity has led to an epistemological shift in the arts import, where poignant activist art made by anonymous and non-star artists seems to be more effective than that created by distinguished artists. Additionally, art has become part of everyday life

1 Michelle Langford, *Allegory in Iranian Cinema: The Aesthetics of Poetry and Resistance* (London: Bloomsbury Academic, 2019), pp.118–119.

without being associated with powerful agents, big names, auctions, galleries or museums. Activism, in turn, has become a kaleidoscope of aesthetic modalities that transform the grit of politics and dissent into art. In fact, the line between art and activism in the Woman, Life, Freedom protests has blurred so much that they have become impossible to differentiate, and many instances of political activism have adopted strategies of art production.

Q: *The artwork has come from both artists inside Iran and from the Iranian diaspora. They have also been joined by a wealth of artists and activists from the international community. Why has the Woman, Life, Freedom movement attracted these disparate and sometimes opposing voices together? It is also worth questioning what the reaction of Muslim communities in diaspora has been. For a long time, religious communities rejected traditional so-called 'Western feminism' championed by figures such as Simone de Beauvoir and promoted their own Muslim feminism instead. Which version of feminism are women in Iran identifying with?*

PK: While Iran's revolution certainly holds an allure, it is important to acknowledge that it has also elicited mixed feelings and reactions from some who view certain aspects of the revolution as insensitive to practising Muslim communities. Even in scholarly circles, addressing and examining specific facets of the revolution can prove challenging. Following the murder of Jina Mahsa Amini, Bahareh Hedayat, a detained journalist, wrote from Evin Prison about how progressive voices in the West dismiss the concerns of Iranian women about compulsory hijab because they see it as Islamophobic. This, she argued, stems from the West's tendency to silence the voices of Middle Eastern women and disregard their right to express their frustrations with the pressures of Islam's historical oppression.[2]

2 Bahareh Hedayat, '"Revolution Is Inevitable": Bahareh Hedayat's Letter from Evin Prison in Tehran, Iran' (December 2022), *Jadaliyya,* 4 January 2023.

Feminism is focused on the discrepancies between gender identities and their societal constructions, which can vary based on historical and social contexts. The Woman, Life, Freedom protest in Iran challenges the post-colonial literature on women in the Islamic world. Saba Mahmood, a late UC Berkeley professor, has written very influential texts on pious Muslim women participating in the mosque movement in Egypt; she sheds light on how these women exercise their freedom and secure their independence.[3] Other scholars, including those writing in the context of Iran (e.g. Ziba Mir-Hosseini), have elaborated on the ways in which the connotations of Muslim women's agency and freedom are different from those of Western societies. Mir-Hosseini also uses the term 'Islamic feminism' to refer to the work of pro-women reformist activists from within the circles of the Islamic regime.[4]

By contrast, the Woman, Life, Freedom revolution has shown that Iranian women are seeking the same values championed by Western feminism. According to historian Ervand Abrahamian, this revolution is primarily focused on individual rights and it is a call to enlightenment similar to that which was pursued in the Western world; it is not at all concerned with promoting or preserving religious values.[5] Regardless of disagreements, challenges and shortcomings, I believe that the Woman, Life, Freedom movement is very healthy for the feminist discourse as a whole. The movement urges feminists, including those who have been proponents of Islamic feminism, to remain in a state of discomfort and continuously examine their own commitments.

3 Saba Mahmood, *Politics of Piety: The Islamic Revival and the Feminist Subject.* (Princeton, NJ: Princeton University Press, 2005).

4 Ziba Mir-Hosseini, *Islam and Gender: The Religious Debate in Contemporary Iran* (Princeton: Princeton University Press, 1999). Also see Valentine Moghadam, 'Islamic Feminism and Its Discontents: Towards Resolution of the Debate,' *Signs: Journal of Women in Culture and Society*, 27: 4/11 (2002): pp.35–71.

5 Ervand Abrahamian, 'On the History & Current State of Iran', YouTube, 10 January 2023.

Q: *Which individuals and groups have been influential in amplifying voices and protests inside Iran, and have conveyed a wider understanding of Persian politics and art outside the country?*

PK: In my view, the most compelling voices have emerged from anonymous artists and activists that are unconstrained by name or status. In the aftermath of Jina Mahsa Amini's tragic murder, Iranians took to the streets in masse, particularly in the Kurdish region where she came from. What ensued was an authentic performance, with women taking their veils off to confront state authorities, girls twirling headscarves in joyful defiance, activists destroying propaganda billboards and residents chanting from their windows under the cover of night. College students, too, played a very important role. They refused to be divided by gender-segregated dining areas and many of them abandoned their classes and called for the release of their detained friends. Instead of regular recitals, music majors at various universities filmed themselves performing protest songs while blurring their faces or only showing their tapping feet. Fine Arts majors at Tehran's Art University participated in a mass choreography of the word blood (*khoon*) on the campus quad, and stained their school's bathroom mirrors with red stencilled words that read, 'This is the face of someone who can make a change.' Despite facing brutal suppression, such as being stripped of their official enrolment status at the university, these predominantly anonymous student groups persisted and have continued to challenge the system.

Q: *Revolutions engender collectives and there have been open-sourced Google docs of visual material available on the internet. Which ones have you consulted?*

PK: I have had the pleasure of following a Telegram channel called Manjanigh that showcases, among other things, the works of the underground collective known as Aftabkaran, who are responsible for many of the daring posters and graffiti art

pieces that have animated the walls of Tehran particularly since September 2022.[6] I am very grateful for these resources. Without them it is very difficult to know what is going on in Iran beyond what the mainstream (social) media gives us.

The use of these online platforms is, however, not exclusive to this particular revolution. Allow me to take this opportunity to underscore the importance of exchanging ideas and engaging in discussions on open-sourced forums as well as social media platforms. The usage of social media platforms actually accelerated during the pandemic, to the point where, in June 2021, the Iranian government revived its controversial legislation, the internet restriction bill (*tarh-e sianat az fazay-e majazi*; literally, 'protecting users in cyberspace'), which had been in development for several years. The bill was intended to criminalise the use of forbidden online platforms, which Iranians detour by using proxy servers and filter bypasses. The parliament eventually suspended the bill due to widespread grievances. After President Ebrahim Raisi's inauguration, there was a significant increase in the usage of social media platforms such as Club House, which had recently been launched, and the sharing of documents and sources through the more secure and password-protected Telegram platform. At that time, we even saw a shift in the political tone of activism. Some activists went on social media and mocked 'slacktivism' (*koneshgari-e zir lahafi*; literally, under-the-blanket activism), and instead called for concrete engagement with important social issues. Heated debates reignited around engagement with the regime, with several artists taking to social media to announce their intention to boycott any project that required permission from the authorities or necessitated close collaboration with the government.

Oppositional voices escalated in August 2021 when Mohammad Mehdi Esmaili, the newly appointed Minister of Culture and Islamic Guidance under President Ebrahim Raisi,

6 I am grateful to the artist Homayoun Sirizi, who brought this group to my attention.

issued a new 'programme' (*barnameh*) for revamping the Ministry of Culture and Islamic Guidance's existing rubrics to further 'Islamicize' the arts. Every single faction of the arts community, from filmmakers and theatre experts to graphic designers and painters, published open statements on social media addressing the newly appointed minister, scrutinising and disapproving almost every single phrase within the new 'programme'.

Social media has proven to be a valuable source of information for my own scholarship, especially given the lack of organised oppositional institutions. It is important to recognise that social media cannot be relied upon as an unquestionable source of truth. It is necessary to seek out trustworthy platforms that are maintained by experts. In the Iranian art circles, social media posts by prominent figures often provide insight into a particular situation. Some artists and activists are more structured in their approach; platforms like Manjanigh on Telegram (addressed above) are particularly useful in providing a glimpse into the situation on the ground, including images of underground and anonymous activist groups.

Q: *In the protest artwork, hair in all its guises, uncovered, cut, etc., has appeared in posters, illustrations and graffiti. What have been for you the main recurring motifs?*

PK: In the Woman, Life, Freedom revolution, women have taken bold actions such as posting pictures of themselves without the hijab and removing their headscarves in public, facing the risk of arrest and detention. Artists have also contributed to the movement through provocative works that critique gender oppression and state policies. But I understand the recurring motif of women's bodily gestures and performative acts as encompassing more than just displaying or cutting hair. The corporeal expressions of women are thought-provoking, and what makes them particularly captivating is an enduring consistency in the displays of resistance, whether they are orchestrated by artists or non-artist activists.

In December 2022 a woman in Tehran, whose identity remains unknown, wore an outfit from the TV series 'The Handmaid's Tale' on a pedestrian bridge. This show, based on Margaret Atwood's bestselling book from 1985, depicts a dystopian Republic of Gilead, where women are treated as property of the state. Many commentators have compared Iran to this oppressive society. Similar to the handmaids in the show who wear bonnets to prevent personal connections, the woman in Tehran wore a bonnet to obscure her identity.

Five years earlier, another woman in Enghelab Street stood on a utility box above a busy sidewalk and waved her headscarf like a flag tied to a stick. She was immediately arrested and given a prison sentence, but her assertive pose became a symbol of the anti-hijab movement, inspiring many other such performances and artistic depictions. In 2022, the anonymous 'handmaid' in Tehran also kept this very same message alive. Indeed, most protest gestures and performative acts in Iran carry historical significance and evoke iconic images from previous events. Despite the regime's attempts to suppress the feminist movement and political dissent, the struggle for dignity and freedom in Iran continues. This ongoing process, characterised as a 'revolutionary course' by Asef Bayat, could eventually lead to significant political reform and a new era of openness and possibility.[7] A 'revolutionary course' differs from a 'revolutionary situation' in that the former occurs over an extended duration, while the latter takes place within a limited timeframe and location. To reiterate, Bayat suggests that the gradual accumulation of change leads to a 'revolutionary course'.[8]

Q: *A distinct visual vocabulary has emerged from the protests. Have these symbols, despite their simplicity, or perhaps*

7 Asef Bayat, 'Is Iran on the Verge of Another Revolution?', *The Journal of Democracy*, 1 March 2023.

8 *Ibid.*

*because of the directness in their simplicity, enabled the
meaning and the message?*

PK: The current wave of protest art is part of a broader
 revolutionary history and its representational regimes in
 modern Iran. A comparison can be made between the Woman,
 Life, Freedom protest images and those from the women's
 anti-compulsory hijab rally that occurred shortly after the
 1979 Islamic Revolution, objecting to the mandatory Islamic
 dress code for women declared by Ayatollah Khomeini.
 Furthermore, the Woman, Life, Freedom revolution's focus
 on women's bodies draws similarities to images and news
 items from Iran's Constitutional Revolution of 1906, where
 women played a central role. The Woman, Life, Freedom
 protests have even reignited interest in the book *The Story
 of the Daughters of Quchan: Gender and National Memory in
 Iranian History*, first published in 1998 by Harvard Professor
 Afsaneh Najmabadi, which focuses on the story of 250
 kidnapped girls from north-eastern Iran and their role in the
 nationalistic discourses of the Qajar dynasty that eventually
 led to the Constitutional Revolution.

 Other sources come from abroad: images from the Algerian
 War, the Palestinian resistance movement and the protests
 that took place in France in May 1968. During the 1978–1979
 uprising, many of these iconic visual materials inspired Iranian
 revolutionary posters and gradually found their way into the
 lexicon of post-revolutionary Iranian art.

 The revolutionary images from May 1968 are of particular
 interest to the underground Aftabkaran group that
 emerged in November 2019. The group was initially
 created in response to Iran's 2019 workers' protests and
 has since been advocating for the rights of workers and
 underprivileged individuals. It is no surprise then that the
 1968 events that involved workers and labour unions in
 France have been of interest to Iranians. The influence of
 these images is amplified by social media, which facilitates

their reproduction and dissemination, thereby endowing them with greater impact.

Q: *In what way does the artwork go beyond preaching?*

PK: In my view, despite certain artworks created during the Woman, Life, Freedom movement appearing to adopt political propaganda techniques, the majority of them do not carry a preachy or didactic tone. In particular, protest art made inside Iran is admirable for its originality and creativity. Unlike the propagandistic visual language of the Islamic Republic, which Walter Benjamin famously referred to as the 'aestheticization of politics', the art of the Woman, Life, Freedom protests operates in informal, tangible and profound ways.[9] Art has become an integral part of everyday life. To reiterate, there are also many instances of political activism that have adopted art production strategies, blurring the lines between activism and aesthetics.

Q: *Meysam Azarzad's posters quote Ferdowsi's Persian classic, the* Shahnameh. *This suggests a certain relationship the artist has with the past. How has Persian poetry provided an important prism through which to view the contemporary events that have been shaping the country?*

PK: The work of contemporary Iranian poets has played an active role in the Woman, Life, Freedom revolution since its inception, with many creating new works that acknowledge the contributions of renowned feminist poets like Forough Farrokhzad or play with the rhythmic qualities of the word *zan* (women). Following in the footsteps of older poets, some have composed elegies that mourn the loss of the

9 Walter Benjamin, 'Theories of German Fascism: On the Collection of Essays War and the Warrior,' *New German Critique* 17 (1979): pp.120–128.

revolutionary youth.[10] In a somewhat unprecedented way for modern poetry, Mehdi Ganjavi composed a multi-lingual poem using Kurdish and Farsi words in one elegy. Additionally, several compose poems that directly address the murder of Jina Mahsa Amini. Often these poems gain momentum by being turned into popular songs. An example is the feminist poem 'The Song of Equality (*Sorood-e barabari*)', which was originally developed by a collective of feminist activists and repurposed for usage in Woman, Life, Freedom protests.[11]

Poetry has also found its way into the realm of the visual arts. Meysam Azarzad's appropriation of the *Shahnameh* passages serves as an effective, nationalistic means to chronicle the Woman, Life, Freedom revolution. One of his early posters features an image of a young, unveiled woman with her fist raised in defiance against a backdrop of bright red; rows of soldiers stand in front of her, but she remains undaunted (see page 145). Above the image is a modified version of a couplet from Ferdowsi's *Shahnameh*: 'This massive army is useless. Indeed, a single fighting girl is worth hundreds of thousands of them.' Ferdowsi's original couplet reads: 'The increase of troops is of no use. For from Egypt and from the Hamaavaran (the lands beyond the Oxus) there are a hundred thousand.' The original couplet speaks of the futility of increasing troop numbers, because a hundred thousand soldiers from beyond the Oxus would be enough to counter them. In the modified version by Azarzad, the message is one of empowerment, suggesting that the strength of a single determined woman can outweigh a large army.

Q: *During the 2009 Green Movement protests, a wholesale movement of documentary photographers into the safety and security of artists' studios adversely affected the way in*

10 Esfandyar Koosheh in conversation with Fatemeh Shams, *'She'r-e Enghelab-e Novin dar Iran* (The Poetry of the New Revolution in Iran), Radio Zamaneh, 23 December 2022.

11 'Three Narratives of the Birth of the Song of Equality', *The Feminist School*.

which news and imagery were reported from Iranian streets. Has this breach been filled during the Woman, Life, Freedom protests?

PK: Former photojournalist Newsha Tavakolian captured a photograph of a Green Movement protester who shielded their face to remain anonymous. Tavakolian, along with other photographers and journalists, were continually approached by state security who sought to identify such individuals documented in photographs. Photography itself is considered a problem. In a personal conversation, Mehraneh Atashi communicated with me that the Iranian regime was sensitive to photographing the 2009 protests and placed immense pressure on anyone who was seen with a camera. Atashi was taken into custody due to her documentation of the 2009 protests. In the Woman, Life, Freedom protests, photojournalists have faced similar pressures. Niloofar Hamedi, who documented Jina Mahsa Amini on her deathbed, was imprisoned after her photographs went viral. In general, one could say that (photo)journalism is fraught with danger, particularly when attempting to report the truth about the government and establishment figures.

A few years ago, under the rubric, 'Censorship, Iranian Style', *IranWire* recorded instances of journalism censorship in Iran.[12] The document, which is available online, is a compilation of stories from eighteen Iranian journalists, writers and cartoonists who have been subjected to censorship. Their accounts of being silenced, harassed and imprisoned provide insight into the bravery and courage required of Iranian journalists and expose the twisted mentality of Iranian censor officials.

In the current Woman, Life, Freedom revolution, ordinary people are primarily using their personal iPhones to record the events, making it safer to document and post images of the revolution. The Instagram page, @1500tasvir, has

12 Hasan Sarbakhshian, 'Censorship, Iranian Style. "I Could Not Document History"', *IranWire*, 12 April 2016.

been an effective platform for featuring these unofficial photographs and videos taken by ordinary people as the events unfold on the ground. This is particularly important in the absence of free foreign press in Iran. It is essential to acknowledge that behind every footage or photograph taken under challenging circumstances, there is always an individual. It is imperative to recognise that these images showcase the strength of individuals rather than promoting stereotypical images of the courage of a group of nameless people.

Q: *Media Farzin's* Bidoun *article, 'The Imaginary Elsewhere: How Not to Look at Diasporic Art', is a primer on the gaze through which art from Iran or the wider Middle East is exoticised in the West. How can museums and curators go beyond a colonial gaze and fetish about decoration and re-educate Western audiences?*

PK: I concur with Farzin's observation. More often than not, the art-market tendency is to favour images and references that depict Iran as an unchanged ancient civilisation. There is also an unwavering fascination with traditional Iranian arts, such as calligraphy and carpet-making, which make Iranian art somewhat distinctive from other forms of artmaking in the rest of the world. Frequently, these inclinations result in neglecting contemporary artistic forms that portray real-life circumstances in present-day Iran. These circumstances often involve fully modern lifestyles with concrete buildings and modern roads, entirely devoid of traditional elements. Moreover, there is a propensity to sensationalise Iranian culture by perpetuating images of oppressed women and victimised populations.

 According to Rozita Sharafjahan, the founder and curator of Tehran's progressive Azad Art Gallery, the global art market is more interested in buying and promoting art that

contains easily recognisable codes and conventions.[13] This often includes art based on familiar Iranian symbols and signs, such as Shirin Neshat's fully veiled women in 'Women of Allah' or Shadi Ghadirian's 'Qajar' series which portrays contemporary models dressed in nineteenth-century harem girls' costumes, juxtaposed with modern elements like Pepsi cans or vacuum cleaners. Such works are systematically exhibited and acquired by prominent art museums and collectors as they are easier for outsiders to understand.

The tendency towards art forms that are easily comprehensible is also disseminated by what Iranian-American art critic Negar Azimi refers to as a 'poornographic' realm of art, which perpetuates the image of Iran as a sealed vacuum of repression, portraying Iranians as poor and victimised.[14] This is in contrast to Iran's vibrant conceptual, experimental and ephemeral art scenes.

The prevalence of anonymity in the Woman, Life, Freedom revolution has brought about a shift in the significance of contemporary Iranian art and its connection to socio-political issues. In the 1990s, the art world was captivated by a collection of staged self-portraits featuring Iranian-American Shirin Neshat. The photographs depicted her adorned in a veil and armed with Persian feminist verses inscribed on her body. The aim was to depict the determination of Iranian women who had to comply with Islamic dress regulations, which Neshat herself encountered when she returned home to visit her family. Consequently, international art establishments shifted their focus from the artwork to the life stories of renowned Iranian artists. However, the more recent preference for anonymous expression over celebrity culture has been so pronounced that when a banner displaying one of Neshat's self-portraits, entitled 'Unveiling'

13 Pamela Karimi, *Alternative Iran: Contemporary Art and Critical Spatial Practice* (Stanford: Stanford University Press, 2022), p.293.
14 Negar Azimi, 'Don't Cry for Me, America,' in *My Sister, Guard Your Veil; My Brother, Guard Your Eyes: Uncensored Iranian Voices*, ed. Lila Azam Zanganeh (Boston: Beacon Press, 2006), pp.104–112, p.108.

(1993), was hung outside the Neue Nationalgalerie in Berlin, Iranian artists reacted negatively. They questioned why the banner featured a seemingly passive veiled woman with the mantra Woman, Life, Freedom, which contradicted the feminist ideals for which Iranians were fighting.[15]

Curators and museum experts have an important role to play in acknowledging diverse forms of art, rather than simply being swayed by conventional or familiar imagery. Similarly, art historians must take responsibility for representing a wide range of perspectives, beyond established frameworks. As an art historian, I see my role as uncovering the points of connection between the ordinary experiences of daily life and the processes involved in creating art. While this can be a difficult path for research, it is by no means an insurmountable one.

Q: *The Egyptian Arab Spring was called a Twitter revolution because of the part Twitter played in disseminating information and bringing protestors out on the streets. Even though there has been some talk that the Iranian women's protest is an Instagram revolution, once you name a revolution after technology, inevitably the revolution dates when the technology grows obsolete. For the ongoing women's protests, should it not rather be called 'a revolution made by art'? 'Art' is a more timeless and enduring concept, especially in the context of Iran.*

PK: To label the Woman, Life, Freedom revolution merely an Instagram revolution is reductive; it fails to acknowledge the significant amount of effort that is dedicated to producing the Instagram content itself. I believe that art plays an important role in this ongoing revolution. As a matter of fact, I am currently in the process of writing a book provisionally titled *Women, Art, Freedom*, which I feel appropriately captures the essence of this revolution as well as the important and

15 I have reflected on this in my article, 'Art of Protest in Five Acts' (*Iranian Studies,* 2023).

politically aware artmaking processes that Iranians have been producing for four decades.

It is crucial to give more consideration to the role of the arts and the media platforms that enable the dissemination of art. The phrase 'a revolution made by art' is suitable as it properly captures the significance of the artists and activists who utilise visual and performance-based methods to generate change.

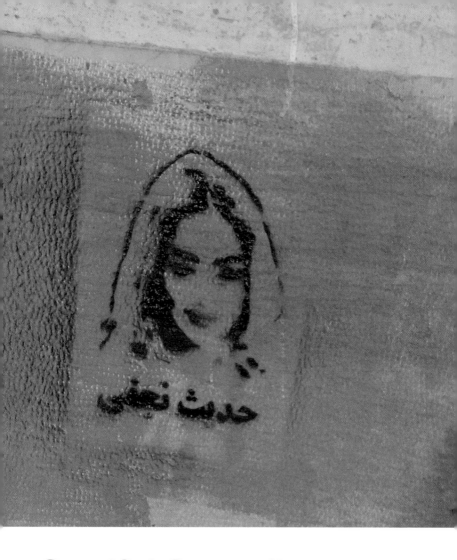

Graffiti Stencils

A tribute to women killed during the protests

Khiaban Tribune
Text by Malu Halasa

Graffiti has a short shelf life on the walls and public spaces of the Islamic Republic. Images and slogans appear suddenly, before being quickly painted over by the regime only to show up in another place, at another time. Popular themes include women's rights and denunciations of those in power, like calling the Supreme Leader, Ali Khamenei, 'a bloodthirsty dictator'.

Graffiti in the West has lost its power to shock and challenge the status quo. In Iran, it remains a potent art form. Stencilled faces of the women killed during the first months of the 2022 Woman, Life, Freedom protests soon appeared in Tehran. Anonymous street artists braved the city public spaces to spray-paint, despite the state's extensive facial recognition technology, from video, crowd and traffic surveillance cameras to phone call and text messages monitoring.[1]

← Hadis Najafi, born 5 January 2000; died 21 September 2022 in Mehrshahr; buried in Behesht-e Sakineh Cemetery, Karaj

Hadis was not an activist; she never spoke about women's rights. However, on the evening of 21 September she sent a video to a friend, in which she said, 'When I think about this a few years later I'll be pleased I joined the protest.' Reports said she was shot at least six times in the face, hand, neck, abdomen and heart, on Eram Boulevard in Mehrshahr, an affluent area near Karaj in Alborz Province, around 8 pm. The Iranian government maintained the bullets came from weapons not used by the police, to suggest the protestors had attacked her. This claim was strongly disputed by Najafi's family, activists and international media.

1 Tehran Bureau, 'The Chinese Companies Building Iran's Surveillance State', 30 September 2022.

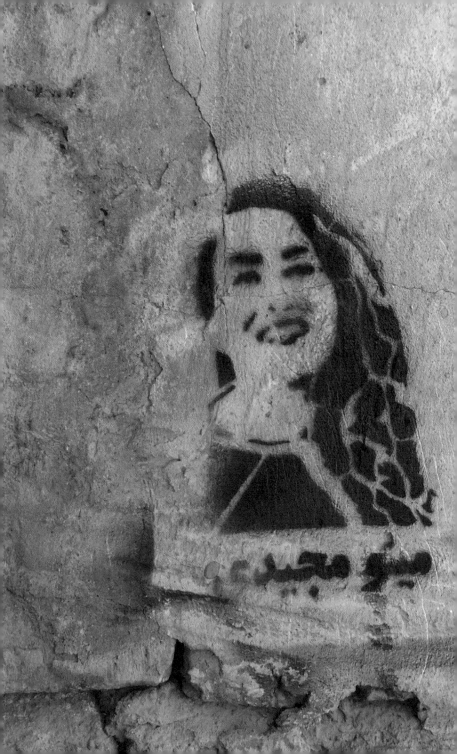

Khiaban Tribune documents graffiti in Iran by photographing it and regularly posting these images on Instagram and Twitter – sometimes more than a few posts per day. In operation since 2017, the group describes itself as a 'democratic, anti-capitalist campaign' made up of 'socialist youth whose activity is mainly focused on defending ... the rights of political prisoners, workers, immigrants, national and religious and non-religious minorities, women and the LGBTQ+ community', among others. Without the efforts of this campaign and other anonymous groups inside Iran, which take precautions to protect themselves from regime scrutiny, much of the graffiti would fall into obscurity or would not be seen outside a specific neighbourhood.

← Minoo Majidi, born 1960 in Qasr-e Shirin; died 20 September 2022 in Kermanshah, buried in Mina Abad Cemetery, Kermanshah

This 62-year-old mother of three children who belonged to the Yarsan religious minority was shot by security forces on the streets of Kermanshah. Her daughter reported that Majidi had been shot with 167 gun pellets. 'If I don't go out and protest, who else will?' she asked before she died on her way to hospital.

↑ Hajar Abbassi, born in Qasr-e Shirin; died 20 September 2022 in Mehabad; buried in Mina Abad Cemetery, Kermanshah

The seventy-year-old grandmother and mother of seven was shot in the eye in Iran's largely Kurdish city of Mahabad, in West Azerbaijan Province, northwestern Iran, on 20 September 2022. Videos of her wounded body circulated online before the government's shutdown of the internet. Abbassi died after she was taken to hospital.

↑ Nika Shakarami, born 2 October 2005 in
Khorramabad; died 20 September 2022 in Tehran;
buried in Hayat ol Gheyb, Veysian Rural District,
Lorestan

In Tehran, on 20 September 2022, the 16-year-
old schoolgirl disappeared after she burned a
headscarf, her mother told BBC Persian. Dozens
of videos and eyewitness accounts obtained
exclusively by CNN showed Shakarami being
chased and detained by Iranian security forces.
An eyewitness told CNN that she saw Shakarami
bundled into a car by 'several large-bodied
plainclothes security officers'. Her mother
rejected official regime claims that her daughter
died after falling from a building. She said that
her daughter had been beaten to death. She was
taken to Lorestan Province, where she was buried.

The consequences are grave for those who are caught. Ardalan Ghasemi, a young Kurdish man from Gilan-e Gharb, was spray-painting protest slogans on Taq-e-Boston Boulevard in the city of Kermanshah, in western Iran. According to the Kurdistan Human Rights Network, security forces shot Ghasemi three times. They then refused to take him to a medical facility. Two other protestors were wounded in the shooting. Ghasemi's family was forced to sign an official declaration, which said the young man had been stealing a car when the police shot him.[2]

← Ghazaleh 'Chalavi' Chalabi, born 1989 in Amol; died 21 September 2022 in Amol; buried in Emamzadeh Ghasem Cemetery, Amol

Chalabi, a 33-year-old mountaineer in Mazandaran Province, northern Iran, was filming a protest. She recorded the moment she was shot in the head and killed by an Islamic Revolutionary Guard sniper. The video was widely circulated on the internet, social media and news agencies. Chalabi had wanted her organs to be donated, but the authorities refused her request 'because it would make her seem like a martyr'. In the cemetery she was buried next to a public toilet. The space was too small to accommodate her, so her knees had to be bent.

2 Akhtar Safi, 'Kurdish Man Killed by Security Forces for Anti-government Graffiti', *IranWire*, 13 November 2022.

As well as direct threats, the veracity of the artform is under attack by regime propaganda. The identity and circumstances surrounding the death of one of the stencils Khiaban Tribune included in an early Instagram photo-album of women victims' faces were unverifiable. It turned out that the stencil had been disseminated by the regime.

→ Mahsa Mogoi, born 2003; died 22 September 2022 in Fuladshahr; buried in Fuladshahr

Mogoi's family said she was a highly intelligent and a popular young woman who liked to help people. The 18-year-old taekwondo champion was shot in the head twice by the regime's security forces. She died in the industrial city of Fuladshahr, in Isfahan Province, central Iran.

The campaign explained in an email to *Woman Life Freedom*: 'We were informed that the regime had purposefully spread fake news about the death of a fictional character in the streets, in order to discredit protestors and their claims about the casualties. Later, most opposition news outlets removed any trace of this name and face, but since Instagram does not allow us to edit photo-albums, we explain it in the caption.'

The image was replaced with a stencil of Jina Mahsa Amini's face. It was a powerful reminder of the collective nature of both street art and the women's protests.

'Fighting VPN Criminalisation Should Be Big Tech's Top Priority', Activists Say

Iranian authorities increasingly targeting VPNs is part of a global trend

Ashley Belanger

In response to Iran's ongoing protests – mostly led by women and young people – the Iranian authorities have increasingly restricted internet access. First, they temporarily blocked popular app stores and indefinitely blocked social media apps like WhatsApp and Instagram. They then implemented sporadic mobile shutdowns wherever protests flared up. Perhaps most extreme, the authorities responded to protests in south-east Iran in February 2023 by blocking the internet outright.[1] Digital and human rights experts say motivations include controlling information, keeping protesters offline, and forcing protesters to use state services where their online activities can be more easily tracked – and sometimes trigger arrests.

1 'New Protests in Iran's South-east As Internet Blocked: Activists', Al Arabiya, 24 February 2023.

As getting online has become increasingly challenging for everyone in Iran – not just protesters – millions have learned to rely on virtual private networks (VPNs) to hide internet activity, circumvent blocks and access accurate information beyond state propaganda. Simply put, VPNs work by masking a user's IP address so that governments have a much more difficult time monitoring activity or detecting a user's location. They do this by routing the user's data to the VPN provider's remote servers, making it much harder for an ISP (or a government) to correlate the internet activity of the VPN provider's servers with the individual users actually engaging in that activity.

But as demand for VPNs has peaked, the authorities have recently started moving more intently to block VPN access. That includes potentially taking drastic steps like criminalising the sale of VPNs.[2] The Iranian parliament couldn't be reached to confirm what, if any, new restrictions may be coming. But experts say that it's likely censorship will intensify. Seeming to confirm the ongoing escalation, Ruhollah Momen-Nasab, a parliamentary special adviser who is overseeing an internet restriction bill condemned by more than fifty human rights groups,[3] has recently called for VPN sellers to be executed.[4]

However, VPN providers have not buckled under this intense pressure. Using a pseudonym to protect his identity under heightened government scrutiny, Lucas is a spokesperson for Lantern, one of Iran's oldest and most popular free VPN tools, with close to nine million monthly active users in the country. Lucas said that Lantern's traffic has grown by 400 per cent since Amini's death, and because of that, server costs have skyrocketed. To keep VPN access stable while auto-scaling services to meet rising user demand, Lantern started taking donations, maxing out credit cards, and collaborating with other organisations providing VPN services in the area to troubleshoot connection issues as they arise.

2 'Iran: Human Rights Groups Sound Alarm against Draconian Internet Bill', *Human Rights Watch*, 17 March 2022.

3 *Ibid*.

4 'Hardliner Regime Insider Calls for Execution of VPN Retailers', IITV (Iran International TV), 8 February 2023.

'We're constantly getting attacked by the Iranian government,' said Lucas. 'So we're in this constant state of looking at the data, listening to users, and trying to come up with completely new techniques to keep everyone online.'

Censorship Evolves Daily

As part of a small group of organisations defending internet access in Iran, Lantern helps people like Milad, a 35-year-old Lantern user who requested that his full name is not disclosed while discussing his secret VPN use. Circumventing internet blocks daily, Milad mostly relies on VPNs to 'figure out which news is not as reliable' and to direct friends and family to 'threads they should follow' so they can read beyond state propaganda and monitor how the authorities are responding to protests. For Milad, getting online requires more than just one tool. He needs a complete toolbox of VPNs, anonymity networks, and varied proxy solutions – a personal arsenal of circumvention tools that he has been building for the past decade to stay ahead of ever-changing censorship tactics.

'Censorship here evolves weekly, if not daily,' explained Milad. 'I use a few tools on a daily basis.'

Iran is second only to Russia as the nation most affected by internet shutdowns, according to a report from Top10VPN,[5] an independent review site that monitors VPN use and internet shutdowns. Last year, internet shutdowns cost the Iranian economy £603 ($773) million – money that businesses lost during 130 hours of internet throttling, 2,179 hours of internet blackouts and 4,863 hours of social media shutdowns. Globally, the cost to economies in 2022 was nearly £19 ($24) billion, which is more than 300 per cent higher than shutdown costs in 2021.

Lantern plans to combat this worrying trend by deploying global networks that can be more resilient to increasing censorship tactics. But that plan depends on more support networks getting involved, explained Lucas, and only some major

5 Samuel Woodhams and Simon Migliano, 'Government Internet Shutdowns Cost Almost $24 Billion in 2022', Top10VPN, 3 January 2023.

tech companies have responded with urgency to ever-increasing blocks and shutdowns. In one prominent example from earlier this year, Meta introduced a new proxy support feature[6] to help WhatsApp users who were blocked indefinitely in Iran. Every new solution to get around blocks adds a tool to Iranians' toolbox.

Milad said that as far as he can tell, 'there is no plan' to reduce restrictions in Iran, and it's discouraging to know there's only so much that individual people or companies can do to open the internet back up. Like Lucas, he dreams of a greater collective response that would provide both technical support and social activism – one that's powered by a global network of government agencies, Big Tech companies, and other organisations that could combine resources to build support systems that would make government internet shutdowns impossible.

Until that day comes, Lantern remains one of many go-to VPN tools for Milad and others. Lucas said Lantern has no plans to abandon Iran; seeing protesters sacrifice to defend their rights has inspired Lantern to invest in building more long-term solutions. He also wants to rally others in the industry to build more technologies to help more users around the world combat authoritarianism.

'I feel like as an internet community, in general, there needs to become more urgency around implementing these censorship-resistant, privacy-preserving technologies now because authoritarianism, it's just getting crazier and crazier,' Lucas said.

Keeping Iranians Online

A week after Iran responded to protests by blocking WhatsApp and Instagram last September, Top10VPN documented[7] a spike in demand for VPNs on 21 September 2022 that was 2,164 per cent higher than the demand over the previous twenty-eight days. Over the next few days, demand kept rising, peaking at more than

6 Ashley Belanger, 'WhatsApp Just Made It Harder to Censor Citizens with Internet Shutdowns', *Ars Technica*, 5 January 2023.

7 Op. Cit. Woodhams and Migliano, Top10VNP.

3,000 per cent higher than it was before the protests started. Remarkably, demand stayed high for weeks, remaining almost 1,000 per cent higher than pre-protest rates.

'It was one of the most pronounced and sustained increases in demand that we've seen,' observed Samuel Woodhams, Top10VPN's digital rights lead. Then, in mid-October 2022, demand suddenly started dropping. That drop 'may reflect that the Iranian authorities are having increasing success at blocking VPN traffic', Top10VPN reported. Lucas confirmed that was true in Lantern's case.

As VPNs are targeted, a cat-and-mouse game starts between the government and VPN providers. Woodhams said that 'as the restrictions get more and more repressive, the methods which people use to get around them will become more innovative.'

For Lantern, innovating in this space has meant developing techniques or methods that make it harder for the Iranian authorities to block VPNs with simple firewalls. VPNs commonly use standard methods that are easy for censors to identify and block without impacting other traffic, but Lantern uses a wider variety of obfuscation and encryption methods to hide user activity that's less desirable to block. When VPNs employ this strategy, Woodhams said it's effective, and the 'really blunt approaches' to block VPNs 'don't seem to work,' mostly because blocking access to Lantern could impact access to web services that they authorities want to keep online, such as banking services. By relying on 20,000 global proxies that constantly change IP addresses while retrieving user data, Lantern makes it more cost-prohibitive for the authorities to target its VPN tool or monitor its users.

While its VPN tool is more sophisticated than standard VPNs, Lantern doesn't require much tech savvy to use. Milad said it might even be a little 'too easy,' adding that 'anyone with the simplest abilities can find their way around the app.' Digital rights experts explain that for many VPN users, it's not a struggle figuring out how to use VPNs. Issues only arise when users have to troubleshoot a tool that stops working.

That's where organisations like ASL19 come into play. According to Executive Director Fereidoon Bashar, his organisation's help desk gets more than 2,000 requests daily from Iranians trying to connect to the internet. 'Fielding these

requests,' Bashar said, 'it's very hard to really pinpoint what the underlying issue is,' but ASL19 works to determine whether access is blocked due to a solvable roadblock – like issues affecting a certain IP address used by a certain tool – or due to larger issues affecting access to all tools, like confirming whether there are regional internet shutdowns where the user is based.

ASL19 was founded in 2012 specifically to help people in Iran circumvent internet censorship, providing a wealth of resources over the past decade to help internet users develop customised solutions as restrictions have tightened, including providing its own VPN tool. Lantern is just one of many tools available on ASL19's platform, which became more popular when the Google Play Store was blocked in Iran.

Lantern experienced 'quite an uptick in downloads', said Bashar. Since September, ASL19's platform has seen more than 20 million downloads of VPNs. Over just four months, the spike in downloads amounted to a third of the total downloads on the platform since its 2016 launch. This spike troubles Bashar, though, because the more users try to connect to VPNs and other tools, the more issues are likely to arise.

'As much as there's been an increase in demand for these tools and usage, with that also comes a significant number of people who struggle to be able to connect to different tools on any given day,' Bashar said.

Big Tech's Role in Ending Internet Censorship

ASL19 also runs proxies for Iranian internet users who want to use WhatsApp. Bashar said that 'It's good to see major tech companies are taking notice' and that recently, 'There's been a fairly good movement on their side to try to help people in Iran get access to tools.' TechCrunch reported a variety of ways in which tech companies have responded to help Iranians get online after protests started last autumn.[8]

8 Mike Butcher, 'As Iran Throttles Its Internet, Activists Fight to Get Online', TechCrunch, 5 October 2022.

Some companies already providing services have worked to raise awareness of anti-censorship tools. For example, within the past few years, the Google-managed tech incubator Jigsaw launched Outline VPN, which people have been using to create their own VPN servers since 2018. Groups like ASL19 have been increasingly promoting Outline VPN as a new solution for people in Iran, and Bashar said that ASL19 has been using Outline VPN code to improve its own network and VPN tools, which is 'a big priority' right now.

Vinicius Fortuna, the lead engineer on the Jigsaw team behind Outline VPN, explained that it became harder to track usage when the Google Play Store was blocked but that clients like ASL19 shared metrics that showed a 'large growth in Iran', bringing in millions of Outline VPN users since September. That spike represents roughly fifteen times more users than Fortuna said Outline VPN drew before protests started.

Fortuna said that as censorship tactics have evolved, Outline VPN has collaborated with researchers to create a dashboard monitoring internet blocks globally[9] and to update Outline VPN with new mitigation methods to circumvent blocks as they arise in different regions. Fortuna said his team considers China the most sophisticated at blocking VPNs, so if a mitigation method works in China, it usually 'works everywhere'.

Based on observations in China, for example, Outline VPN released a new feature in Iran that makes it easier to disguise connections – a feature Lantern has since implemented. But it's 'trickier' to mitigate blocks in Iran because, unlike in China – where methods of government internet censorship, including VPN blocks, are very centralised – internet service providers in Iran have varied strategies for blocking VPNs. 'So you need to try different things with different ISPs' in Iran, stressed Fortuna.

As Outline VPN develops new mitigation strategies, it is sharing insights, code and features with VPN providers like Lantern and ASL19 – becoming part of the increased collaboration that Lucas wants to see more of. Fortuna said that because internet censorship is 'a constantly evolving game', it requires 'constant investment and collaboration', and Outline VPN has strived to be

9 Censored Planet Dashboard, 15 March 2023.

'the missing piece' by providing Google's engineering and product expertise to communities constantly in need of novel solutions.

But even Jigsaw's dedicated efforts to share Google's expertise may not be enough. Bashar said that when censorship increases in Iran the way it is now, coping with it can feel like running a marathon, trying to update circumvention technologies to stay ahead, as the authorities slowly chip away at internet access day by day. To make it through the marathon, Bashar said there's an ongoing need for more resources to fund both existing infrastructure and research-and-development efforts exploring new technologies.

Obviously, Big Tech companies would have the deepest pockets to provide such resources and build new technologies, but Bashar said that an even more urgent need is for tech companies to push governments to remove tech sanctions on Iran. He added that companies' over-compliance with tech sanctions ends up blocking a large number of services.

This issue was raised earlier this year by the American technology company Cloudflare, which decided to deny a senior White House official's request to help circumvent Iranian internet censorship because Cloudflare said sanctions prevented the company from putting equipment in Iran.[10] Cloudflare discussed the troubling impacts of these sanctions on the free global internet in a December blog post, providing policy recommendations and noting that, 'It's a tricky balance to impose costs on bad actors while maintaining open lines of communication for ordinary citizens.'[11] A Cloudflare spokesperson said that the company is working with human rights organisations to track how government internet shutdowns evolve.[12]

The Internet Society, a non-profit advocacy group with chapters around the world, welcomed a US Department of

10 Sean Lyngaas, 'Cloudflare Says White House Asked Tech Firm to Bypass Iran Censorship, But US Sanctions Got in the Way', CNN Business, 19 January 2023.

11 Laura Klick, 'The Challenges of Sanctioning the Internet', Cloudflare, 12 December 2022.

12 Jocelyn Woolbright, 'Partnering with Civil Society to Track Internet Shutdowns with Radar Alerts and API', Cloudflare, 15 December 2022.

Treasury decision to shift sanctions guidance last September[13] to 'authorise technology companies to offer the Iranian people more options of secure, outside platforms and services,' according to Hanna Kreitem, the group's senior adviser on internet technology and development in the Middle East and North Africa. But Kreitem explained that this decision illuminated 'how sanctions are also bad for the internet'. To reduce the impact of sanctions on Iranians' internet freedom, Kreitem said the Iranian technical community needs to be invited to participate in wider internet governance activities, protocol development and standards development. Because of sanctions, Kreitem noted, 'Many of the global forums do not include people from Iran.'

While governments and tech companies grapple with changing sanctions guidance, internet users in censored regions keep waiting for more solutions. Milad warned that tech companies and organisations 'should be more vigilant'. 'There's a lot that can be done, but little has been,' he said.

Lantern's Lucas said that there's a 'huge disconnect' between organisations like his and cloud providers. But he thinks 'the whole world' needs to mobilise to 'actually solve these problems', saying it would be very helpful if more Big Tech companies took responsibility for providing services to people living in 'shocking conditions' where censorship and state surveillance are increasingly becoming the norm.

'It's fairly clear that if we did [mobilise], we could fully uncensor the internet in Iran in a much more robust way,' Lucas stressed.

VPN Access Increasingly Blocked Globally

For Iranians coping with internet shutdowns, the question isn't when restrictions will end but what restrictions are coming next. It's hard to know what exactly will be covered by the 'Regulatory System for Cyberspace Services Bill' that the Iranian parliament

13 Press Release, 'US Treasury Issues Iran General License D-2 to Increase Support for Internet Freedom', US Department of Treasury, 23 September 2022.

has been drafting over the past few years (see page 89). The human rights group Article 19 reported that some parts of the law have already been implemented prior to ratification.[14]

Other human rights groups have warned that in addition to increasing the risk of complete internet blackouts, the bill could introduce criminal measures against anyone developing, reproducing or distributing VPNs or proxy services, possibly resulting in two years' imprisonment for violators, Human Rights Watch reported last year.[15] As peer-to-peer proxy services – like the feature WhatsApp launched this year[16] – become more popular, censorship circumvention methods could put tech companies and individual internet users at risk of being charged with crimes.

Bashar explained that there have been even more rumours swirling about the current version of the bill, which he said is difficult to track because it's currently being drafted 'behind closed doors'. However, Bashar said there isn't necessarily consensus among Iranian officials on whether to outlaw or criminalize VPNs. Some factions want to make accessing the internet 'as hard as possible', Bashar said, while others are in favour of creating tiers of access to the internet so that different demographics can retain access to more services than others.

If Iran did decide to outlaw VPNs, it wouldn't be the only country to do so. Russia recently outlawed a group of popular VPNs, observed Woodhams. Last year, *Fortune* reported that Russia has banned at least a dozen VPN services,[17] and TorrentFreak reported that Russia's anti-VPN legislation led Google to block hundreds of thousands of VPN-related links.[18] This created a scenario in which alternative VPN tools became harder

14 Article 19, 'Iran: Cyberspace Authorities "Silently" Usher in Draconian Internet Bill', 9 September 2022.

15 Op. Cit. 'Iran: Human Rights Groups Sound Alarm against Draconian Internet Bill'.

16 WhatsApp blog, 'Connecting to WhatsApp by Proxy', WhatsApp, 5 January 2023.

17 Grady McGregor, 'VPN CEOs Are Making Some Services Free in Russia Because Russians Have No Way to Pay', *Fortune*, 25 March 2022.

18 Ernesto Van der Sar, 'Google Delisted Hundreds of Thousands of URLs to Comply with Russian "VPN Law"', TorrentFreak, 20 July 2021.

to find, just as some popular tools became less reliable. Lantern started experiencing issues in Russia when VPNs were banned, a common outcome when governments in Iran, China and Russia target major VPN providers, Lucas said. 'There are definitely moments when Lantern's not going to work for everybody.'

Woodhams said that when trusted circumvention tools go down, shoddy products sometimes take their place, subjecting internet users to privacy vulnerabilities and surveillance risks. Woodhams cited one case in Iran where the authorities allegedly blocked a VPN tool and then launched their own tool with the same name, deceiving users who didn't realise their data was being monitored by the government.

Iranians must stay vigilant to detect when their online activity might be tracked, which chills online speech, advised Kreitem. 'Even if they had access to the service, the perception that the service is being monitored impacts how much they can express.' That's why, beyond economic impacts, internet shutdowns endanger 'the future of the internet itself'.

Woodhams agreed, saying that 'Alongside all of the censorship, I think increased surveillance works in tandem in quite terrifying ways that will really, really negatively impact the kind of freedom of expression in the country going forward.'

Just a few months into 2023, internet shutdowns have been reported not just in Iran but also in Ethiopia, Myanmar, Iraq, India, Turkey, Mauritania and Suriname, costing economies close to £179 ($230) million already.[19] Bashar noted that circumvention tools are the only reliable way for people in these regions to track information and express themselves online. The tools become especially crucial to citizens during protests, which are the events Top10VPN reported as having trigged the majority of shutdowns this year.

Kreitem said that the Internet Society expects to 'record more and more internet shutdowns and internet limitations in general,' while noting that 'Shutdowns seem to actually increase violence during unrest and protests.'

As of January, more than 500 Iranian protesters have died,

19 Op. Cit. Woodhams and Migliano, Top10VNP.

and approximately 14,000 are believed to have been jailed, PBS reported.[20] In response to this and other violence, the US Treasury Department in March announced more sanctions against Iranian officials accused of 'rape, torture, or other cruel, inhumane, or degrading treatment' of jailed protesters.[21] These sanctions are viewed as critical to ending state violence, but without safeguards, experts said they can work to further isolate Iran's tech community.

As bleak as the situation has become, Kreitem maintained that Iranians have never given up on fighting censorship to defend open communication and free expression. He said, 'In the case of Iran, people will still be able to communicate using circumvention tools.'

While Big Tech companies weigh how much they want to get involved, dedicated VPN providers like ASL19 and Lantern will continue defending internet access in the region as protests continue, censorship tactics evolve and ordinary citizens get caught in the crossfire.

'Access to these tools becomes quite vital during events such as protests because there's a lot of footage of the protests that is shared online,' observed Bashar. 'It's important for people to be able to communicate with each other in a safe way, securely, inside the country, and to be able to check in on family or friends to make sure they're safe.'

20 Jane Ferguson and Zeba Warsi, 'Iranians Protesting Regime Refuse to Back Down Despite Threats of Arrest and Execution', broadcast on PBS, 12 January 2023.

21 Anthony J Blinken, 'Sanctioning Those Connected to Human Rights Abuses in Iran', Press Statement, US Department of State, 8 March 2023.

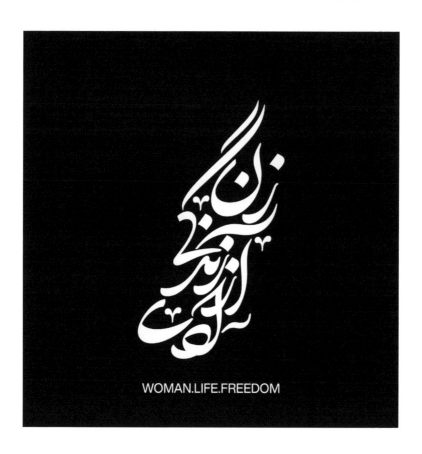

WOMAN.LIFE.FREEDOM

Graphic Designers Take Action

A global artistic response to the women's protests

Iranian Women of Graphic Design

Iranian Women of Graphic Design (IWofGD) provided hundreds of images of art and protest posters in support of the Woman Life Freedom revolution through an open access drive on the internet. The drive became a rallying point, and not just for Iranian artists at home and in the diaspora. Artists from around the world have contributed images and artwork for protestors to download, print and take on demonstrations.

A spokesperson from Iranian Women of Graphic Design explains their work and vision:

'With more than 40,000 members from all over the world, Iranian Women of Graphic Design is a collective, but not in a formal or traditional sense. We began in autumn 2020 as a curated collection of historical and contemporary works of female-identifying graphic designers from Iran. The group initially started as an initiative to combat the low visibility and representation of female graphic design in the state-regulated cultural sector in Iran. The idea was born when a book was published in Tehran, covering 100 years of Iranian graphic design history. It showcased works by 100 designers, of which only five were women.

'This book triggered discussions about women in graphic design and other art disciplines and led to the founding of IWofGD. We wanted to promote the female legacy as well as significant contemporary figures of Iranian graphic design. Within a few hours of the group being formed, in excess of 100 works by several women designers were published from a private archive. They showed the systematic oppression of women by state publishers. Iran, especially Iran under the Islamic regime, is a patriarchal society and this is reflected in all fields, including culture.

← Eilya
Tahamtani,
Freedom.
Digital
illustration.

→ HVNYCK,
Freedom.
Digital
illustration.

'The regime's ideal is for women to stay at home and take care of their man, children and family and to this end they systematically try to restrict women. Therefore, women's chances of finding a job in society are always lower than men's. Even when women do find professional employment, it is often as assistants under men. The same is true of the graphics field, as well as art and culture. And there is a lack of confidence in women and their skills. Often they are not taken seriously.

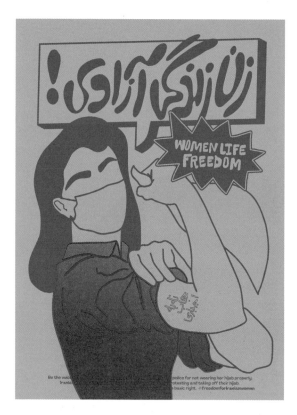

← Ghazal Foroutan,
The Persian Rosie.
Print size: 27.94 ×
38.1 cm.

ARTIST'S STATEMENT

The Persian Rosie poster series is printed on a
Risograph printer duplicator using two colours,
cyan and magenta. The concept comes from the
famous Rosie the Riveter 'We Can Do It' poster,
first produced during World War II. Rosie's
gesture and posture became a symbol of resistance
and empowerment for women over the years, and the
poster has been redesigned and adapted multiple
times. The Iranian Rosie holds her white scarf
in her hand - echoing the white scarf of Vida
Movahed, from Revolution Avenue - while showing
off a tattoo that says, 'No to Compulsory Hijab!'
Wearing masks became a part of our daily lives
during Covid. But specifically, for this movement,
masks are protecting people's identity - and
that's what she is doing here. The slogan on the
top says 'Woman Life Freedom', which is what this
revolution stands for.

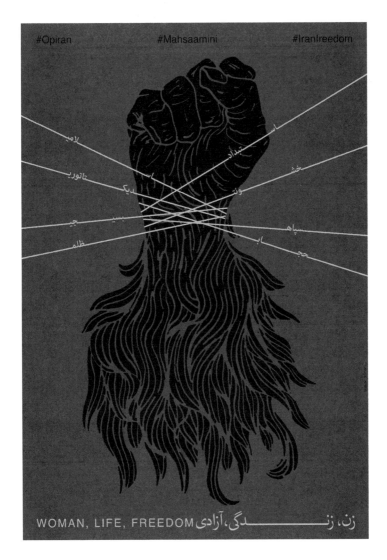

↑ Babak Safari, *The Power of Women*. Digital illustration.

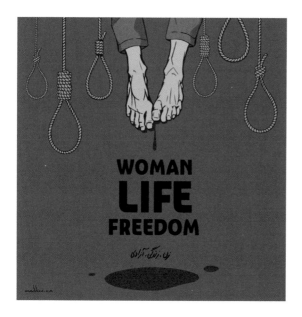

← Mahdieh
Nadimzadeh,
Zendagi (Life).
Digital
illustration.

→ Elham Ataeiazar,
Rang-e-dooran. Digital
illustration.

The artwork's title,
'We Have Suffered a
Lot', comes from a line
of poetry by Nader
Ebrahimi (1936-2008).
The singer Mohammad
Nouri (1929-2010)
popularised it in the
song, 'Baraye anke Iran
khanei khooban shaved'
(Make Iran the Place
for Good People). Also
on the poster is the
name of Mahabad, a
city in Iran's Kurdish
province.

← Kamran Mohagheghi, 100
Days. Digital print.

'But this has changed because women have created their own independent medium in social media and now can present themselves and their skills independently. The idea for the open access drive came from demonstrators who were looking for a print file for their demos. In parallel, there were some designers who made their work available on their own server. So we set up a shared drive in consultation with them. In recent years, many people from different contexts have helped us. Collectors sent images of historic posters or books from their own archives. Professors introduced young designers to us, who in turn introduced their friends to us. The name of our Instagram page was changed several times in the first two or three days as our followers gave us new suggestions. A number of people write us messages and correct the information relating to the graphic works we post. Others help us with writing articles and proofreading.

↑ Mina M Jafari, *Woman Life Freedom*. Digital illustration.

A graphic representation of the name, Jina, also appears in the artwork.

↑ Jamshid Dejagah, *For Iranian Women, Who Are Courageous More Than Ever*. Digital illustration.

'We are in constant contact with designers. Neither we nor the designers could have imagined that the posters would reach millions of people across borders, in large demonstrations, on the streets, in store windows, museums, stadiums, in newspapers, on television and other places. This touches and influences viewers as well as the designers themselves and their perspective on their artistic work. The response has reminded designers once again what a strong voice and medium they possess and the responsibility they have in relation to social and political issues.

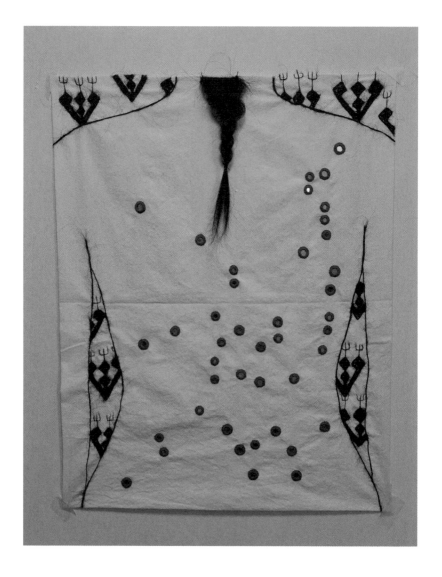

ARTIST'S STATEMENT

In Iran, woman's hair is a political issue. If cut and changed into a
wig, it will lose its controversy. Hair signifies - 'You will be free,
if you die.' That's why we can use hair as a material to speak about
liberty and freedom. Therefore, I asked women to send me their hair.
From their hair I knitted (which is considered a 'feminine' art) this
artwork. Women's hair is a material which speaks to all women, about
the hopes we have for freedom and equality.

← Mansooreh Baghgaraei, A
Mirror in Front of You / News:
A Woman Wounded with 500
Shotgun Pellets. Tapestry, size
41 × 51 cm)

→ Milad Nazifi, Brave. Digital
illustration in honour of Elnaz
Rekabi.

'The connection between Iranian Woman of Graphic Design
and the Woman, Life, Freedom movement is the shared fight
against the oppression of women and the violation of their rights
and the struggle for equal justice and freedom. We oppose any
oppression and discrimination based on gender. In this context
we stand not only for women but also for other gender identities,
including binary and non-binary people. Since the death of Jina
Jina Mahsa Amini, we publish not only the works of Iranian women
designers, but graphic works of all designers, regardless of
their gender and nationality, who relate to the oppression and
discrimination of people, especially women.

'Our open access drive contains posters that have been
voluntarily designed for solidarity and humanitarian reasons and
not for commercial reasons. These posters amplify the voice of the
protesters and this can only happen if the posters are seen more
publically, in the digital media, newspapers, public media and on the
streets. New technology makes this possible.

↑ Parastoo Ahovan, The Eyes.
Digital illustration. Words on canvas:
'Woman Life Freedom'.

↑ Jalz, *Untitled*. Digital
illustration.

Image of the Azadi (Freedom) Tower
with Matisse's dancers and the
protest slogan, 'Women, Life,
Freedom'.

↑ Parisa Tashakori, *Mahsa Amini Forever*. Tapestry, size: 40 × 40 cm.

'The posters are a visual narrative of the history of the revolution and represent different themes. No one theme dominates, but the scissors and the act of cutting hair are one of the main motifs on posters designed for the Woman, Life, Freedom movement. It has become a worldwide symbol of protest against cruelty, injustice and anti-women laws.

'Cutting hair is one of the millennia-old mourning rituals in Iranian culture. Ferdowsi, one of the Iranian poets of the late-tenth century, also mentions this ritual in his book, the *Shahnameh*. In the famous narrative Siyâvash – a mythical Iranian figure – is killed, after which his wife Farangis cuts her hair as a symbol of mourning and to protest against injustice.

'This ritual is still common among some ethnic groups in Iran such as the Bakhtiars, Kurds and Lurs, among others. It became a symbol of anger and protest against the misogynistic laws of a patriarchal society after Jina Mahsa Amini's death. Women all over the world cut their hair in solidarity with Iranian women and in protest against oppression and gender inequality.

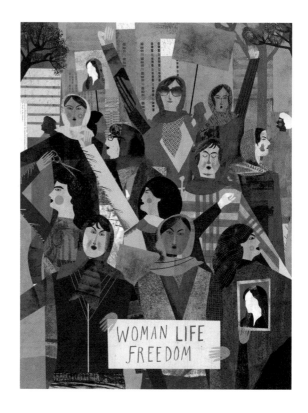

→ Martin Haake,
*Iran Freedom
Woman.* Digital
illustration.

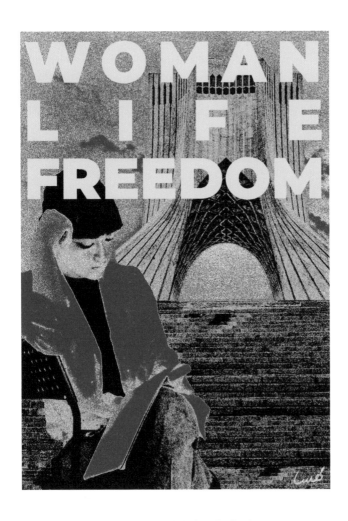

↑ Mahsa Salekesfahani, We Will Get It Back.
Digital illustration.

The poster shows Nika Shahkarami (2005-2022),
sitting in peace and reading a book beside
the Azadi (Freedom) Tower. She was brutally
kidnapped, raped and killed by the Islamic
Republic of Iran.

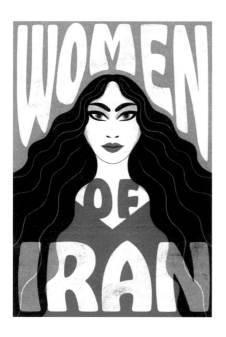

← Or Yogev, *Women of Iran*.
Digital illustration.

← VVORK VVORK VVORK,
Bright Days, My Homeland.
Digital illustration.

'Woman, Life, Freedom is not the first Iranian protest against the regime, specifically in defiance of the oppression and discrimination and for freedom of expression. However, these protests have not gained much visibility beyond the country's borders. Some have been forgotten, like the Green Movement of 2009. We are trying to give Woman, Life, Freedom more visibility and a longer, more sustained life. The protests have evolved. People, especially women, are stronger and braver in the streets than before. They're seen everywhere without hijab, hand in hand, dancing and singing. These are the forms of protest that can break the basic structure of this Islamic regime.'

↑ Sara Emami, Woman Life Freedom: Iranian School Girls. Digital Illustration. Amsterdam, The Netherlands.

In Kurdish, 'Jin Jyan Azadî' (Woman Life Freedom).

↑ Happy Borders, *In Solidarity with All Women in Iran*. Digital illustration.

ARTIST'S STATEMENT

We are all connected, we are all equal, we will always support each other. The power of solidarity and resistance will be forever with us. There will be so many posters showing how strong women are, we would need a new gallery to collect them all.

↑ Touraj Saberivand, *Iranian Women*.
Digital illustration.

The artwork was inspired by Vida Movahed, the
human rights activist who started the Enghelab
(Revolution) Avenue movement. In 2017, she
climbed on top of an electrical substation
utility box, in front of a gathering crowd, and
waved her white hijab on a pole, to protest at
the compulsory veiling of women in Iran (see 'The
Girl of Revolution Avenue', page 1).

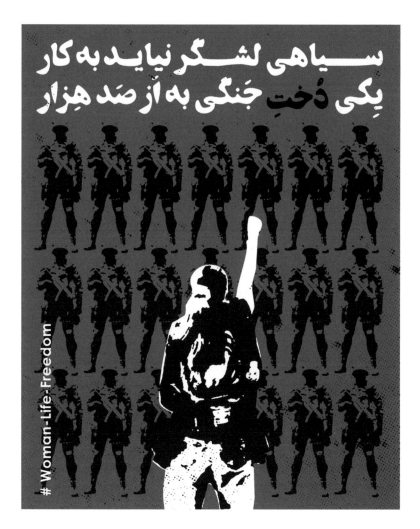

↑ Meysam Azarzad, *Just a Warrior Girl*.
Digital poster.

Originally released on Instagram, this poster
quotes the eleventh-century epic, the *Shahnameh*
(Book of Kings) by Ferdowsi: 'This massive army
is useless. Indeed, a single fighting girl is
worth hundreds of thousands of them.' Azarzad's
posters are discussed by Pamela Karimi in her
interview, 'A Revolution Made by Art', pages
93-4).

Protest Music in Iran

Rappers, turntablists and classical musicians provide the soundtrack for dissent

Clive Bell

Iran possesses one of the most refined classical music traditions in the world, but the country has often treated its musicians like scum.[1] Even in the 1960s no respectable person would be seen in public carrying an instrument. After Khomeini's Islamic Revolution of 1979, if you stepped outside with a guitar, you risked being attacked – and you were lucky if it was just with words.

Since 1979 it has been illegal for a woman to sing alone in public unless she performs for an all-female audience and is accompanied by an all-female band. For forty-four years this restriction has blighted Iranian music.

Googoosh is a Persian pop diva, originally a child actor, whose music summons up 1970s Iran to millions at home or in exile. Known as the 'Daughter of Iran', she has a special place in the hearts of Iranians. She remained in Iran after 1979 but fell silent for twenty-one years. In 2000 she was eventually allowed to tour outside the country. She left for Los Angeles, where her diaspora status remains high.

1 Contradiction and sometimes hypocrisy exist in some countries' attitude towards their musicians. In the 1970s, during a series of lectures on Persian classical music, Iranian-American composer Hormoz Farhat (1928–2021) said you could get abused for carrying a musical instrument in the streets of Tehran rather than playing it. In neighbouring Afghanistan, for example, from Veronica Doubleday's research and fieldwork, women musicians often perform at traditional weddings though 'respectable' people avoid associating with them.

In the present day, two female singers in their twenties, Faravaz and Justina, were both arrested and sentenced to jail. Faravaz is a singer/songwriter who has performed power ballads with a full orchestra, while Justina is a rapper (or *rapkon* – a 'rap-doer' – as Iranian rappers call themselves). In 2020 they collaborated on 'Fatva', a pop ballad with subtle allusions to the Iranian tradition in its instrumental phrasing and vocal styling. Faravaz has now emigrated to Germany, Justina to Sweden.

In October 2022 the two women were interviewed by the BBC World Service,[2] during which Justina said she felt she has lost her youth and she has started a campaign called 'Right to Sing'. She was told by the authorities in Tehran that if she collaborated – meaning write songs praising the hijab or criticising the US and Israel – they would make her more famous. Her response is 'Enghelab', a no-prisoners hard rock song with a fierce rap and chorus refrain: 'Do you wanna revolution?' She's no longer in Iran, but says, 'They share my songs, my voice is there on the streets, I feel I'm with them.'[3]

Faravaz learned what was at stake when she came back from a childhood guitar lesson with a trace of lipstick on her lips. Her father responded by smashing her instrument. She now believes Islam is fundamentally against art: 'They want art to serve its ideology; they don't know anything about creativity.'[4]

Protest songs have a long, sturdy history in Iran. Mohammad Reza Shajarian, who died in 2020, was perhaps Iran's greatest classical vocalist. After the disputed election results in 2009 he sang, 'Join our path, dear one/ Don't remain alone with this pain/ Because this shared pain/ Never will be/ Separately cured' ('*Razm-e Moshtarak*', or Common Battle). After President Mahmoud Ahmadinejad referred to the 2009 protesters as 'dust and trash', Shajarian told an interviewer that he considered himself the voice of dust and trash.[5]

2 Cultural Frontline, 'Protest Songs in Iran', presented by Tina Daheley, aired 15 October 2022 on the BBC World Service.

3 *Ibid*.

4 *Ibid*.

5 'Mohammad Reza Shajarian', Wikipedia. Also see Marian Brehmer, 'Mohammad Reza Shajarian embodied the timeless beauty of Persian music', *The Guardian*, 9 October 2020.

The year 2009 saw the Green Movement protests. Then in 2019 came Bloody November, triggered by an increase in fuel prices. Violent suppression of protests led to the killing of an estimated 1,500 people, many by regime machine guns. These protests are recalled in a recent song, 'Mah-e Aban Bood' (It Was November), recorded, as many of these songs are, by anonymous musicians. A woman sings over a gentle piano and a military snare drum.

In a country where live performance is still regulated for women, Iranian men have proven good allies to the movement. If one song could be said to stand for the 2022 demonstrations, it would be 'Baraye' by Shervin Hajipour. It was written in the wake of twenty-two-year-old Mahsa Amini's death after being arrested and beaten by Iran's notorious Morality Police for not wearing a proper head covering. This protest movement is arguably one powered by social media. Hajipour drew on this idea, creating a song by collaging phrases from hundreds of tweets. Less than forty-eight hours after his self-recorded music video appeared on his Instagram account in September 2022, the song became an instant hit, quickly receiving forty million views. Once Haijpour was arrested and forced by the authorities to delete his posts, the song's popularity surged. Its title means 'Because of' or 'For': 'For dancing in the street freely/ For our fear of kissing our loved ones/ For my sister, your sister, our sisters/ For the renewal of the rusted minds.'

Unlike rap, which favours a single voice, 'Baraye' is a carefully crafted pop song suited to being sung by large groups of people. The style is reminiscent of live concert singalongs, the crowd holding lighters in the air. Hajipour keeps his chord sequence simple, but it's hard to create something as catchy as this. The song became a global phenomenon, and was performed by Coldplay in concert in Argentina, joined on stage by exiled Iranian film star Golshifteh Farahani. In February 2023 Jill Biden announced that Hajipour had won a Grammy award for Best Song for Social Change, by which time he had been arrested. On 20 March 2023, at the first-ever reception held at the White House for Nowruz, Iranian New Year, Iranian-American singer Rana Mansour sang the song in English to President Joe Biden.

A song as powerful as 'Baraye' deserves a musical response, and it received a thundering one in 'Inyekiam Vase' (This One Is

For …) by the so-called Father of Iranian Rap, Hichkas. Also known as Soroush Lashkari, Hichkas is now based in London and married to human rights activist Azadeh Akbari. His song has a rampaging flow that recalls Dylan's 'Subterranean Homesick Blues'. Now thirty-eight years old, back in 2005 he released *Jangale Asfalt* (Asphalt-Paved Jungle), perhaps the first Persian hip hop album. During the Green Movement protests of 2009 he wrote 'Ye Rooze Khub Miyad' (A Good Day Will Come), a slow rap song.

Rap has a massive presence in Iranian protest music. In the West, where rap and hip hop have become so dominant and mainstream, the genre can feel like a kind of international currency for anyone pissed off about anything. So it's refreshing to hear it being adopted for serious purposes, rather than American millionaires complaining about perceived insults from other millionaires.

Toomaj Salehi is today's most impressive contemporary rap artist in Iran. In his hard-hitting October 2022 song 'Meydoone Jang', we see him rhyming beneath a motorway underpass: 'They sold Iran, buddy/ You lose your home/ It's the day of reckoning with dictators/ Here is the battlefield/ They took the sun from us/ We will take the sleep from them at night.' Iranian percussion and strings can be heard in the mix. Another from the same period is 'Faal' (Fortune Telling). Toomaj is in the desert, predicting Iran's future by reading coffee grounds in a cup: 'I'm the predictor, I'm the fortune teller/ I saw a cage in the coffee cup of the government/ And a lion was hunting a jackal.' Since his arrest last year, he has been held in a high security ward controlled by the Islamic Revolutionary Guard Corps (IRGC), in Dastgerd Prison, in Isfahan. A video of the rapper after a forced confession, sitting on the floor, with a large blindfold over his face to hide his injuries, was circulated on state media. He has been threatened with the death penalty.

Roody is a prominent woman *rapkon* and hip hop dancer from west Tehran. She is twenty-four years old and has been rapping for the last decade. Her song 'Zan' (Woman) was written and recorded after four people died and sixty-one people were injured in a major fire at Tehran's notorious Evin Prison, in October 2022, nearly a month after the initial Zen Zendegi Azadi protests. Despite

Iranian rapper Toomaj
Salehi was arrested
for his songs, which
criticised the Islamic
Republic regime, and
for his support of the
nationwide women's
protest movement.
Editorial cartoon
by Mana Neyestani,
IranWire, 9 December
2022.

everything, she's optimistic about music: 'When I look at Persian hip hop, I see that it has progressed a lot during the last few years. The main reason for that is better and more regular productions. Considering all the obstacles and limitations here, Persian hip hop has become a great movement.'[6] Roody's 'Tehran' was written in 2019: 'It's the outcome of a tiny part of my personal experience in this merciless metropolis,' she explains. 'Its beat is sampled from Psycho Realm's "The Stone Garden" that I've been listening to every day for years, and every time it reminds me of the dark and closed suffocating atmosphere of Tehran. It's disgusting but real and that was the reason I wrote "Tehran".'[7]

There has been overwhelming international support for Iranian protesters and artists but, as Tehran-based composer Siavash Amini observed, 'Global financial systems and governments have mostly shown indifference, and in a few cases, disdain. Because of sanctions, Iranian musicians can't sell their music directly online, nor do they have access to many services that people routinely use globally. Recently underground mainstays Temp-illusion and

6 Ali Eshqi, 'Interview: Roody', Beehype.
7 *Ibid.*

Roody had to cancel their long-planned European tour because the German government rejected their visa applications citing the performers' financial situation and the current uprising in Iran.'[8] There's also an Iranian government embargo on the import of musical instruments and equipment. Independent musicians are barely surviving.

Not all Iranian musicians have been cast out by the government. In 2017 Mehdi Yarahi was given an award by the Ministry of Culture and Islamic Guidance for best pop album. Less than a year later he was banned from stage and television because he wore the uniform of workers arrested in the 2017 labour protests in Khuzestan, a south-western province of Iran, and because he later released 'Pare Sang' (Broken Stone), criticising the 1988 Iran–Iraq War. In 2022, inspired by Mahsa Amini's death, he wrote 'Soroode Zan' (Woman's Anthem). This is a revolutionary marching song, recalling the military songs of the Shah regime, but Yarahi stands such values on their heads: 'We say we don't want a king/ A beggar comes and becomes a leader/ The blood in our veins is a gift to our nation.'

This style of revolutionary song can sound antique to Western ears, but in Iran there are plenty of them. The global history of these revolutionary anthems stretches back to 'La Marseillaise', written in 1792 and adopted by the French Revolution. Another Iranian example is 'Soroode Sogand' (Oath Hymn, aka Everlasting Cry) from November 2022. The song reworks an anonymous 2008 song and is performed by students from the Culture and Arts Department of Tehran University. In the video all we see is their stamping feet as they sing in a circle. If the students' identities were revealed, they could face a prison sentence or worse. 'I wrote this letter to you from the ground of the cold alleys/ I wrote it with my red blood so that laughter would grow from the pain.'

Famous historical examples of universally recognised revolutionary songs have come from Russia, China, Italy and Chile, and several have wonderful tunes. 'The People United Will Never Be Defeated' was composed in 1970 by Chilean Sergio Ortega. This

8 Siavash Amini, 'Siavash Amini on Music amid Protest and Civil Unrest in Iran,' *The Wire*, issue 467, January 2023, p.44.

ong has travelled the world, resurfacing in Iran as 'Soroode Azadi' ('Freedom Anthem). This time it is arranged by an anonymous student choir – and there are more stamping feet.

Soroode is Persian for 'anthem'. 'Soroode Barabari/Javane Mizanam' (Anthem of Equality/I Will Bloom) is a 2008 feminist anthem, which was later covered in 2022 by a roll call of Iranian female singers living in the diaspora (including Justina), some of them in tears. It is a message of solidarity from the diaspora to 'the people of Iran who are fighting for freedom and equality'.

Another beautiful melody is 'Bella Ciao', originally sung by women who weeded the rice fields of Italy in the nineteenth century, and later adopted by Italian partisans fighting the occupying Germans in 1943. This is a classic revolutionary song, and in Persian it has associations with Iran's 1970s socialist movement. It is now being sung by the young sisters Behin and Samin Bolouri, who have been making music together since 2015 and who have covered dozens of Iranian songs from the 1960s and 1970s, considered a golden age of Persian pop music.

It is striking how much musical variety there is in the current protest song boom. Another voice from the diaspora is the US-based rock band Kiosk. Founded in Tehran in 2003 by guitarist Arash Sobhani, they faced impossible obstacles and eventually emigrated to America. In September 2022 they released the extremely catchy 'Zan Zendegi Azadi' (Woman Life Freedom), borrowing the protest movement's main slogan. There's a whiff of the Bee Gees about this upbeat offering from one of the diaspora's most popular combos.

Finally, representing both Persian classical music and the underground, is Mariam Rezaei, born in Gateshead, UK, but Iranian on her father's side. She's a pianist and pioneering turntablist, in her thirties, and the last word should go to her. In 2022, BBC Radio 3 commissioned a piece from her titled 'This World Which Is Made of Women', in which a piano recording is manipulated live on four turntables. The piece was broadcast, but Rezaei was not happy about the way in which the context was withheld. She said, 'That piece is very much, for me, about the Iranian revolution – about what is happening now in Iran, about what's being continually

fucking censored and erased.'[9]

This context was not mentioned on the radio broadcast, despite being included in her programme notes and during the interview she gave to the station.

'They commissioned the piece and they played the piece. So they allowed the narrative to come through the sound, but they didn't let me say very directly, "This is, for me, my flag of solidarity for my sisters, my brethren in Iran."'[10]

← Turntablist Mariam Rezaei in a comic by Chris Whitehead. Image appears courtesy of Mariam Rezaei.

9 Emily Pothast, 'Force the Hand of Chance', *The Wire*, issue 470, March 2023, p.43.
10 *Ibid.*

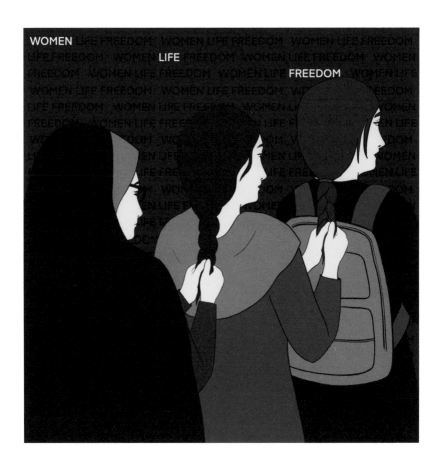

Keeping the Revolution Alive

Art for social change

Roshi Rouzbehani

Historically, the contributions of women in society have been largely ignored or marginalised, especially under a patriarchal dictatorship system like Iran's. In my digital illustrations for the Woman, Life, Freedom movement, I want to praise the strong women of my country who are shouting for freedom, despite the fear of getting arrested or even killed. I want my work to echo their strength and resilience in challenging restrictions and promoting gender equality.

The first artwork I created after hearing about Jina Mahsa Amini's death was a collage of portraits showing some of the women, men and children who had been killed or injured before her. The point was to emphasise that she is neither the first nor the last victim of Iran's brutal regime. After a photo of Mahsa's gravestone went viral – with the words 'You didn't die. Your name will be a symbol [for our protest]' – I recreated that photo in my own visual language. This work and others not only express my sadness and anger, they show solidarity and raise awareness among non-Iranian friends and followers on my social channels. Later, many of these illustrations were used as protest materials, placards and signs.

By employing familiar images or motifs in the artwork, I arrest viewers' attention and ask them to see in a new and different context. For example, in 'Stop the Execution', Hokusai's 'Great Wave off Kanagawa' warns about the onslaught of executions by hanging, which threatens people's freedom as symbolised by the Azadi (Freedom) Tower in Iran. Vibrant colours also force the viewers to confront the darker themes of the artwork. Among these colours, red holds a significant presence as it is widely regarded as the loudest colour owing to its connotations with blood and anger.

'Weapon' was created after seeing viral photos taken in the Tehran underground. Last November, women covered CCTVs with sanitary pads so that the security forces couldn't recognise people who were protesting. I was amazed how a feminine product could be used as a weapon in this women-led revolution. In Iran, like many other conservative countries, sanitary pads are sold and carried around in black plastic bags. Using them in public to cover CCTVs was not only a subversive act; it also broke the taboo around menstruation.

← For Freedom,
digital
illustration.

→ Stop the
Execution,
digital
illustration.
The onslaught
of executions,
symbolised
by Hokusai's
Great Wave
off Kanagawa,
threatens
Tehran's Azadi
(Freedom) Tower.

'All Together for Freedom', 'For Mahabad' and 'My Hair Is Not Your Battleground' were inspired by the bravery of young Iranian women. They are sick and tired of compulsive controls on their bodies, minds and lives. Born and raised in Iran, I left Tehran twelve years ago. So I know everything that an Iranian woman could go through and fight with in everyday life while living under a patriarchal dictatorship. My book *50 Inspiring Iranian Women* sheds light on the achievements of some remarkable women despite all the disparities, obstacles and limitations they faced. Many of them challenged restrictive traditions to advance and break new ground in male-dominated fields. Some are established, others are lesser known but they deserve worldwide recognition for their significant roles in art, science, education and sport.

← Weapon,
digital
illustration
[Persian
text reads
'Revolution'
(brand name
on box top),
'bulletproof-
winged sanitary
napkins' (side),
'Woman, Life,
Freedom' (top)].

→ For Mahabad, digital
illustration. Mahabad is a
Kurdish city in Iran.

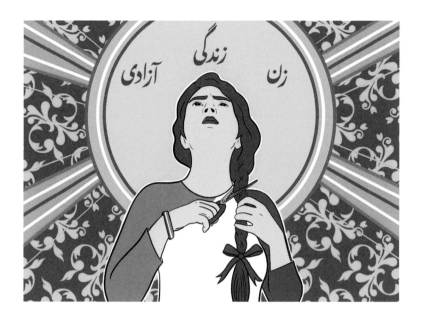

↑ *My Hair Is Not Your Battleground*,
digital illustration [Persian text
reads 'Woman, Life, Freedom'].

The idea that 'good' art shouldn't be political or social is often
rooted in the belief that art should be an escape from the realities
of the world. But I believe this is changing, and people are noticing
that art is not created in a void and cannot be separated from
the society in which it is created. Actually, we should use art as a
powerful tool for social change. I'm not suggesting that all artists
have to be political activists, but I believe they should participate
in discourse. Art can shape viewers' perceptions and attitudes and
bring attention to important issues.

In my work, I commemorate those who lost their lives and
I keep their memories alive. I also celebrate the actual heroes
whom the Iranian regime doesn't want to be seen as heroes –
people who maybe never wanted to be heroes and are just fighting
for ordinary lives. I recreate the iconic moments of the current
revolution in my own visual language.

This is my way of keeping the revolution alive.

Be Our Voice

On activism

Fari Bradley

'Blending in' is a particularly Iranian skill.

In 2001, while interviewing Bapsi Nariman, wife of a famous Parsi (Zoroastrian) judge in India, she told me the defining story of 1,000 Zoroastrian refugees and their arrival in Gujarat, northern India. They had been escaping religious conversion by the sword by successive waves of invaders between 800 and 1000 CE, and they had sailed in a fleet of eight immense ships south to the port of Gujarat. Local lookouts sent for the king, who arrived on horseback and met the Zoroastrians as they docked.

With no language in common, the two groups employed mime and props to discuss the arrival of so many families in his land. The king took a bowl of milk to demonstrate that the land was full to the brim with inhabitants and that there was no room for so many more. The Zoroastrians sent for sugar and showed the king that not only could they dissolve into society without causing any overflow, but they would also sweeten it. The diplomacy worked and they found permanent refuge. This 'blending in' is something Iranians do. The millions in self-imposed exile do not rock the boat; we get on, some of us adapt our names, we avoid politics and even say 'I'm Persian' to avoid any connection with the news.

Since 2005 I broadcast weekly about Iran on the arts-radio station Resonance104.4FM. In London, I keep mostly away from the hoary, violent world of Iranian politics because I feel other platforms covered this. In fact, that was the only way mainstream media portrayed Iran, as a political hotbed. I also ran residencies bringing Iranian creatives over to the UK for the first time, to exchange and learn. If my programme 'Six Pillars to Persia' was

thought to be too political, participants would have been at risk associating with us. Anyone with family ties to Iran, or who was repeatedly travelling there, played safe and adapted their public selves to never cross the regime.

It takes immense effort to programme, produce and present a weekly show on Iran and the region without becoming embroiled in politics. So, in September 2022 when I saw the citizens of Iran begin to call to us overseas and repeatedly implore 'Be our voice!', I was stunned. This was new, urgent; this was immediate. Some of us dropped everything – work, family, leisure – and began amplifying the voices of those risking all to protest against the regime. The atrocities rose as the level of amplification increased. After the United Nations voted to investigate Iran for human rights violations, I saw hashtags for towns under siege suddenly flooded with innocuous images of tourism, travel, commerce. The regime and its cyber army cared about social media intensely, which fired up our defiant posting even more. I made a jacket with '#IranRevolution' on my back and wore it to a Tate private view to raise awareness.

We went to Trafalgar Square each weekend of a hot October; we gathered, making new connections, mobilising. I soon learned many of the flags appearing at the protests: Kurdish, Balochi, Socialist, Communist, Royalist, Sassanian (pre-Islamic Persia). I used my art materials to create a massive banner that avoided partisan colours, painting white block capitals on blue cloth: 'Dictators Are So Passé!'

I did a call-out for a spare broom handle on my street and someone dropped one off, I needed strangers to hold the other side. It felt universal, it felt good. People stared, chuckled, took a photograph – how could they not agree?

I had several art commissions coming to fruition in November and had to make them about Iran. I began using new mediums at my disposal to fit the context. I made a video-piece for the gallery MOCA London using costume, photography, my personal archive: 'A Jineology for Iran'.

After so many months watching and speaking secretly online with kids from mountain towns, I was reminded of the years I had lived and studied in the Himalayas. There I encountered the universal, rebellious mountain spirit, which I discovered also proves

indomitable from the Pennines to the Hebrides, and the myth in the Middle East and Central Asia of the jinn. I performed Sanskrit invocations, which I learned while studying at an Indian music academy. In my introduction to each performance I would remind listeners that Persian is an Indo-Iranian language, as is Sanskrit. It was time to assert the identity of Iran in our public lives.

Many who have been active in London for the Woman Life Freedom movement dug into our and our mothers' wardrobes, to find the symbols of something that we hadn't wanted to parade before: our identity, our distinction from our host countries. We took the press to a London pub to watch the World Cup; we staged a women's football match outside Parliament; we held a silent dramatic tableau in the Turbine Hall at London's Tate Gallery.

Yet at the same time I found myself drawing on what I had learned from British culture. The traditional ballad 'Black is the Colour (of My True Love's Hair)' immediately came to mind when I first saw Iranian young women cut their luscious hair and throw off their headscarves. I used it to create videos about the revolution in Iran. When I heard the song performed at Soheila Sokhanvari's opening for her exhibition *Rebel Rebel* at the Barbican – where I publicly cut my own hair as a defiant, I hoped, viral act – I wept, realising the song was in the zeitgeist.

In October 2022, I sang it at every art opening, at my group show at Gavin Turk's studios for *The Great Imagining*, *Le Son 7* at Club Row during the Frieze art fair week and at fundraising gigs. I introduced the song with a speech on the bravery of the families in Iran who face the vilest totalitarian state imaginable. Yet again I wanted to connect people to, and humanise, the news, and the teary eyes of other nationalities were my recompense.

When my network of arts professionals from wider West Asia did not respond to my media posts, I made a wearable banner: 'The UnIslamic Regime of Iran'. I felt nervous walking around with it on my back (and later on a bowler hat) even when I was inside a rally. I posted a video explaining why we should isolate the regime from other Muslim countries and highlight how it had mechanised and mutated the religion for its own purposes of control. I wanted to promote the hashtag #TheUnIslamicRegimeofIran in case neighbouring countries felt the revolution was an attack on

their faith. We needed them to have confidence in a new Iran and explain the truth that Woman, Life, Freedom is pro-choice and not anti-hijab.

We all have grandmothers and aunties who would still cover their hair in a free Iran without forcing us to.

← The UnIslamic
Regime of Iran,
protest in Trafalgar
Square, London, 1
April 2023. Photo:
Niaz Maleknia.

California Dreaming

Collage art and experience

Marzieh Saffarian
Text by Emilia Sandoghdar

Marzieh Saffarian is a California-based artist whose work is inspired by iconography from the sixties and seventies. Her collages allude to the parallels between a bold, free Californian lifestyle and a pre-revolutionary Iranian culture.

Saffarian not only manages to embrace the vibrant colours and textiles of her Persian heritage through her artwork. She shares her vision with an online audience of followers on her Instagram accounts, PsychPersia and VintagePersia. Her PsychPersia prints have been sold by Urban Outfitters. Her experimental designs from 2016 were some of the first to feature Iranian art history in mainstream US pop culture.

Since the inception of the Woman, Life, Freedom movement, Saffarian has created iconic digital illustrations, which express solidarity with protesters. In 'Azadi (Freedom) Square' she depicts three of the five women dressed in summer tops, all without hijabs, in a hoped-for future summer. 'Squad Goals' shows a group of *jazzab* (Persian street slang for 'attractive') girls imagined on a street of Tehran, through an amalgam of Iran's fanciful and historic pasts. Saffarian's juxtaposition of her two cultures – Iranian and Californian – opens a playful yet important dialogue about women's right to dress and express themselves as audaciously and freely as they wish.

← Azadi (Freedom)
Square, collage.

→ Squad Goals,
collage.

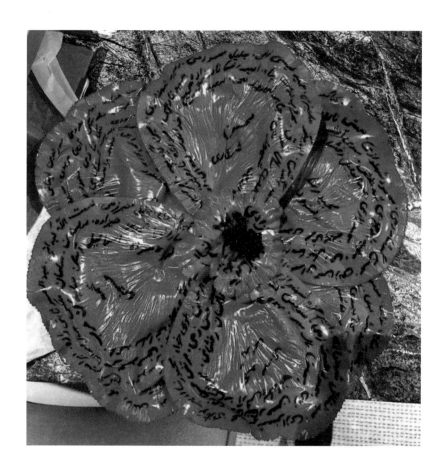

A Beautiful, Tragic Rosette

Tribute to the martyrs of the ongoing revolution

Milad Ahmadi

I was initially approached by my friend and long-time collaborator, the American fashion designer Amir Taghi, to contribute artistically to a look that he was designing for dear Sepideh Moafi[1] to wear at the 2023 Golden Globes, an annual awards ceremony that celebrates the best of American television. Sepideh, an American-Iranian actress, was determined to use the opportunity to make a statement about the atrocities occurring in Iran. It was a particularly harrowing week for all of us as we woke every morning to news of police brutality, rape and executions.

Amir told me that the original, unadorned rosette, which first appeared in his Fall 23 collection, was inspired by a Persian ballad 'Az Khoon-e Javānān-e Vatan' (Tulips Blooming from the Blood of Our Youth). Many singers have covered the song composed by Aref Qazvini (1882–1934) during Iran's Constitutional Revolution (1905–11). However, recently, it has become popular on social media in connection with the women's protests. My role was to help bring its message to life.

1 Sepideh Moafi is best known for her roles in the US TV series, *The L Word: Generation Q* (2019); *The Deuce* (2017– 2019); and *Falling Water* (2016–2018), and in the film *The Killing of Two Lovers* (2020). In Iran, actresses fell afoul of the Islamic Republic during the 2022 Woman Life Freedom protests. In November 2022, award-winning actresses Hengameh Ghaziani and Katayoun Riahi were arrested. They were accused of acting against the Islamic Republic after they appeared in public not wearing their headscarves. Taraneh Alidoosti, from the Academy Award winning film *The Salesman* (2016), was also arrested a month later (see page 184). On her Instagram posts, she had expressed solidarity with the Woman Life Freedom movement and the executed protestor, Mohsen Shekari.

Amir, Sepideh and I brainstormed many different ideas until we finally decided on the one we believed was most poignant: honouring the lives savagely and unjustly stolen during the protests by immortalising their names on the rosette's flower petals. I was able to obtain a gut-wrenchingly long list of over 400 names of people who have been killed or executed during the recent protests from my friend Tara Mohtadi, who works for the human rights organisation Abdorrahman Boroumand Center.[2]

Fashion has always been a very important signifier of change throughout history. It is also a vast industry with undeniable influence on contemporary culture. What better way to draw attention to a cause we care most deeply about than bringing it to life at a prestigious red-carpet event watched by millions around the world?

Art is daring. It can breathe hope into those who struggle to find any, and allows us to imagine what *could* be. It is an indispensable part of any cultural revolution. As an artist and fashion designer, I have made it my mission to use any platform within my reach to shed light on what is happening in Iran. I am deeply grateful to have been a part of this collaboration, which resonated strongly with many Iranians – and non-Iranians – around the world.

Revolution is the epitome of chaos and uncertainty. It comes in waves, some big and loud, some gentle and silent. Both are necessary. What is most important is to believe in our individual and collective powers, and never lose hope.

→ 80th Annual Golden Globe Awards: Arrivals
By Kevin Mazur

2 The Abdorrahman Boroumand Center for Human Rights in Iran is an NGO.
 The full list of names and the circumstances of their deaths were compiled in
 'Iran Protests 2022 – Detailed Report of 82 Days of Nationwide Protests in
 Iran', published 7 December 2022 by the Human Rights Activists News Agency
 (HRANA).

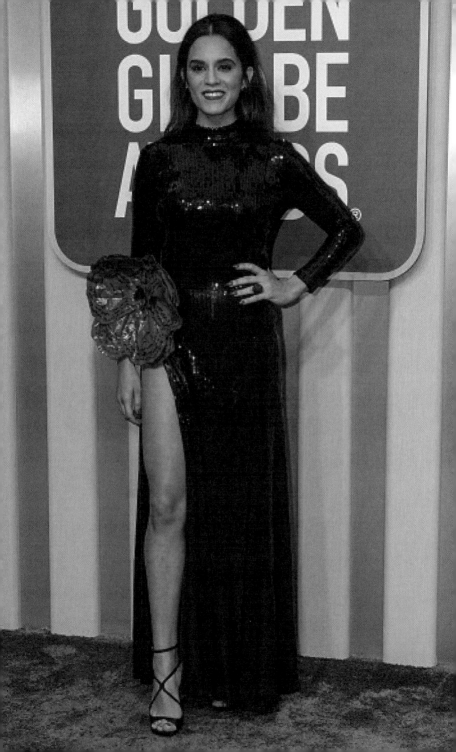

Don't Be a Stooge for the Regime

Iranians reject state-controlled media

Malu Halasa

In December 2022, seven armoured response vehicles filled the streets of a sleepy London suburb after the Metropolitan Police informed Iran International TV (IITV) of a credible and significant threat against two of its journalists. The seriousness of the intelligence prompted UK Foreign Secretary James Cleverly to summon Iran's most senior diplomat to the Foreign Office. The conversation wasn't made public, but the outraged pronouncements of British officials afterwards suggested the UK government didn't take kindly to the intimidation of journalists by a foreign power on its soil.

These days, the twenty-four-hour Persian, non-regime satellite channel IITV broadcasts from behind a fence and three-metre-high concrete barriers, which can stop a seven-and-a-half-ton truck going sixty miles an hour. No cars are allowed in the vicinity; metal detectors, armoured response vehicles and police protect the site. Private security guards control entrances. My name was on a list, and the young man who escorted me to the offices of Volant Media, IITV's parent company, came from the garrison town of Aldershot, which suggested a private security firm with access to freelance British squaddies (soldiers).

Upstairs, Adam Baillie, a news producer who helped set up the channel in 2017, explained that the two threatened journalists, still unnamed, are now under police protection. 'There's low-level harassment against families inside Iran – that's a given,'

he explained, 'The IRGC [Islamic Revolutionary Guard Corps] commander-in-chief Hossein Salami said, "We're coming for you." They've had us under surveillance. Given the opportunity, presumably they would strike.'

The Revolutionary Guards aren't the only ones watching IITV and the other Farsi-language TV channels and news websites, including BBC Persian, Manoto TV and *IranWire*. These channels are all currently based in London, now an important hub for the Persian press outside of Tehran. Since 16 September 2022, when nationwide protests erupted in Iran after the beating and death of twenty-two-year-old Jina Mahsa Amini, increasing numbers of viewers and website users inside the country have deserted state-controlled media to seek news and information elsewhere.[1]

Threats in the past and present colour the experience of Persian-speaking journalists in London. Many take precautions as a matter of course. Some BBC Persian personnel keep their place of work secret. At Manoto TV, phone and email messages go unanswered. The 2009 detainment, arrest and subsequent release of former *Newsweek* reporter Maziar Bahari at *IranWire* are well documented. Along with Voice of America (VOA) Farsi in Washington DC and Radio Farda, part of Radio Free Europe/ Liberty Radio service in Prague, the international Persian-language media outlets, which beam into Iran, pose an existential threat to the Iranian regime. The government's pushback is an indication of how seriously Tehran takes the information war over the hearts and minds of ordinary Iranians.

A female broadcast journalist who fled the country last year requested anonymity before speaking with me. 'Iranians have more trust in a video or photo they see published on Instagram or Twitter than any media related to the government,' she said, 'and they tend to search for news in other countries.' She was also keen to stress that none of the Persian news networks have correspondents or reporters inside Iran. They too are reliant on the news that Iranians at home post on their Instagram accounts.

1 The migration of Iranian audiences from state media to media outside their country mirrors a similar journey made by a young generation of Syrians away from Assad-controlled media and news during the 2011 Syrian Revolution.

IITV's Baillie agrees. The channel relies on UGC (user generated content) in addition to the informal connections of the channel's 350-strong staff inside the country and their reporters living outside. The channel also broadcasts from Washington DC, with journalists covering the United Nations in New York and the IAEA (International Atomic Energy Agency) in Vienna. 'Our mission is not to foment revolution or pick and choose stories that are uncomfortable for the authorities in Iran. As an independent news channel, we mirror back to Iran what's happening in Iran, and Iran-related, international stories.'

On Saturday morning, few seats are empty in front of the array of computer monitors on row upon row of long tables, which fill an open-plan newsroom. Screens on the walls broadcast IRIB (Islamic Republic of Iran Broadcasting). At one end is a television studio. Sombre in black, anchor Parisa Sadeghi prepares to go on air. She sits in front of a larger-than-life screen image of women protestors holding each other's hands in the air.

Recently news inside Iran's corridors of power has been coming from Black Reward, the Iranian hackers' group, which introduced itself on Telegram in October 2022 with a spectacular treasure trove of documentation from the country's nuclear agency. In October, the group sent an SMS message to five million Iranians, calling them out onto the streets.

Baillie said nobody at the channel knows them. However, the group is a professional outfit and not made up of 'teenage activists'. Because of the channel's popularity inside Iran, IITV has become the hackers' 'first port of call' and, he stresses, 'that's not at our behest.'

Last month, the group released an audio file of a meeting between the Basij commander and IRGC's General Salami, and a treasure trove of archival material from the regime's propaganda arm, Fars News Agency. Dubbed 'Farsgate' at IITV, the hacked emails revealed the pressure Iran brought to bear on Qatar during the 2022 World Cup to cancel the official FIFA accreditation of the channel's sport reporters, which barred them from the event.

The Iranians also reminded the Qataris that the border with Iran was only forty miles away and, if the channel's reporters did

come, they might be persuaded to 'prolong their stay' in the region – i.e. be kidnapped.

Before the Netherlands versus USA game, Baillie introduced me to a roomful of IITV sports reporters. When I asked if they were upset not to be in Doha covering the World Cup, one cried out, 'Better to be alive!'

IITV has eleven million followers on Instagram and features stories that don't find a home on family-oriented channels like Manoto, which means 'you and me' in Persian and has been known to broadcast lengthy documentaries on the Shah's wife, Empress Farah. The different audiences of Persian media outlets are reminiscent of the division between the sensationalist *New York Post* and the more traditional *New York Times*.

The hackers' collective Black Reward leaked security camera footage inside a Fars News Agency office. The video shows an editor locking the door to his office, then proceeding to smoke cigarettes and eat crisps while surfing the net and jacking off. The footage went viral. It was one of the most read stories trending among readers of IITV's English-language website, which closely mirrors its Persian site.

This channel and the other Persian media organisations are not inexpensive propositions, and the sources of their funding have made them vulnerable to criticism. The British Foreign Office funds BBC Persian, as does the US government for VOA Farsi and Radio Farda. A British-Saudi businessman funds IITV, which was accused by *The Guardian* of having ties to the kingdom's ruler, Mohammed bin Salman.[2] These allegations were strenuously denied by the channel and its then parent company, DMA Media Limited.[3] Today IITV is owned by Volant Media UK.

'There is no editorial interference,' shrugged Baillie. 'No hotline between us and anyone else.' To prove his point, he turned to the channel's coverage of the murdered Saudi dissident and journalist Jamal Khashoggi. IITV broadcast the first interview with Agnès Callamard, the UN Rapporteur on extrajudicial executions. 'If

2 Saeed Kamali Dehghan, 'Concern over UK-based Iranian TV Channel's Links to Saudi Arabia', *The Guardian*, 31 October 2018.

3 *Ibid.*

anyone was pulling our editorial strings, they'd make us cover the story in a different way.'

Three months later, IITV closed its London office and moved its operations to Washington DC out of concern for its journalists. The Met Police revealed it had foiled fifteen plots to kidnap or kill individuals considered 'enemies' of the Iranian regime.[4]

Breaking the News in Tehran, from London

A *New York Times* report on the shutting down of Iran's Morality Police,[5] responsible for policing Iranian women, suggested the regime had made a concession to the protests. But Iranians on Twitter and Middle Eastern news outlets criticised the analysis. The next day the *New York Times* backtracked by publishing another article[6] explaining why 'the concession' might be a red herring. The newspaper's coverage of Iran was a lesson on how *not* to be a stooge for the regime at a time when women protestors are being shot in the face and genitals.[7]

The website *IranWire* breaks important stories by forensically dissecting events inside the country, finding and checking sources and understanding the regime's *modus operandi*. The platform's work has not gone unnoticed. Last year, the *Washington Post* called it 'an essential player using technological savvy and Internet sleuthing.'[8]

IranWire's Aida Ghajar was the first reporter to write about Jina Mahsa Amini's death after seeing tweets from initially unnamed and

4 Mark Townsend and Geneva Abdul, 'Met Police and MI5 Foil 15 Plots by Iran against British or UK-based "Enemies"', *The Guardian*, 18 February 2023.

5 Vivian Yee and Farnaz Fassihi, 'Iran Has Abolished Morality Police, an Official Suggests, after Months of Protest', *New York Times*, 4 December 2022.

6 Cora Engelbrecht and Farnaz Fassihi, 'What Does Disbanding the Morality Police Mean for Iran?', *New York Times*, 5 December 2022.

7 Deepa Parent and Ghoncheh Habibiazad, 'Iranian Forces Shooting at Faces and Genitals, Medics Say', *The Guardian*, 8 December 2023.

8 Pranshu Verma, 'Reporting in Iran Could Get You Jailed. This Outlet Is Doing It Anyway', *Washington Post*, 22 October 2022.

then named sources, both inside and outside the country. The trail Ghajar followed led to Mahsa Amini's brother, who told Ghajar: 'I have nothing to lose. Please use my name in the report.'[9]

The story so outraged the Intelligence Organisation of the IRGC and the Intelligence Ministry that two women journalists with no connection to *IranWire* other than they were covering the story in Iran were arrested. The jailing of Niloofar Hamedi from *Shargh* newspaper and Elaheh Mohammadi from *Ham Mihan* prompted *IranWire* to post: 'How Did *IranWire* Publish the First Report about Mahsa Amini?'[10]

In it, Ghajar revealed the extent of her reporting, while *IranWire*'s Persian editor Shima Shahrabi shed light on the website's verification process. One of Shahrabi's contacts was a 'former police employee who still maintains special relations with the police …'[11]

IranWire's editor-in-chief Maziar Bahari was also quoted in the piece: 'For the safety of professional journalists in Iran we never contact them. However, we are in contact with many citizen journalists, and they help us in our reporting, including when we report on breaking news.'[12]

Bahari and I have known each other since the late 1990s. He took a copy of the anthology we coedited together, *Transit Tehran: Young Iran and Its Inspirations*,[13] when he went to cover the disputed 2009 presidential elections in Tehran for *Newsweek*. The book's launch, an exhibition and a documentary film festival at the London School of Economics took place during his 118 days

9 Aida Ghajar, '*IranWire* Exclusive: Morality Patrol Beats a Woman into a Coma', *IranWire*, 15 September 2022. Ghajar joined actress and rights activist Nazanin Boniadi onstage, in Washington DC, on 9 May 2023, to accept the second 2023 Freedom House award given to the women of Iran, in recognition of their 'unwavering commitment and activism to advance democracy and freedom'. In her speech, Ghajar mentioned Iranian women reporters Niloofar Hamedi, Elaheh Mohammadi and Narges Mohammadi. Others, Mehrnoosh Zarei, Nasim Sultanbeigi and Saeideh Shafie remain under prosecution.

10 *IranWire*, 10 October 2022.

11 *Ibid*.

12 *Ibid*.

13 Malu Halasa and Maziar Bahari, *Transit Tehran: Young Iran and Its Inspirations* (Garnet Publishing, 2008).

in solitary confinement in Evin Prison.[14] Following his release, he started *IranWire* in 2013. The site publishes in six different languages – primarily Persian and English, alongside Kurdish, Azari, Arabic and Spanish. The platform has a reach of seventy million people, with 90 per cent of its readership inside Iran. Around 65 per cent are between the ages of eighteen and thirty-five.

Since Mahsa Amini's death, *IranWire* has experienced a 225 per cent increase in users, with approximately 200 million monthly online impressions, which refers to when a user follows through and clicks on a website.

Other than reporting, professional journalists at *IranWire* have another *raison d'être*. They act as mentors for citizen journalists inside the country. Bahari explained in an interview, 'It's mentorship about storytelling: character development and context. Even news pieces have to be a character-based story. So basically, you're asking people to tell a story when they send in an article or news piece or a video.'

IranWire places a strong emphasis on human rights. 'We try to be correct and accurate, but at the same time we don't pretend to be neutral,' maintained Bahari. 'We are very pro-human rights. We also think about our articles, videos, any of our content, as advocacy tools for activists. So when activists want to raise the issue of, for example, the killing of children in Iran, we want to do a report that activists can use. It's always in the back of our minds. We have that mandate.'

Mandates differ in the Persian media outlets in the West. BBC Persian, the best-known foreign media brand in Iran, has 13.8 million viewers on average each week across TV, radio and digital platforms. It prides itself on impartiality, a stance explained on Twitter, in Persian and English. 'Our sole aim is to report the truth about Iran in an independent and impartial way …'[15] Yet, in the current climate, some Iranians prefer that a side be taken – understandably against the regime.

14 Maziar Bahari with Aimee Molloy, *Then They Came for Me: A Family's Story of Love, Captivity, and Survival* (Random House, 2011). Also see the film based on Bahari's memoir, *Rosewater* directed and produced by Jon Stewart (2014).

15 BBC News Press Team, 'Statement on BBC Persian', Twitter, 19 October 2022.

For Bahari, the impartiality of BBC Persian shows its 'professionalism'. More importantly, the ongoing protests have strengthened the links from inside to outside of Iran.

He explained, 'It's a two-way connection. We're inspired by what the people are doing [there] and how they get information and use websites to communicate with each other and the rest of the world.'

But connectivity relies on access, and the Iranian government has been adept at slowing down internet accessibility. As Bahari outlined, 'Internet censorship happens on several different levels of Iran. They narrow the bandwidth, so people have slow connections. Sometimes they cut the national internet so people don't have access to sites that require a cloud like Google, Twitter or YouTube etc. Sometimes the national internet connection is shut down. So even government offices and ministries cannot communicate with each other.'

The level of control depends on the unrest. In north-west Kurdistan, for instance, the government closed phone lines when the fighting intensified. However, the Kurds still had access to phone signals, which they could pick up across the border from Iraq.

Dodgy VPNs

Hooman Askary, the senior social media producer at Radio Farda – which means 'tomorrow' in Persian – monitors internet speeds and disruptions in Iran. Farda is one of twenty-seven language services that Radio Free Europe/Radio Liberty broadcasts to twenty-three countries that stifle press freedoms. By blocking access to Instagram, the Iranian government impedes communication between its citizens inside the country and slows down dissent.

'If you look at the mobile phone of the typical, middle-class Iranian you would find all sorts of messaging applications,' said Askary. 'Just in case one of them doesn't work, they try another one.'

To keep communicating, Iranians download VPNs (virtual private networks), which they switch between. Askary cited former

Iranian leader, President Ahmadinejad: 'He was asked about the internet filtering in Iran and laughingly he said, "The internet is not filtered in Iran because those who block and filter internet sell anti-filtering software themselves."'

VPNs have become a lucrative business in Iran. 'If you don't get your VPN from a trustworthy source,' Askary noted, 'you are not able to tell as a common internet user that your data is safe and is not being sent elsewhere using your very own internet connection.'

He recalled one of the government's tactics during the cost-of-living demonstrations that took place in December 2017. After Telegram was blocked, a few versions of Telegram emerged on the internet. Through an application called 'Golden Telegram', a user could access all the material from Telegram but only through the filtering, monitoring and surveillance of the intelligence organisations. Again, Black Reward provided real insight into the Islamic Republic's thinking. Askary translated one of their hacked bulletins into English, which he sent to his colleagues at Radio Farda that morning.

'According to the result of a recent survey by the Ministry of Interior, 25 per cent of people inside Iran get their news and information from state television and radio; 24.6 per cent receive their information vis-à-vis from the news of social media; 16.4 per cent from satellite channels; 11.1 per cent from their friends and 6.4 per cent from websites and other news media.'

He went on to say, 'They have not mentioned the remaining percentages, but the figures are quite significant. They are in effect admitting that the number of people who receive their news from state television – with all the budget [and] funding [that goes into a] huge network all around the country – is almost the same number as Iranians who receive their news from social media – and this is according to the very sources of the Islamic Republic.'

He drew an analogy between Iran now and the Arab Spring. Egypt's was called the 'Twitter Revolution'. Even though the country's literacy rates were not high, the people who had access to Twitter were the ones who influenced their family members, peers and social groups. 'So you have to remember that this 25 per cent in Iran who receive their news from social media are mostly the young generation, the educated. Each one has a

social network around them. The actual percentage of Iranians influenced by social media should be much higher [than statistics provided by the Islamic Republic].'

Iranians on the street have made no secret of the fact that they have been let down by their state media. One of the slogans shouted during the demonstrations has been: 'Our shame, our shame – state television and radio.'

Some of those who watch Iran from afar believe the current protests are different from those that have come before. Bahari, from *IranWire*, called them 'the most seminal in the past four decades,' while Radio Farda's Askary wondered out loud if the smaller demonstrations, which have taken place in the country over the past five years – of retirees, teachers, factory and oil workers, students, among many others – were just a warm-up to the present-day unrest.

Askary asked, 'Unwittingly, did the Islamic Republic teach and train people in mastering the art of protest?'

Speaking from Prague, he told this story: 'At the beginning of the Islamic Revolution, supreme leader Ayatollah Khomeini famously said, "My soldiers right now are in cribs," referring to the children who were born just after the revolution. Those very children turned into us. We did not manage to topple the regime. Many of us left the country. Many of us died. Many of us are being crushed inside Iran under the pressures of daily life.

'But this new generation,' Askary concluded, with an ominous tone in his voice, 'they didn't turn into his foot soldiers.'

→ A uniformed vice squad officer removes one of thousands of illegal satellite dishes from a rooftop in Tehran. The other officer finalises the paperwork for the fine the owner will pay for possessing it. Photo: Peyman Hooshmandzadeh.

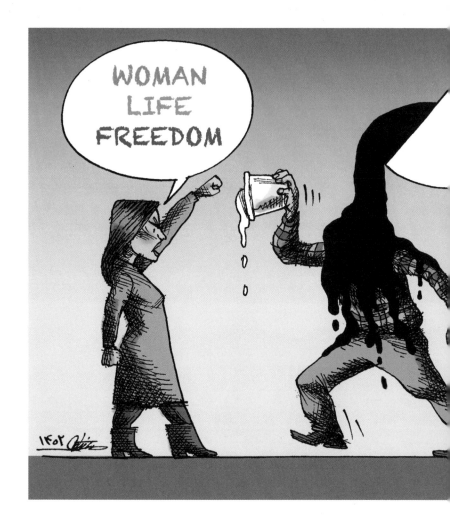

Drawing the News

Editorial cartoons in the age of censorship

Mana Neyestani

← Yoghurt Attack, Man Throws Yoghurt at Two Unveiled Women in Iran, Reuters, YouTube, 2 April 2023.

In April 2023, a viral video on social media showed two young women waiting to be served in a busy yoghurt shop in Iran. A man in a chequered shirt enters the shop, sees that the women are not wearing hijabs and becomes agitated. He scolds the women - although the audio is unclear on the CCTV footage. The women turn away. The man reaches off camera for pots of yoghurt and throws yoghurt on the head of one woman and then on her companion's. An enraged shopkeeper comes out from behind the counter and forcibly pushes the man through the doorway, out onto the street.

↑ 'Blinding As a Weapon of Suppression in Iran: Special Report', from *IranWire*, 14 March 2023.

Iranian security forces are targeting protesters with shotgun or paintball gunfire to their faces, inflicting them with severe eye injuries. The victims say they don't regret protesting against the Islamic Republic.

→ 'For Taraneh Alidoosti', from *IranWire*, 22 December 2022.

Iran's clerical regime arrested prominent actress Taraneh Alidoosti on 17 December 2022 after she expressed support for the nationwide protest movement. Local media reported that Alidoosti, was accused of 'publishing false and distorted content and inciting chaos'. The actress posted a picture of herself on Instagram without a headscarf and holding a Kurdish-language slogan of the protest movement reading 'Jin. Jiyan. Azadi' [Woman Life Freedom].

Creating sketches and cartoons about Iranian women's rights and associated issues is not a new aspect of my work. I have been addressing these issues almost since I left Iran, when I was no longer under the pressure of censorship. What has happened now is that the demands of women have become more radical, more men have joined them and there is a more serious national will to bypass the Islamic Republic regime, one of the main obstacles to gender equality. Patriarchal and masculine culture still prevails in parts of Iranian society, but not to the scale it was in previous decades; it has improved a lot.

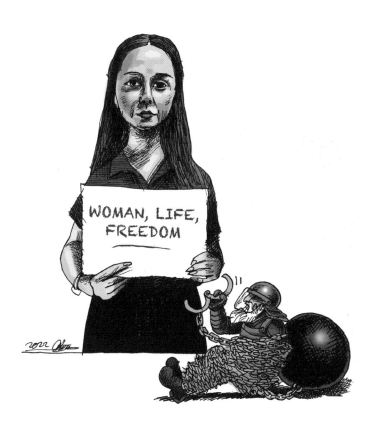

Iranian men and women – especially women – no longer obey the discriminatory laws but defy them. This development has brought with it real hope, not illusion. This radicalism and hope have probably found their way into my drawings as well.

I drew an editorial cartoon about pouring yoghurt, which was published on the Persian *Deutsche Welle* website. Here, the one pouring the yoghurt is portrayed as the victim of brainwashing and 'thought pollution' by the mullahs, a symbol of religion, especially politicised religion. The subject and theme of my works often come from current events or the current atmosphere in Iran. This can be general, such as commenting on the 'mandatory hijab', or specific to an event, such as the arrest of the Iranian actress Taraneh Alidoosti. The way I respond to a topic or theme depends on the type of event and the inspiration I get from it.

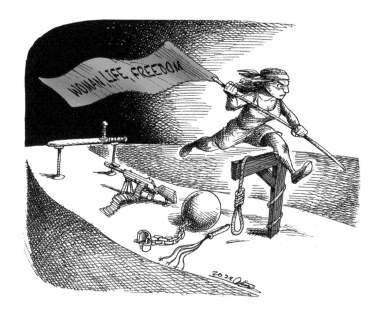

↑ 'For Mohsen Shekari', from IranWire,
8 December 2022.

← 'A Historic Struggle', from IranWire,
14 December 2022.

Iran's clerical regime hanged Mohsen Shekari, the
first known execution connected to the ongoing
nationwide demonstrations.

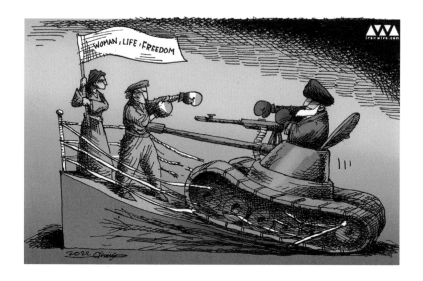

↑ 'Khamenei vs Kurdistan' from *IranWire*,
22 November 2022.

People in the western Iranian province of
Kurdistan have been resisting the Islamic
Republic's brutal crackdown on popular protests
against the clerical regime.

Browsing news and events on the internet is one of my daily tasks to get ideas. Editorial cartoons are produced based on news, so there must be reliable sources that can be verified. The cartoonist is not a reporter; they do not prepare or confirm the news. This is where the role of free media outside the country – such as *IranWire* – becomes important. I draw my cartoons based on the news prepared and approved by them. My work can then help to spread that news. Many people save the cartoons separately and send them to each other.

Social media has allowed the audience to play a very different role in my professional work. Before the internet era, contact with my audience was very limited; now hundreds of comments are posted under each of my Instagram posts and I receive dozens of private messages. This is both good and bad. I am more aware of what society thinks about my work. At the same time, it is possible that the psychological pressure of the audience, who don't always agree with my cartoons, causes mental weariness or forces me to self-censor, especially when group cyber-attacks take place. These days, I have to constantly ask myself, 'Have I done this based on my true beliefs?' – to make sure I have not done it for 'likes', to attract attention or escape from criticism.

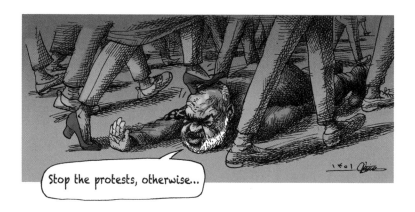

↑ 'The Guards' Ultimatum', from *IranWire*,
4 November 2022.

As an artist, it is your choice to limit yourself to a simple joke that reviews a news story in your editorial cartoon work, or to go beyond that, by strengthening and spreading a belief and delving deeper into an issue. Maybe if I worked on a cartoon about an issue in the US or Sweden, my work might convey a superficial joke and news review. But when I work on Iran, where I have lived, I feel the problems and wounds in a visceral way. This sensitivity and familiarity show in my ideas. I don't believe that the cartoonist educates society; no, they share their views and perceptions of what's going on in a language of humour; a view alongside other views. This exchange of views can emancipate everyone, including the cartoonists themselves.

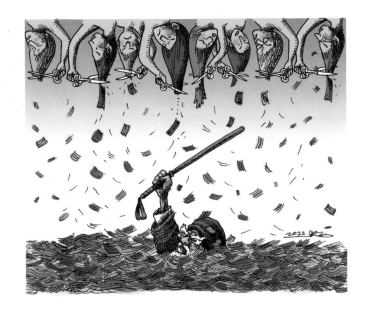

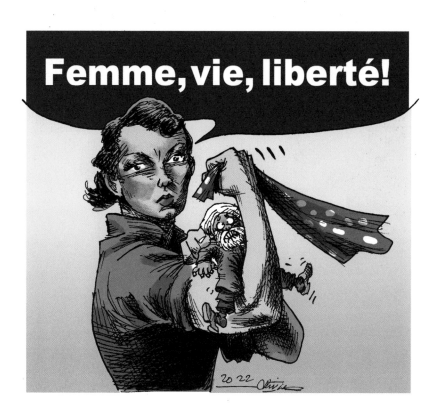

↑ 'Iranian Woman Can Do It!' (Rosie), from
IranWire, 5 October 2022

← 'The Drowning Master', from IranWire,
6 October 2022

As protests against mandatory hijab and the
Islamic Republic itself extended into their
third week in Iran, one of the most visible and
dramatic acts of defiance was the act of women
removing their headscarves and cutting their hair
in public. Despite repeated violent crackdowns on
the protests, Iranians still took to the streets
and cried, 'Death to the Dictator!'

↑ 'Remembering Mahsa', from IranWire,
16 September 2022

← 'Freedom of Choice', from IranWire,
21 September 2022

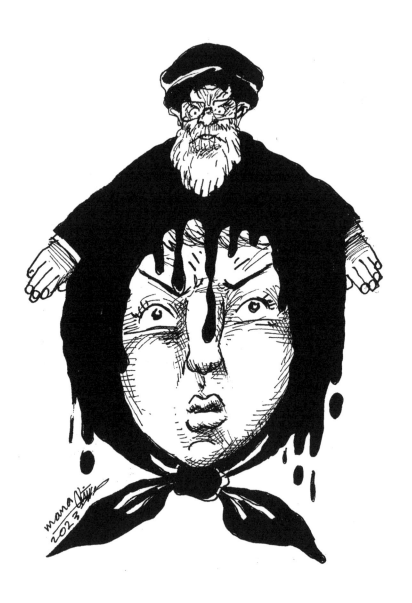

If one feels that the influence of political art is stronger in Iran than in Western countries, it is only because of Iran's closed political system. In fact, cartoons, graffiti, photographs, to name a few, are the only ways to 'breathe'. They reflect the critical opinion of the people, which is not represented by official media. In the West, there are hundreds of open paths to disseminate information and create change in society. Hundreds of newspapers and magazines and private television channels freely publish their opinions and there are numerous political parties and groups. Cartoons alone aren't supposed to bear the burden of all these responsibilities. For me, the power and importance of cartoons in countries such as Iran is not a good sign!

← 'Compulsory Hijab', from *IranWire*, 28 June 2022.

In summer 2022, senior clerics used their Friday sermons to demand a crackdown on women practising so-called 'bad hijab' in public. The ravings of these elderly, conservative men enabled fresh crackdowns on mixed-sex gatherings, detentions of innocent women and girls, and even the forced 'alteration' of women's headstones in Tehran to make them appear fully veiled. Mana Neyestani depicts the suffocating atmosphere created for female citizens and suggests it's the imams who parasitically need hijabs, not the other way around.

The captions accompanying the editorial cartoons published by *IranWire* are also from the website.

The One Who Must Walk on Foot

Reflections from Iran on the uselessness of pity

Habibe Jafarian

My mother, a seventy-six-year-old woman from the outskirts of Nishapur, in the north-east of Iran, has a rudimentary knowledge of the alphabet and is just familiar enough with numbers to be able to call any one of her six children and read them the digits on her blood pressure monitor. She is also the most fervent feminist I know. Hers is an instinctive feminism born of the village: no nonsense, resolute and geared for survival. The other day, this woman happened to catch sight of my phone as I watched a video of a famous French actress cutting off some of her hair in support of Iranian women repudiating the forced wearing of the hijab.

'Who is that?' she asked. I told her.

After a short, pensive pause, my mother whispered a well-known Persian saying: 'The full-bellied traveller knows nothing of the one who is hungry, and the rider on horseback knows nothing of the one who must walk on foot.'

My country is living through some of its toughest times. Such a sentence for a Westerner might be no more than a news headline, a curiosity, or at best a gesture of civic responsibility towards the other. For me, however, it is the essence of the forty odd years that I have spent on this earth. As far back as I can recall, Iran has been experiencing tough times. I was barely four years old when the revolution happened. In my first days of school, Saddam [Hussein] began bombing Iran, and the ensuing war of attrition lasted until I was well into my fourteenth year. Whenever people

asked my mother when she would marry me off, she'd shoo them away and say she was going to send her daughter to university. At the time, my older brother was in Afghanistan with the Northern Alliance, holding off a brutal and misogynistic Taliban regime that only last year came back to power, courtesy – among others – of the United States. As I was getting ready to head to Tehran for university, the first woman in my family to do so, my brother sent me a long note from across the border. 'Sister,' he wrote, 'live your life to the fullest, but remember that you are not packing your things for the capital as a tourist. So always pay attention to the good and the bad as they race past you at the speed of light in that harsh city. And as you grow older and wiser, and come to know the world's corruption first-hand, be sure to never, ever rely on the pity of others for anything.'

We Iranians belong to a part of the world where the pity of others is of absolutely no use. Life in Mesopotamia and its environs, the so-called cradle of civilisation, is always in turbulence, always going through some form of revolution. The saying *'Life is short'* is not a metaphor here; it is life itself. We have always been walking on foot, as the proverb goes, and seldom have we received anything of real value from the rider who happens to be passing by. This makes it not interesting, but rather tragic, to hear and read the opinions of others living thousands of miles away, weighing in daily about the courage of Iranian women or the unfortunate but necessary economic sanctions imposed on Iran. If you want to see the effectiveness of harsh economic sanctions on Iran, come to my neighbourhood in the Navab district of Tehran and watch from my window as every few minutes a young boy searches knee-deep in the garbage dump for something to salvage. Often those talking heads overseas are Iranians themselves who have either not been here in decades, or pass through once in a while and imagine they have their finger on the pulse of the country.

Even the taxi driver who was taking me to a physiotherapy session the other day can see the gulf between our reality and the assessments abroad. He notices the cane in my hand and asks, 'Did you hurt yourself in the demonstrations?'

'No, I twisted my ankle two or three months ago.'

'A twisted ankle still bothering you after two, three months?'

'It's because I didn't walk on it and it got worse. I got scared of the pain. I kept thinking, if I walked, I'd twist my ankle again. How about you? Did you go to the demonstrations?'

'I drive by now and then in this old taxi of mine and take a look around. That's about it. We already did our revolution, Madam. The one in '79. And you know what? We're still paying for that one.'

He assumes that perfect knowing look which Iranian taxi drivers have turned into an art form and – in his Azeri Turkish accent from the north-west of the country – he adds, 'A revolution whose spokespeople are a bunch of folks living in America and Europe, in homes that you and me wouldn't dare dream about. What kind of a revolution is that? Give me a break.'

By now the car is at Revolution Square, near the University of Tehran. A young woman with a headful of long curly hair and not a shred of a hijab is strutting past a train of anti-riot police who pretend they are busy on their phones and don't see her.

'That girl sure is fearless,' I tell the driver.

He says nothing and remains quiet for a long time. As we are nearing my destination, he suddenly speaks up. 'You know how your foot will get better, Madam? You have to get your friends to drive you somewhere far away, to the middle of nowhere, and then let you out and leave you there. That's when you'll finally overcome your fear of pain and walk all the way back home on your own.'

His words remind me of that letter from my brother years earlier: *Never, ever rely on the pity of others*. But I am also reminded of my mother. Five years ago, she broke her wrist. It was her left hand, and being left-handed she was unwilling to have surgery on it. In fact, in no time at all she had removed the cast the doctors had put on her. For weeks afterwards, she'd address the hand, talking to it like an old friend: 'You and I, we only have each other. Our friends and our children, they're only with us for a short while, and then they get on with their own lives. All that's left at the end of the day is you, me, and this pain we share. It is what it is. Pain is the lot of us humans.' Then she'd quote Rumi – the towering poet of our own Khorasan province:

In pain there is advantage, because
Fire is the only cure for pain that knows no pain.

It is this devastating practicality – hard-edged and merciless, insightful and real, free from the fleeting solidarity of others – that I think of as the singular path that allows us to endure in this geography, the envisioned cradle of civilisation.

Translated from Persian

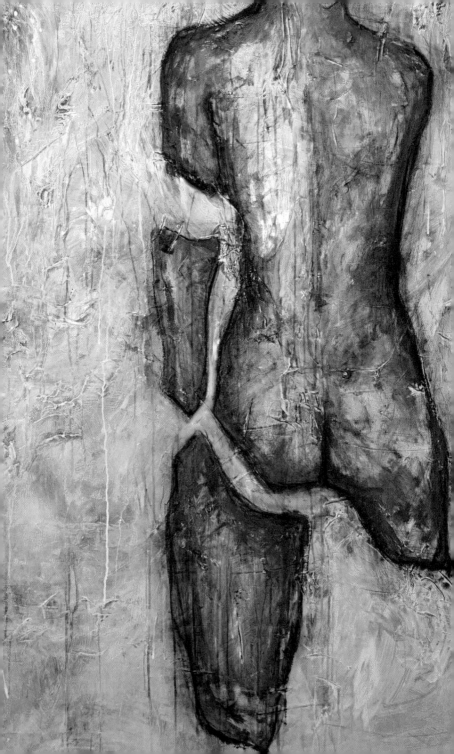

Fragmentation

Art and life practice

Tasalla Tabasom

My personal journey with fragmentation has been deeply rooted in my own experiences of familial separation and the contrast between my upbringing and societal expectations. Fragmentation, defined as the process of breaking down an entity into separate parts, has been a recurring theme in my artistic exploration of the human form. As an artist, I have focused my visual work on the superficial aspect of the human organism, specifically the form of the human figure.

The first major experience of fragmentation in my life occurred when my parents divorced, which was prolonged for over seven years due to the patriarchal justice system in Iran. As my mother was the one to initiate the divorce, she did not have the legal right to do so, leading to a loss of connection with my father and his family. This personal experience deeply impacted my understanding of separation and the ability to rebuild a new sense of self, as well as the complexities of gender and societal norms.

← Tasalla Tabasom, Parts.
Mixed media on canvas, size
180 x 140cm, 2023.

The body has always intrigued me in its raw and nude presence.
The flesh behind the hijab, that thing we were preserving for
the heavens. At school, our life drawing models were always fully
dressed and usually in uniform. My early drawings were rejected
and censored at school. I remember showing my teacher a drawing
of a naked woman I was really proud of. I had just entered school
at that point, maybe around seven or eight years old. She told
me, 'How come you don't draw clothes for her?' She walked
away holding her veil around her body. This is probably the first
feedback I received about my art. I felt challenged. It felt good in
an indescribable way. Of course, I kept painting more nude figures
religiously; it was in a way my silent protest.

In my practice, I manipulate the human form, fracturing each
body part into distinct entities with individual functions. This

process is not only an artistic expression but also serves as a reflection of my personal experiences, where I have observed the patterns of fragmentation in nature and society. Growing up in Iran, my exposure to subcultures, translated literature, American movies and English lyrics kindled a desire to explore life outside Iran. This desire was further amplified by the oppressive Islamic government, which limited our individual expression and freedom.

My friends and I struggled with conformity and the need to hide our true identities. We felt depressed. We were queer but in secret. We partied in secret. We could never see our favourite bands or wear our favourite tops out in summer. We were hot. We swam with full hijab in the sea. The move to London has been a turning point in my life. My mother made the decision due to difficulties with the authorities in Iran. It took us years to financially prepare but, in the summer of 2018, we arrived in London.

I was amazed by the opportunities that were available to me. The city's vibrant arts and culture scene provided me with a sense of liberation that was previously unimaginable in Iran. I revelled in the ability to create without fear of censorship or persecution. However, this short-lived freedom changed when I experienced the limitations of a white male-dominated industry as a queer Iranian. Despite this reality, my artistic practice remains a vital tool for me to question life and find answers.

On the Pain of Others, Once Again

Hashtags for an ill-fated geography

Sara Mokhavat

I am thirty-seven years old. My late teens to early twenties were an endless scuffle with a regime that wouldn't leave me in peace. For around forty years, this country has been in various states of emergency. We came of age during crises, we fell in love during crises, we went to work during crises and we lost our jobs during crises. And each time they expected us to shut up and get on with it.

Lately, though, the crises have worsened and become more frequent. There's hardly enough time to get up in the morning, look at oneself in the mirror, take a breath, and try to fathom the source of those bloodshot eyes before some new emergency is hurled one's way.

Apparently, the world has heard our voice this time. At least that's what we're told. We ourselves are too exhausted, too anxious, to sift the truth from the propaganda. In other countries they now repeat the refrain borne of the streets of Iran: Woman, Life, Freedom. Of course this makes us happy. At least for a few minutes. Then again, the world is always advertising itself, isn't it? I believe in English they call it making a *gesture* … some kind of statement – the one-upmanship of 'the haves' of this earth in their postures of sympathy with a victim, or victims, of the same planet whose heart-rending videos happen to have gone viral.

Lately, for instance, celebrities seem to want to post stories on Instagram about our protests. I happened to see a video of several well-known French actresses cutting off bits and pieces

of their hair to show their sympathy for the women of Iran. In one video Juliette Binoche – who is especially beloved by Iranians for her work with the late great Iranian filmmaker, Abbas Kiarostami – cuts off a piece of her hair, holds it up to the camera, and declares, 'For freedom'. She is smiling and there is something sweetly mischievous in that smile of hers. Other actresses follow: Marion Cotillard, Isabelle Adjani, Isabelle Huppert … I swallow the lump in my throat as I watch all of this unfold. I laugh uneasily. The first thought that comes to my mind: *I wish I had these women's lives.*

With my friend Elham, we watch the avalanche of videos again and again, and this time we are laughing. Elham says, 'How happy they seem. How satisfied.' After a pause she adds, 'I despise how complicated our lives are compared to theirs. They look so free, don't they? So cheerful. Go ahead, then. Go ahead and cut off a little of your precious hair for the women of Iran.'

I wish I could be thankful. Instead, these days more than ever, I think about the divide between us and them. A divide that can hardly be measured. Somehow there is perfection to every display that they grace the world with. Meanwhile – here in Tehran and the rest of the cities of this ill-fated geography – we remain out of focus, muffled and inundated by the background noise of all that is bound to crush us. I would like to call Juliette Binoche on the phone and say to her, 'You are not going to heal our broken bones with a few strands of your hair. It is not possible.'

I would really like to be more appreciative of these expressions of sympathy. But what good is sympathy to me when the times we live in make it so easy to witness pain from a safe distance online? How do I respond to compassion when it is in fact all about some famous actress in Paris or Los Angeles rather than about young women, girls really, thrown to the dogs in the streets of the Middle East?

In my worst moments, my own empathy escapes me, and I imagine many of these perfect women spending their mornings saying things like: *Darling, bring your phone over and let me cut off some hair for the sake of the women of Iran. Can you believe it? They killed a twenty-two-year-old girl because of her hijab. I hate these fascists! Anyways, what's new with you? Did you and that piece of garbage film director reach an agreement at last? And these almond croissants, aren't they devilishly good?*

I want to scream like many have screamed before me: I am George Floyd, the Black American man killed by the police in 2020. It may sound too easy, but there it is: I am George Floyd and I am dying under a four-decade-and-counting chokehold, telling the world that I cannot breathe.

And what does the world do? It makes a hashtag for me and then it moves on:

Dear Sara, we honour your courage. Hang in there. You're strong. During our morning jogs and when we're at the gym and when we're on vacation with our lovers, we remember you. Honestly, we do. We remember that you've spent days and months and years with your neck pinned under somebody's boots, unable to breathe. Poor you! Unbelievable, your endurance. Your courage. You may be a punching bag, but you sure can take a lot of hits. Bravo!

Last time one of us was walking by you, you were giving us a different look though. It felt as if you wanted us to cross the street and give a shove to the guy who was strangling you. You wanted us to scream at him and punch him hard. But … my dear, you know this is simply impossible. Truth be told, your pain is not our pain and we're kind of busy, you know. But we're glad to do another hashtag for you, how's that?

Hopefully one day they'll let go of your neck too. We look forward to that day and we send you our love. We kiss your bruised neck, and your bruised back, and your bruised life. And, yes, we may cut off a bit more hair for the sake of the cameras, so you won't feel totally alone.

Translated from Persian

Lessons from My Grandmother

Education for women across three generations

Vida Zarkeshan

In 1949 a young woman left a large home and comfortable life in Mashhad and moved with her fourteen-year-old daughter nearly 500 miles away to the larger, unfamiliar city of Tehran.

In Mashhad, there was primary school from first to sixth grade and high school from seventh to twelfth grade. Families who could afford the tuition sent their boys to school. However, many families didn't have the money, conscientiousness or understanding to educate their girls, even to primary school level.

The young woman, the second wife in a traditional Islamic marriage, watched her stepsons finish high school. Some then went on to university. She didn't know if girls were even allowed to attend university, but she knew she wanted her daughter to have the same opportunities as her stepsons. When her husband informed her he would not allow their daughter to go to Tehran to live by herself and continue her education, the mother decided that she and her daughter would move together, surviving somehow on the slim allowance the girl's wealthy father gave them.

In the capital, the question for many families wasn't whether their girls should go to high school, but which high school they would attend. The woman's daughter completed high school and continued to university. Her mother insisted she choose for herself what she wanted to study, how she wanted to dress, what work she would eventually do, whom she'd marry and the number

of children she would have. Today, many young women in Iran take these choices for granted. In the 1950s, the lives of women were controlled by their parents and wider society.

This is my grandmother's story. The fourteen-year-old girl was my mother. She graduated with a PhD in microbiology from Tehran University and worked for over thirty-five years in the university's research department, which had close ties to the World Health Organization.

My grandmother was unable to read or write. She had her own philosophy, informed by the struggles she'd faced. She knew life was hard – harder still if you were a woman. 'As women,' she would

often say, 'we face many unwritten laws about our behaviour, our clothing, how we laugh, whom we should marry.'

She enjoyed telling us stories about rebellious princes and princesses. When my own daughters were growing up – my grandmother's great-granddaughters – I told them the same stories she told me. Looking back now, I realise how useful, remarkable and funny those stories were and still are.

The other lessons I took from my grandmother: seize any opportunity for learning, even under the worst conditions; study other languages; alongside your academic pursuits, pick up an art that requires you to work with your hands; do your best and be honest; and not least, figure out how to make money and secure your own finances.

The latter was especially important to Grandma. She believed every woman needed to earn her own living so no one could impose their will on her. And finally, marriage was not the target or goal. It was more important to live, work and have fun. A life partner would join you along the way in the great adventure of life.

My grandmother had been so young when she got married – only thirteen years old. By the age of fifteen, she had a child of her own. When I was growing up, she lived near our family home, by herself. She helped my mother by cooking and cleaning and told stories to me and my sister. She desired the best for her daughter and granddaughters. So no one could do us any harm, she wanted us to be powerful in our own right. That power, she said, lay in money and knowledge. She didn't know anything about feminism, democracy, dictatorship, politics, resistance, revolution or human rights, but she taught herself the important lessons in life. And these have been passed down through three generations of strong women.

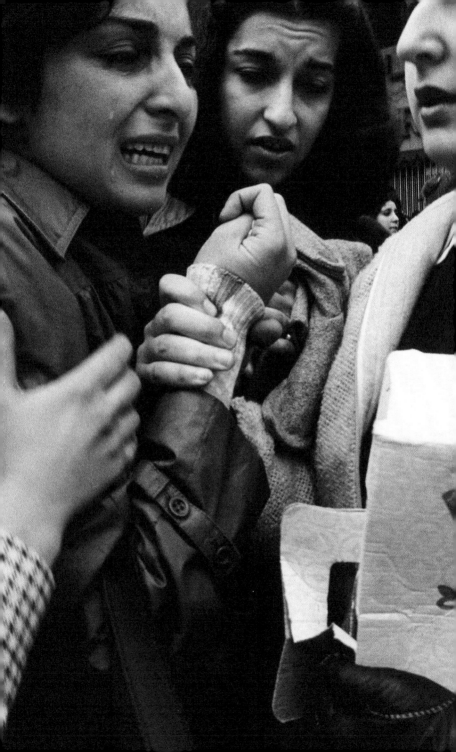

The Last Days

Women's protests against the veil in 1979

Photographs by Hengameh Golestan
Text by Malu Halasa

When there were news blackouts during the 1979 Iranian
Revolution, photographs became one of the few ways of finding out
what was taking place on the streets of Tehran. Photographers,
covering the running battles between protestors and the Shah's
security services, developed pictures secretly at home, then went
out into the city and stuck the photographs on walls in public
spaces for all to see.[1]

1 See *Writing on the City* directed by Kurdish filmmaker Keywan Karimi (2016).
 The sixty-minute film documents the history of Tehran through its walls,
 starting with the 1979 Islamic Revolution.

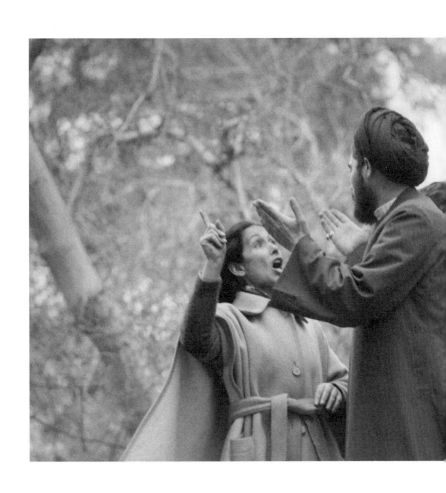

↑ Protestor drives her
argument home, on Anatole
France Street, opposite the
Russian Embassy. Out of
frame, the two are standing
on a bus.

A man used to stroll through the Iranian capital. Pinned to his hat and clothes were photographs showing the bodies of those who had been killed by soldiers during the demonstrations. His outrage had been so great; he turned himself into a walking billboard. Similar pictures of the dead were displayed on the walls and buildings of Tehran University.

Despite the dearth of news throughout the country, foreign newspapers and magazines were still imported into the country and available from the newsstands in international hotels. The US magazine, *Time*, published the first pictures of the revolution. People in Tehran bought the issue and tore out the relevant pages, which showed photographs by Iran's leading photojournalist Kaveh Golestan. Those pages were also displayed on city walls.

Forty-four years later in the Iranian capital, photographs have again appeared on walls, in impromptu, pop-up exhibitions during the Woman Life Freedom protests. These iconic images, taken by Hengameh Golestan, Kaveh Golestan's wife, document the mass women's protests that took place during the last days before compulsory veiling was enforced, in March 1979.

Hengameh Golestan remembered, 'Some of the demonstrations were against the hijab. Others were about the change in laws from the Shah's time, which gave women freedom and the right to divorce. After the Revolution, under the guise of "protecting the family", these laws were changed. Suddenly women weren't allowed to travel without proof of their husband's permission.'

Women were outraged; they had been lied to, said Golestan. 'Journalists had asked

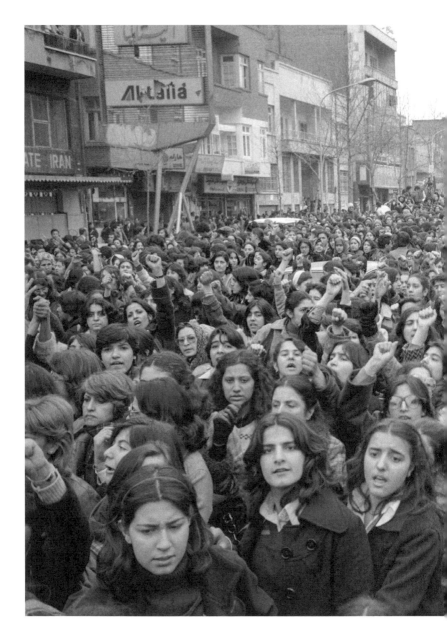

↑ A march coming from Tehran University spills
onto Enghelab (Revolution) Avenue, by the Hafez
flyover.

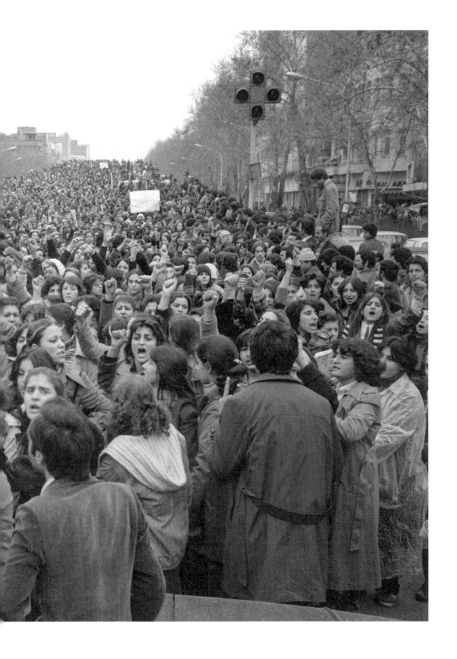

Khomeini when he was in exile in France about what would happen to women's rights, if he came to power. He said everyone would be free, even the leftists.'

Immediately after the revolution, the Islamists did a U-turn. Women's rights were swiftly curtailed, and the leftists killed or imprisoned. When Khomeini was asked why he lied, he cited the Shi'a doctrine of '*khodeh*'. Muslims, facing ostracism or death, were encouraged to repudiate their faith and lie. As Golestan observed, 'Because it was advantageous for his movement, he didn't admit the truth.'

The date Khomeini chose to demote women's status and rights in Iran, 7 March 1979, was on the eve of International Women's Day. Unless they wore a hijab, women were no longer allowed into schools, hospitals, universities and other official offices where government business took place. The women who objected and took to the streets were nurses, teachers, lawyers and other professional and working-class women.

A year later Golestan's opportunities as a photographer were also curtailed. She and another woman photographer had gone to the Ministry of Culture and Islamic Guidance to get official permission to go and cover the Iran–Iraq War (1980–1988). The men in the ministry told her that the front line was no place for women. Better they go home, they were told, and 'make jam and pickles' for the troops.

In some of Golestan's photographs, the anger of the protestors is palpable. A well-known actress lectures a sympathetic mullah. He had been sent to support the women from the offices of Ayatollah Taleghani, a tolerant religious leader. Other men in uniforms and plain-clothed, armed men were sent to protect the women. However, their presence didn't prevent the attacks and some of Golestan's images show women hurt and stunned by the violence against them. She described how the crowds of women, protected by a cordon of their husbands and male family members, were soon squeezed by other men, intent on doing harm before the attacks began. Golestan ran away after one street erupted, but the demonstrating throngs soon lured her and her camera back.

She maintained that the tactics used then are the same as those used today against the Woman, Life, Freedom protestors.

'The authorities in 1979 didn't say that the women protestors were assaulted by the Pasdaran[2] or the Basiji.[3] They said, "ordinary people" had taken offence, and attacked the women.' The government says the same thing today, when seemingly 'normal' men in plain clothes on the street suddenly molest women who no longer wear hijabs in public places. 'These aren't ordinary people,' stressed Golestan. 'The truth eventually emerges on social media, and the identities of these men are revealed. Usually they have ties to the authorities or the Basij.'

Does she believe change is possible today?

'Nobody is going back to the way it was.' The photographer is adamant. 'Thousands and thousands of people say that.'

2 'The Brutal Militia Trained to Kill for Iran's Islamic Regime' by Tara Kangarlou, *Time Magazine*, 5 December 2022. An early inception of the Sepah-e Pasdaran-e Enghelab-e Eslam [Legion of the Guardians of the Islamic Revolution] or the modern-day IRGC (Islamic Revolutionary Guard Corps).

3 Pro-government militia. *Ibid*.

A Changing Dreamscape

The photographs of Mehri Rahimzadeh

Text by Malu Halasa

Many of the images in 'A Changing Dreamscape' were captured
as single, standalone photographs over a period of several years.
Some of them were taken because their aesthetic or mood
appealed to the photographer Mehri Rahimzadeh. In a mixed
residential and shopping district, amid athletic clothing and
sporting goods stores along Valiasr Street, a chance encounter
with an advertising image made Rahimzadeh stop and get out her
camera.

↑ Photographer's roommate, Mahdiyeh.

In this series, she knows most of the women she photographed. They were classmates or roommates. Behind them rages Iran's wild rural landscape – the stuff of dreams and classic Iranian films. These enigmatic photographs suggest a strongly allegorical story, which, although never fully resolved, lingers in the unconscious mind.

↑ Tourist in front of an
earth wall in the historic
city of Yazd, central Iran.

The mystery in Rahimzadeh's work is derived in part from her background. The photographer grew up in the ancient city of Qazvin, at the crossroads between Tehran, Tabriz and the Caspian Sea. She studied film there and started taking photographs at the same time. She says the cinematic quality of her photographs 'comes from the fact that I have made several short films; but besides form, narration is also important to me. I use form and narration together to portray my mental state.'

Her commercial work, as photography editor for two magazines in Tehran, *San* and *Nadastan*, requires a different approach. It is 'more like staged photography,' she explains, 'in that it doesn't happen in the moment.'

← Sahar, on the island of Hormuz, 8 km off the Iranian coast.

Rahimzadeh prefers photographing in nature. She has a great love of trees and one image reoccurs throughout her *oeuvre*: a pair of outstretched hands – her own – reaching towards leafy foliage.

↑ Pregnancy tests, shot for a
magazine cover.

← Photographer's selfie, in
the city of Rasht, on the
Caspian coast.

↑ Photographer's classmate,
Maryam, in the Tehran Faculty
of Arts.

→ Woman washes her face by a
lake.

In the Time of Eros

The totalitarian state and the body

Vali Mahlouji

The twentieth century's most realised, sophisticated and successful model of state-imposed Islamism is on its knees in Iran. It has faced significant resistance in recent decades. What is different about the current movement is that it is not from oppositional political mandates, foreign adversaries or internal power struggles, but from individual citizens' civil acts of human pleasure and delight: dances, songs, kiss-ins and liberally swaying bodies. The historical battleground has shifted to the level of libidinal forces. The movement may or may not be a 'feminist' revolution, but what is culturally significant is that it is undoubtedly a *feminising* revolution.

To understand the complexities of the movement, it is imperative to consider how systems that impose strict, codified dogmas and doctrines on non-believers and believers alike share a profound contempt for their citizenry. They assert a violent disregard for the roles and rights of the individual, right down to the level of the body, its aesthetics, actions, functions and mobilities. What is happening in Iran is no exception to that rule. It is historically salient to demystify evangelical Islamist projects, their regressive populist strategies and their inherently right-wing social, cultural and political agendas. Power, as discussed by German sociologist Max Weber, is the ability to realise one's own will, despite and against the resistance of others.[1] That

1 Max Weber, *The Theory of Social and Economic Organisation,* trans. A. M.
 Henderson and T. Parsons (Ann Arbor: Free Press, 1947) p.152. See also Max
 Weber, 'Power, Domination and Legitimacy,' in *Power in Modern Societies,*
 ed. M. E. Olsen and M. N. Martin (Boulder: Westview Press, 1993) pp.37–47; M.
 Weber, *Economy and Society: An Outline of Interpretive Sociology,* ed. G. Roth
 and C. Wittich (Oakland, UC Press, 1978), chap. 3.

realisation and its sustainability necessitate obedience, submission and loyalty. Power rewards and legitimises obedience/loyalty and delegitimises, threatens or extinguishes dissent/divergence. In today's Iran, the current historical revolutionary thrust has strategically concerned itself with two interlinked paradigms of totalitarianism and evangelism – the totalitarian theocracy. In the coming years, restorative, democratic acts of healthy resistance will dominate the cultural space in Iran, undermining the dynamics of the theocratic system. A rising and audacious collective spirit will accelerate the direct targeting of the perverse and moralising Islamist agendas.

The failed Iranian Islamist project, now in its final developmental stage, is unable to tame the spirit of liberty and the desire for life and joy. It contends with the greatest threat to its existence: the danger of the citizens' innate, legitimate and authentic demand to *be*, to freely exist in time, space and function. The politically disorganised surge of societal resistance hits at the dehumanising core of repression. It derives from the oldest and deepest layer of existence, the drive for gratification in psychoanalytic terms, resisting all repression.[2] It comes directly from the rightful want for the body to claim the private and public space it occupies – where it exists, thrives, experiences and expresses. The release of those libidinal desires, dreams and demands are unstoppable. The body is unstoppable. It is simultaneously individualistic and utterly collective. What has come to strike the Islamist structures of power hardest is the direct affront to its most fundamental error, its most inhumanely rigorous paradigm of violence, the seat of its repressive control – the body of its citizenry. Alarmingly, the regime announced in April 2023 that it will deploy 'smart' surveillance cameras to closely monitor individual citizens, their strict dress uniforms and behaviours. Threatening promises of clampdown on women who fail to properly observe their dress codes are repeated weekly.

It is difficult to predict the victor on such a battlefield. At the forefront, women, young girls and gender and sexual minorities lead the way as the protagonists who have inevitably endured the

2 Herbert Marcuse, *Eros and Civilization: Philosophical Inquiry Into Freud* (Boston: Beacon Press, 1955), pp.21–54.

harshest and most dehumanising punishments and controls. The youth liberate the mind and body, spirit and aspirations, despite state violence, disturbing history in the process. The nation's spirit and psyche refuse to be tamed. The *erotic* forceful life-affirming rage has been released. The protagonists readily embrace the arts and forces of destructiveness and regeneration, for they know that free body equals free will – the Achilles' heel of any repressive master.

The spiritual transcendence of the movement shakes the calm of the senses. Its thrust liberates the compressed unconscious and drives towards a potent Artaudian revolt.[3] I have been tempted, especially in the early days of rebellion, in September and October 2022, to revel in the sheer erotic, direct and corporeal charge of the swaying bodies of women and men. The voice and the body (songs and dances) are weaponised in the defence of *life*. With women at the forefront, a Dionysiac political theatre unfolded.[4] They dispelled all stillness and inhibition. Dancing and chanting, fearless women and men used the power of their being, body and desire to assert liberty and life in a direct affront to authority. Their quest is to diminish and ultimately dismantle the power dynamics – politically, culturally and morally. And the deadly efficiency of the military power and established authority cynically and sinisterly shoots bullets in the eyes and genitals of the brave and selfless demonstrators.

The agendas of Life and anti-Life are brazenly at war. And dangerously for totalitarian theocracy, all its foundational

3 Antonin Artaud, a French radical dramatist, poet, essayist, actor and theatre director, strove to 'liberate the human subconscious and reveal man to himself'.

4 As the ancient story goes, Dionysus' untamed followers were formidable women, called maenads, who were possessed by the determined energies of the god himself – the god of fertility, festivity, ritual mania, drama and ecstasy. His offerings of intoxication, ecstasy and dance liberated the self-conscious soul and subverted the dominance of the powerful. Linked to Dionysus, the Greek god Eros was the first ruler of the universe. I am reminded of Carl Gustav Jung's Eros, the feminine (*anima*) force of psychic relatedness, 'the binder and looser', that asserts the desire for connectedness and relatedness. (Carl G. Jung, 'Woman in Europe', in *Collected Works* vol. 10 [1927], paragraph 255; reprinted in *Aspects of the Feminine*, Princeton University Press, [1982], p.65.)

structures of archaic, patriarchal cis-heterosexism, gender apartheid and sexual discrimination are blatantly exposed. Patriarchal masculinity – that necessary and fundamental convention so brilliantly consolidated by Abrahamic religions – is now under direct attack.

The Iranian renaissance has an unmistakably unique progressive quality: it feminises space and queers space. That is its crucial dimension. It cannot be stressed enough: the revolutionising resistance is, uniquely and distinctly, a *feminising* one. It is also a queering rebellion. In our country, we – the women, the queer, the racialised, the marginalised, the tyrannised, traumatised, victimised and ostracised – are at the forefront of a political, social, civil, cultural, spiritual, ethical and psychological revolution. That is the immensity of the movement and its revolutionising momentum. We burn, denounce and defy symbols of conventional misogyny, patriarchy, cis-heterosexist determinism and racial patriotism.

Historical Context

Forty-four years ago, in February 1979, the Islamist reactionary factions took over (with bazaar funding and on the back of mobs of rural-to-urban masses) from the coalitions of political and social forces that had come together to overthrow the monarchy in Iran. Within weeks of taking control in 1979, the Iranian Islamist agenda set out to violently bring all dimensions of urban and urbane, even rural folkloric, society and history under tight control. To do so, it systematically decimated all political, ethnic, cultural and intellectual dissent. The consolidation of that monolithic political grip was actualised through falsehood and sheer unrelenting violence.

Endemic to the political project was terror, which firstly achieved the decimation of all political counter-options. Secondly, it ensured the transformation of a modernised political and judicial system into a theocracy. Ultimate authority rests neither with the state nor the citizenry but is bestowed upon an unelected religious individual linked to the divine.

From 1979 to today, besides systematically diminishing Iranian citizens' rights and well-being, the new theocratic political order institutionalised an Islamising 'cultural cleansing' (*paksazi-e farhangi*) not dissimilar to the Nazi, Stalinist, Maoist or other totalising doctrinal systems of rule. The regime manufactured and abused every opportunity to forcibly *re-civilise* society. They replaced the Ministry of Culture with a 'Ministry of Culture and Islamic Guidance' (*Vezarat-e Farhang va Ershad-e Islami*). The new 'moral guides' devised a narrowing and severe form of evangelisation. That transformation was such that culture and the totality of the public sphere were tyrannically subjugated to ideological state regulation.

Its grandest narrowing of liberties was the enforcement of the veil on *all* women in public. That was first announced on 7 March 1979, on the eve of International Women's Day.[5] The cynicism at the heart of it was intended to break the spirit. It remains a deep wound, a profound humiliation. Little wonder that women today burn that symbol of repressive state tyranny in defiance, while walls of men support and endorse them. The body-space is epicentral to the Iranian Islamist project of power and humiliation. As the physically subversive carrier of desire, the body is central to all fascist experiments. It is the first to fall prey and the last to be freed from repression. Iranians call upon Eros to undermine the entire political system and regain its rule.

In fascist movements from Japan to Germany, Spain and Greece, strict regulations forced the ordinary citizen to show allegiance to power in public and conformity towards traditions. The regimes determined what the citizen said, heard, wore and danced to, whom it befriended and whom it shunned. Social mores and cultural values were restricted in Francoist Spain alongside political discourse. Women were forbidden from wearing trousers or skirts above the knee. Professional dancing was allowed if it were folklore (tamed by culture), not contemporary (where

5 On 7 March 1979, Ayatollah Khomeini initiated a gradual enforcement of the veil when he declared that public state buildings and institutions required women to cover the hair. Over the course of the next year and a half, the Islamists imposed this on all women, whether religiously observant or not.

experiments abound). A ban on the miniskirt was enforced under the junta in Greece, where listening to the Beatles (lest their music would release non-Greek sways) was a crime. The church (Catholic or Orthodox) and its values were upheld in both cases and traditional forms were encouraged or outright imposed. Abrahamic values and rules often lend themselves and appeal to populist or fascist conditions in modern politics. Thought, expression, action and possible effect that waver from the rigidly imposed concretistic interpretation of society are considered transgressive. Simple public displays of affection are banned, whether in Francoist Spain or Khomeinist Iran. In totalitarian states, Orwellian rules apply to all aspects of life.

Having run its historical course, Islamism will soon be called out for what it is. The Iranian mafia system's moral, cultural, political, economic, environmental and historical bankruptcy has long diminished an ability to govern. The structure is aware of its *ahistoricity*. The project has run its course and cannot reform itself. Yet an awakened and experienced society like Iran's knows the ruin in the project's wake is immense. In the diminished state, the destroyed infrastructure, decimated political alternatives, blocked legislative routes and systemically disempowered citizenry face a vacuum of democratic possibilities for initiating a safe, new transitional path. They have been robbed of democratic leverage and democratic foundations. The road ahead is dangerous and blunts our revolutionary thrust.

The deep fractures and consequential scars of the half-a-century dehumanising project and its profound social, cultural, linguistic, spiritual, moral and psychological traumas will not dissolve overnight to make way for a desired world. It is clear to any free spirit that confronting truth engenders risk and begets unpleasant, even deadly, consequences. It takes great courage to *know* gross abuse and even more tremendous courage to call it out for what it is. But a generation of liberation-seeking youths demands not to be asked to contemplate propitiousness in crime any longer. To whitewash and absolve tyranny in the name of culture has run its course. That history is well and truly now defunct. It would be morally and spiritually degrading, hideously demeaning of a people's half-a-century real-life struggle. It would

be humiliating towards the spirit of culture to contemplate any other presence or form but that of free culture. Instead of conceding, of being coerced as an accomplice, we have a conscience – to defend our will, our right to dream, to be *different*, open and in contact – our freedom to *be*.

Robust Strategies

All veils (to use that tainted word) of illusion, distorted readings that camouflage, reinforce fear, or support an inability to stand up to power have been irredeemably ripped away. The Iranian individual and collective body and psyche are geared to defend themselves. People's robust strategies of resistance are movingly creative, nuanced, joyous and generative, so long as they can withstand the violence thrown back at them. They thwart and dismantle the withdrawal and atrophy necessitated by totalitarian theocracy and they do it with acts of love. Such counter-cultural action liberates new and necessary structures of feeling and social modes that state-sanctioned violence can no longer contain.[6]

The Islamist project has not been defeated, but its control has been impaired for ever. Its authority has been dismissed. *En plein air,* the people claim their right to joy. In defiance, the collective body pain vents and performs itself; its painful honesty acts out across public space and its overwhelming energy swarms the city streets; its spontaneous forms release themselves to pure abstraction. The frenzied, swaying, ecstatic public performances of women's and men's dancing bodies slice across that frigid, coagulated, forged, brutal form of archaic masculine Islamist order. They spread like wildfire, igniting the rageful spirit of a generation of adolescent and young girls/women and boys/men who spin spontaneously on their rebellious feet.

They dance free, abandoned, fearless – simultaneously mourning and jubilantly celebrating one of their own. This time their call to rebellion transcended the need for rational discourse

6 Raymond Williams, *Marxism and Literature* (Oxford and New York: Oxford University Press, 1977), p.135.

and unleashed an alternate mode of consciousness, which cannot be reckoned with. It is not strategic: it is real and inevitable. History shall forge ahead. A liberal spirit has been freed and unleashed, in effect and action. Though the backlash will be vicious (it is expected) and the path remains perilous, a new era of civilisational progress has been ushered in regardless.

The ongoing Iranian uprisings will change the course of history for good: it would be a grave understatement to claim otherwise. As Susan Sontag[7] writes: 'At the centre of our moral life are the great stories of those who have said no.' And consequently, the alarm bell is sounded for all those who incorrectly argued for engagement with Islamist power in Iran over the decades. It is time for that misled political and aesthetic stance to catch up with the unfurling of history from below.

MAKE LOVE, NOT WAR.

7 Susan Sontag, 'Of Courage and Resistance', *The Nation*, 5 May 2003.

Hoor-al-Azim

The disappearance of traditional wetlands

Maryam Haidari

My mother does not know a lot of things, and yet she remembers many things. When I tell her over the phone that I am thinking of learning how to sail a boat, she does not ask how it is that I could do something like this in Tehran, a city far from the sea and with no river running through it. Instead, she recalls, 'When I was very young, I knew how to handle a boat. In those days we lived by Hoor, and your father would jump at any excuse to go fishing with his friends. Sometimes for fun, other times to bring food to our table. You know all of this, of course.' Then she sighs and repeats a familiar old refrain, 'I wish someone would take me back *there*.' To Hoor.

My mother imagines that the Hoor wetlands that once existed on the Iran–Iraq border are still there – still overflowing with water and an abundance of long reeds, which my father would bring home to make mats.

Unlike my mother, my father believed he knew many things. Much more so than our mother. But also unlike my mother, he was a man who did not or could not recall much. Once, when my hair had finally grown long enough, I asked my mother to braid it for me. 'Your father knows how to braid hair far better than me,' she said.

'How come?' I asked.

'Because he used to weave the leaves of the palm trees and the reeds of the Hoor.'

My father ended up braiding my hair. Carefully. As if he were back to the mat-making of their early years before we children were born. He was meticulous, and the symmetry with which

he did the job was admirable. Yet he never spoke a word of the disappearing wetlands and those bygone days.

With the long war against Saddam over, my displaced family finally returned to Ahvaz, the principal city of Khuzestan Province in the south-west of Iran. 'Content refugees' is what my parents were, now they were finally able to return home. Content despite the fact that their eldest son had been lost to the war and it would take many more years before the slightest traces of him were found.

War makes some want to forget everything that ever happened, while it makes others want to remember and remember. In this way, my mother and father were strangers to one another's minds. I was a devoted enthusiast of the darkroom of my mother's recollections. And whenever my father would announce that his wife only lived in an ether of fantasies, I'd feel the burden of our collective lost lives and lost geography multiplied. My longing was twofold: that one day my mother might be gifted with the whereabouts of a son missing in action, and that before long her fantasies – whatever they were – would move from the realm of the past to that of the future.

The things she paid attention to on television or in magazines – chickens, cows and buffaloes, rivers and trees, buckets laid out for milking domestic animals, earthen bread ovens, brooms made of palm leaves, fishing nets and boats – she'd inevitably connect to a past that turned more and more impossible with each drying year: Hoor's waters and its boats, our relatives across the border in Amarah, Iraq, and the names of long-absent birds from those retreating magical spaces, birds that I had never witnessed and never would. The world became borderless then, and for a few moments I'd pretend to see through my mother's thousand-yard stare the reed beds and the fish, the water buffaloes and the blood-red dusks. Then I'd come to myself and wonder if she wasn't imagining it all, just as our father always said. What if it was all merely a figment of a war-stricken mother's despair at the loss of a son?

Years later they eventually found a few bones which they said belonged to my brother. The bones killed the last of my mother's hopes for a safe return. And her dreams too, all of them, died

soon afterwards. Yet today we know that all of what she used to remember some thirty years ago had once been true.

This old woman never left Ahvaz again, even after her husband died and half her children moved to other places. I no longer braid my hair, and my mother still goes about her days without the intrusion of too much information. She has, for instance, no idea that there are man-made parks in riverless cities where people can rent boats by the hour, while the boats of Hoor-al-Azim, like the wetlands themselves, are gone for good. All that remains of the great lagoons are hollow pits here and there, with the vast reed beds now turned to dry wastes where nothing grows anymore.

The calamity of Hoor is heard on the nation's mobile phones nowadays; amateur videos of the parched and ravished landscape are a shared rebuke to us all. In one video, a man stares into a camera and screams, 'Can't anyone in this world hear our cries?'

The camera pans away to give us a glimpse of the exhausted buffaloes with their drained eyes lying in a thick of muck and sludge.

My mother, who does not own a smartphone, knows nothing of these images. On a Friday afternoon she calls from Ahvaz and passes the phone for a minute to one of my sisters who has been staying with her.

'Has she heard the news about what's happened at Hoor?' I ask my sister.

'No,' she replies.

'Don't ever let her find out.'

Translated from Persian

From Hair to Hugs, Times Are Changing

Another letter from Tehran

Anonymous

Dearest _____,

Things are going from bad to worse. Mostly it is the level of violence, which seems to have increased exponentially. And one cannot be anything but utterly depressed about the deaths of children, and young men and women. In the last weeks the movement itself has changed in tone. It's no longer just about Woman, Life, Freedom, but instead economic factors have become a source of anger and rioting, especially in some of the lesser provinces which were relatively quiet in the early weeks of the uprising.

I should say that in Tehran itself things are mostly quiet in comparison to the first days. Only on specific nights and in specific neighbourhoods might something happen and it's usually quickly quelled. But all of this is smouldering fire beneath the ashes; the flames could return with the slightest spark. On the other hand, they are arresting a lot of activists and journalists – many more than before. They'll suggest you're connected to the United States or some other Western country and send you to jail. All with the aim of creating a permanent atmosphere of fear.

One might believe the Islamic Republic has been destroyed. But I don't see things that way at all. The reality is different. We have a

long way to go – two or three years at the very least. And so much will also depend on the eventual death of Ayatollah Khamenei. That said, it's important to note that the Iran of today is no longer the Iran of two months ago, and it is doubtful that things will ever return to how they once were. The intensity of rebellion may rise and fall, but I don't believe it will ever be entirely quelled. There has simply been too much bad blood, too much anger, rage and violence, on the part of the regime.

Yet, with the violence and crushing of demonstrations aside, I also think that the people have for the first time truly come to believe that this regime can be overthrown. This gives people hope. And hope means they are not going to return to their homes and go quiet this time around. Nevertheless, I can't deny that so much that happens in Iran also gets channelled through the balance of power between the United States, Russia, Europe, China and the Arab countries, and so on. It is naive to consider Iran's turmoil through the prism of Iran alone.

My dear friend, the way I see things today, even if there were to be a change eventually, it would not necessarily be good change. Whoever takes on the reins of power after the Islamic Republic will lack leadership and management. As things stand, I predict that in the decades ahead we'll see revolution after revolution here. People outside should understand that this population has zero ability to go head-to-head against the regime's uniforms and its supporters. It's a pipe dream to think otherwise. And yet things could change with Ayatollah Khamenei's death or even a limited attack of some kind by a foreign military. What that change would entail, I don't know. And I am also of the opinion that from Israel to the US, and wherever else, it's not exactly to their disadvantage to see the Islamic Republic weakened and off-kilter in the way it is currently. This might be a more expedient state of affairs for some foreign states than seeing total regime change in Iran.

Culturally, however, so much change has taken place. It's hard to believe. In the northern parts of Tehran, easily thirty to fifty per cent of the women no longer wear a head covering of any kind. Women walk around freely and show off every hairstyle you can think of. It's different though on the south side and in the outer

boroughs: here maybe no more than five to ten per cent of women go out without wearing the hijab. Another thing: since people are finding hope again after so many years, they have become a lot kinder to each other. This change is particularly apparent in people's attitudes in the middle- and upper-class areas of the city. You'll often see young men and women holding each other tight right in the middle of the street. They call these embraces the kindness hug. Some girls and boys carry cards with them to hand to women who are not wearing the hijab. On the cards they write things like: Thank you for making our city so lovely with your beautiful hair.

To make a long story short, every day here, thousands of sad and thousands of sweet acts are taking place at the same time. And truly this social movement is now taking on a new colour with every passing day. But if you were to ask me if the Islamic Republic is going to crash tomorrow, I'd give a definite no. I simply don't see any signs of that. A lot more still needs to happen – and much depends on outside confluences. But hope … hope for this actually coming to pass one day is stronger now than it has been in the last four decades. It is amazing to witness.

My dear friend, I'm sorry I took so long to reply. Let me know how you're doing.

Yours always,

A.

Translated from Persian

About the Contributors, Translators and Editors

Milad Ahmadi is a multidisciplinary artist and fashion designer. On completion of his studies at Parsons School of Design in New York City, Ahmadi founded his own design studio, Haus of Milad. His work is rooted in his experiences as a queer artist living in exile. Ahmadi was born in Tehran and lives in New York City.

Parastoo Ahovan is a sculptor and interdisciplinary artist. She studied sculpture in Tehran and New York City before graduating with an MFA from Boston University. Ahovan's sculptures have been presented internationally, including at the Venice Bienniale and the 8th National Sculpture Biennial of Tehran. She is based in Brooklyn.

Anonymous, author of two letters, 'The Girl of Revolution Avenue' and 'From Hair to Hugs, Times Are Changing'.

Elham Ataeiazar is an award-winning illustrator who previously worked as an animator for the United Nations Development Programme. She is now an associate producer and animator at CNBC's 'Make It'. Ataeiazar is based in New York.

Meysam Azarzad was born in Tehran in 1985. He works as a graphic designer and art director, specialising in the fields of visual arts, cinema and video art.

Mansooreh Baghgaraei is an artist whose ceramics and sculptures have been displayed in numerous national and international exhibitions, including Buckham Gallery (US) and the 8th Biennale of Ceramics (Austria). Baghgaraei studied traditional arts and handicrafts at Elmi Karbordi University.

Ashley Belanger is a journalist and senior tech policy reporter at *Ars Technica*, where she writes news and feature stories on tech policy and innovation. Her investigative reporting has been published by *National Geographic*, *The Boston Globe* and *Frontline*. Belanger is based in Chicago.

Clive Bell is a music critic and composer who specialises in World Music. He writes for *The Wire* music monthly and is also a renowned multi-instrumentalist. His shakuhachi flute and other East Asian wind instruments have been featured on multiple films and games, including *Ghost of Tsushima*. Bell lives and works in London.

Fari Bradley is an artist and activist for the Woman, Life, Freedom movement.

Her solo shows and exhibitions have been platformed internationally, including in Lebanon, the UAE, Bahrain, Kuwait and Pakistan. A member of CRiSAP (Creative Research into Sound Arts Practice), Bradley is currently completing a PhD in Sound Arts at the London College of Communication. Born in Iran, Bradley is currently based in the UK.

Amirhossein Darafsheh is a visual artist and street photographer who started working in digital graphic design as a teenager. He took his first photographs aged sixteen with a 2MP digital camera and has since studied with the filmmaker Abbas Kiarostami. Darafsheh has worked as a freelance photographer, graphic designer and videographer. He lives in Tehran.

Jamshid Dejagah is a graphic designer with an academic background in architecture. He was co-founder and art director of Savaad Studio, a graphic design studio based in Tehran.

Sara Emami studied industrial design at the Technical University of Delft in The Netherlands and currently works as a designer and user experience lead at Philips. Emami lives in Amsterdam.

Ghazal Foroutan is an Iranian designer and educator. In 2012 she won the Khawrizmi Youth Award for illustration. Foroutan studied at Alzahra University in Tehran and completed an MFA in graphic design at Oklahoma State University. She is currently an assistant professor at Augusta University in Georgia.

Hengameh Golestan is considered a pioneer among female Iranian photographers. She studied at London College of Printing in 1988 and worked as an assistant to the renowned photographer, photojournalist and filmmaker Kaveh Golestan. Her photographs covering the 1979 Revolution are widely celebrated and her work has been exhibited internationally since 1995. Golestan lives and works in Tehran.

Martin Haake is an award-winning artist and illustrator. His artwork has received numerous international awards and his illustrations have been published in *The New York Times*, The *Wall Street Journal*, *The Guardian* and *Die Zeit* among others. Haake's first picture book, *City Atlas* (Wide Eyed Edition, 2016), was translated into fifteen languages. He lives and works in Berlin.

Farnaz Haeri is a translator, literary consultant, researcher, teacher and essayist. She has translated eighteen books into Persian, including *The Sound of Waves* by Yukio Mishima, *Honey Pie* by Haruki Murakami and *Revolutionary Road* by Richard Yates. Her most recent translation is of *Journey by Moonlight* by Antal Szerb. Haeri lives in Tehran.

Maryam Haidari is an Iranian-Arab from Iran's Khuzestan Province. She is the translator of noted Arab poets such as Mahmoud Darwish and Sargon Boulus

into Persian. She is also the author of the collection *Bab Muareb*, [A Door Ajar] (Al-Mutawassit Publishing House, 2018) and the 2018 recipient of the Arab world's prestigious Ibn Battuta Prize for Travel Literature. Her latest book is *Persian Carpets* (Al Muheet Publishing House, 2022), a collection of modern Persian poetry translated into Arabic. She is also the culture editor of the Arabic language journal *Raseef 22* in Beirut. She lives and works in Tehran.

Peyman Hooshmandzadeh is a photographer based in Tehran. Hooshmandzadeh graduated with a B.A. in photography from Tehran's Azad University and has worked as a photojournalist for Iranian newspapers and agencies, as well as various international organisations, including Reuters, Panos Pictures, and Polfoto. Hooshmandzadeh has had over eighty solo exhibitions and won dozens of national and international awards for photography. His books include *One Hundred Photographs, A People of the Horse* and five collections of short stories.

Iranian Women of Graphic Design is a collective of Iranian women graphic designers. Since the death of Jina Mahsa Amini in September 2022, their work has expanded exponentially. IWofGD's open access drive on the internet has attracted artists from around the world who are keen to show their support for the Woman, Life, Freedom revolution.

Mina M Jafari is a fine artist and graphic designer of Iranian descent. She runs her own graphic design business, using her skills to help advance social issues she cares deeply about. Jafari also owns a shop in Brookland Arts Walk called Kucheh, the Persian word for the smallest unit of community and society. She lives in Washington DC.

Habibe Jafarian is considered Iran's leading nonfiction writer and is the author of several award-winning biographies. She has worked at various newspapers and journals, including *Hamshahri-e-Javan, Mostanad, Dastan* and the Iranian film magazine *24*, where she was senior editor. Born and raised in Mashhad, she lives and works in Tehran.

Jalz is an Iranian graphic designer who has been practising since 2021. Most of his works are in the form of design and collage, which is inspired by Iranian style between the 1960s and the late 80s.

Dr Pamela Karimi is an architect and historian of art and architecture who earned her PhD from MIT in 2009. Her book *Alternative Iran: Contemporary Art and Critical Spatial Practice* was published by Stanford University Press in 2022. Karimi's critical essays have appeared in *Journal of the Society of Architectural Historians*, *Harvard Design Magazine*, *The Jadaliyya*, *Art Journal*, *Ibraaz*, *Bidoun*, *Hyperallergic*, and the *Arab Studies Journal*, among others. She is a professor of art history at UMass Dartmouth, USA.

Shiva Khademi is a photographer from Mashhad. In 2018 she was awarded Honoured Photographer in the 76th annual Photograph of the Year competition for freelance photography (Columbia) and ranked first in the Andrei Stenin International Photo Award, for the best portrait series (Moscow). Her first solo exhibition, 'The Smarties', was held in Tehran in 2019. She has been shortlisted for the Prix Levallois (Paris) and won the 9th Rendezvous Image awards (Strasbourg).

Khiaban Tribune was created in 2017. The group defends the democratic rights of women, political prisoners, workers, immigrants, religious and non-religious minorities and the LGBTQ+ community.

Vali Mahlouji is an art curator and founder of Archaeology of the Final Decade, a non-profit platform which recovers erased histories. He has worked with Tate Modern, Musée d'Art Moderne de la Ville de Paris, Smithsonian Institute, Los Angeles County Museum of Art and The British Museum. Mahlouji is a member of Art Dubai Modern Advisory Committee and a board member of Bahman Mohassess Estate. He lives in London.

Shokouh Moghimi is a poet, journalist and documentary filmmaker. Her first collection of poetry, *I'm Slightly Missing a Few People* (Mordad Publishing House, 2016), won several of Iran's prestigious literary awards including the Best First Book award. She is working on a project related to the history of protest art in Iran. Born in Ahvaz, she currently lives in Tehran.

Kamran Mohagheghi is a graphic designer.

Kamin Mohammadi is an author and journalist. Her journalism has appeared in *The Times*, *The Financial Times UK*, *The Guardian, Harper's Bazaar*, *Marie Claire, Vogue*, *GQ*, and *Truthdig* among others. Her journalism has been nominated for an Amnesty Human Rights in Journalism award, a National Magazine award and two awards by the LA Press Circle. Mohammadi's books include the co-authored *The Lonely Planet Guide to Iran*, *Bella Figura: How to Live, Love and Eat the Italian Way* (Bloomsbury, 2019) (published in sixteen countries and in development as a television series) and *The Cypress Tree: A Love Letter to Iran* (Bloomsbury, 2011). Born in Iran, she now lives in the UK.

Sara Mokhavat studied film at the University of Art in Tehran. She has worked in cinema and theatre as an actress, writer and director. A recent selection of her work includes the novel, *The Woman Who Was Found at the Lost & Found* (Morvarid Publishing House, 2016), her play, *Farewell My Cherry Orchard*, which was performed at the City Theatre of Tehran in 2018, and her short film *Private*, which was selected for the 2021 Chicago International Film Festival.

Tahmineh Monzavi is a photographer who lives and works in Tehran. Formerly a social documentary photographer, she changed her practice and now focuses on the region of Baluchestan in Iran and Afghanistan, where she explores the influence

of water on culture and people. Her work has been exhibited internationally at LACMA (Los Angeles County Museum of Art), the MAXXI Museum, Rome and the Musée d'Art Moderne de la Ville de Paris.

Mahdieh Nadimzadeh is a graphic designer. The posters he made for the '30-Day Project Society' explore what has transpired in Iran since the death of Jina Mahsa Amini. These artworks have now been distributed worldwide. Born in Iran, Nadimzadeh currently lives outside the country.

Milad Nazifi is an architect and illustrator. The Woman, Life, Freedom movement has been a source of inspiration for his creative practice. Nazifi lives in Iran.

Mana Neyestani is an Iranian cartoonist, illustrator and graphic novelist. His work has appeared internationally in economic, intellectual, political and cultural magazines. Neyestani is the 2010 recipient of the Cartoonists Rights Network International Award for Courage in Editorial Cartooning. He lives in France.

Steffi Niederzoll is a filmmaker from Nuremberg. She studied audiovisual media arts at the Academy of Media Arts Cologne (KHM) and the Escuela Internacional de Cine y Televisión (EICTV) in Cuba. Her short films have been screened at numerous film festivals including Berlinale, Brecht Festival, the Kunsthalle Baden-Baden, the Museum of Contemporary Art in Roskilde and Vejle, Denmark, among others.

Alexander Cyrus Poulikakos is an architect and artist based in Zurich. He currently works as an architect alongside running his own design and research practice Bab Al Morpheus. He is the author of *Resurrecting Babylon* (2021), a portrait of the contemporary urban landscape in the Arabian Gulf Region. He graduated with an MA degree from ETH Zurich in 2019. Born in Illinois, the last time he visited Iran was in 2017 to be with his grandfather.

Anna Rabko is a graphic designer and illustrator working under the name Happy Borders, who stands for equal rights and the respect that we all as immigrants and refugees deserve. She uses colours and surrealism as a universal language everyone can understand. Her education started at the Academy of Fine Arts in Cracow, Poland with an endless love for Polish Poster design and continued in Kathmandu, Nepal learning traditional Thangka painting. She has worked with theatres, NGOs and collaborates with other artists.

Tarlan Rafiee is an Iranian visual artist and contemporary art curator. She has curated several exhibitions for international museums such as the Ducal Palace-Museum of Mantova and Tyrolean State Museum in Austria. She also co-founded and is a curator for Bread & Salt Projects and KA:V Editions. Her artwork has been exhibited and collected by the British Museum and the Victoria and Albert Museum in London.

Mehri Rahimzadeh is an artist, filmmaker and photographer. Born in Qazvin, she has a BA from Qazvin Islamic Azad University and an MA in photography from Tehran University of the Arts. Rahimzadeh's work has been exhibited at Aban Gallery (Shiraz), Cité Internationale des Arts Galerie (Paris) and in Athens, Brussels and Warsaw. She is the photography editor for the magazines *San* and *Nadastan*, in Tehran.

Niloofar Rasooli is a writer, journalist and a doctoral fellow at the Institute for the History and Theory of Architecture, gta, ETH Zürich. Niloofar moved to Zürich in 2021 after working as a journalist, editor and essayist in Tehran. Her primary focus on writing is on the politics of memory, queer theory, women's stories and resistance in Iran. Niloofar's writings have been featured in the *trans magazine*, Woz, 1.mai committee pamphlet, *Etemad*, *Kargadan* and *Abadi*, among many others.

Roshi Rouzbehani is an Iranian freelance illustrator who has created editorial illustrations for *The New Yorker*, *The Washington Post* and *The Guardian*, among others. She's passionate about gender equality and women's empowerment is at the centre of her work. In 2020, she self-published the illustrated biography, *50 Inspiring Iranian Women*. Her work has been featured in *Creative Boom*, *Design Week*, *Middle East Eye* and more. Rouzbehani is based in London, UK.

Touraj Saberivand is an award-winning Iranian artist and activist. In 2014, he organised the popular protest against medicine sanctions on Iran. Saberivand often draws from masterpieces of Persian book painting to highlight contemporary issues. He lives in Tehran.

Babak Safari is an Iranian art director, graphic designer and teacher of graphic design. He holds an MA in visual communications from Sooreh University. His work has been selected for numerous national and international festivals, including the International Poster Festival (Turkey) and the 35th Fadjr International Theater Festival (Iran). Born in Bandar Abbas in 1986, Safari currently lives in Tehran.

Marzieh Saffarian is a collage artist and speech-language pathologist. In 2016 she founded @vintagepersia, an Instagram account that documents her collection of memorabilia and family photos from pre-revolutionary Persia. She also creates collages, watercolour paintings and clothing under the brand PsychPersia. Saffarian lives in California.

Mahsa Salekesfahani is an Iranian graphic designer. Inspired by the Woman, Life, Freedom movement, she has created multiple posters in honour of the victims of the protests.

Soheila Sokhanvari is an Iranian-British artist whose multimedia work focuses on pre-revolutionary Iran. Sokhanvari received her BA in Art History and Fine Arts from Anglia Ruskin University in 2005, a postgraduate diploma in Fine Art from Chelsea College of Art and Design in 2006 and an MFA from Goldsmiths College in

2011. She was the recipient of the Derek Hill Foundation Scholarship at the British School at Rome (2018) and has exhibited extensively throughout Europe and the Middle East. Sokhanvari is based in the UK.

Tasalla Tabasom is an artist whose practice explores themes of race, sexuality and identity through the use of the body. Born in Iran, she studied at the University of the Arts, London and her work has been exhibited in various group exhibitions in London and Tehran. She works across a variety of media, including painting, performance and sculpture.

Eilya Tahamtani is a contemporary artist, illustrator, graphic designer and filmmaker with a PhD in Philosophy of Art. He has participated in over forty solo and group exhibitions. As a performance artist and author, he has won several awards at national level and published several books. Born in Shiraz, Tahamtani currently lives in Tehran.

Parisa Tashakori is an Iranian visual designer based in Boulder. She has been practicing as a graphic designer and design educator for more than 20 years. Tashakori has collaborated as a designer and art director with several international advertising agencies and cultural institutions, and she is currently the director of the Masters in Strategic Communication Design at the University of Colorado Boulder. Tashakori's work is focused on the field of social, envirpnmental, and cultural communication. Her work has been presented at hundreds of international exhibitions and has received many awards in design.

VVORK VVORK VVORK is a design studio based in Brooklyn, New York.

Or Yogev is an artist and illustrator. He displays his artwork on the Instagram page, @shabloolim.

Hanik Yousefi is a photographer and multimedia artist. His work is predominantly in black and white and he cites Irving Penn and Arnold Newman as influences. Alongside his work for clothing and fashion brands under his HVNYCK label, Yousefi specialises in illustration, content creation, portraiture and street photography.

Vida Zarkeshan has degrees in architecture, photography and translation. She works as a photographer's assistant and archivist and was previously employed by Iran's Cultural Heritage Organisation Document Centre. She has two adult daughters and lives in Tehran.

Translators

Salar Abdoh is an Iranian novelist and essayist. His novel, *Out of Mesopotamia* (Akashic Books, 2020)*,* was a *New York Times* Editors' Choice and named a Best Book of 2020 by *Publishers Weekly*. He is also the author of the novels *The Poet Game* (Picador,

2000), *Opium* (Faber & Faber, 2004), *Tehran at Twilight* (Akashic Books, 2014) and *A Nearby Country Called Love* (Viking, 2023), and editor and translator of the anthology *Tehran Noir* (Akashic Books, 2014). He directs the creative writing programme at the City College of New York. Abdoh lives and works between Tehran and New York.

Farrokh Hessamian is an architect and worked as a town planner in Iran for twenty-seven years. He moved to the UK in 2006, where he has since been employed as a Persian-English translator for the BBC Monitoring Service and as a voice-over artist for BBC Persian. Hessamian has translated for VNC, *Al-Mashareq*, *IranWire* and *Middle East Monitor*. He also established Bmarz, a professional group for bilingual Persian translators. Hessamian lives in London.

Editors

Malu Halasa is a writer and editor of five anthologies on Middle Eastern art and culture, including two on Iran: *Transit Tehran: Young Iran and Its Inspirations* (Garnet, 2008) and *Kaveh Golestan: Recording the Truth in Iran* (Hatje Cantz, 2011). Her other coedited volumes include the critically acclaimed *Syria Speaks: Art and Culture from the Frontline* (Saqi Books, 2014) and *The Secret Life of Syrian Lingerie: Intimacy and Design* (Chronicle Books, 2008). Halasa's novel, *Mother of All Pigs* (Unnamed Press, 2017), was reviewed by *The New York Times* as 'a microcosmic portrait of a patriarchal order in slow-motion decline.' Halasa was editor at large for *Portal 9* in Beirut, managing editor of the Prince Claus Fund Library in Amsterdam and a founding editor of *Tank Magazine* in London. She is currently the literary editor of *The Markaz Review*.

Lawrence Joffe is a journalist, author and editor who has written about the Middle East for *The Guardian, The Independent* and *The Middle East*, among others. His books include *Keesing's Guide to the Middle East Peace Process* (Cartermill Publishing, 1996), *Abandoned Sacred Places* (Amber Books, 2019) and *A History of the Jewish People* (Lorenz Books, 2020). He is the director of Meretz UK and CMO of Arab Research and Advocacy Bureau. Joffe lives in London.

Emilia Sandoghdar is the art editor of *Woman Life Freedom*. She co-curated *Jorat* (Courage), the first London exhibition to show grassroots protest art from the Woman, Life, Freedom revolution in Iran. She holds an MSc in strategic design and management from Parsons School of Design in New York City, and currently works as a data catalyst at Wunderman Thompson. Sandoghdar is based in the UK.

Myfanwy Craigie is a writer, translator and editor from Somerset. Her articles have appeared in *The Times*, *The New Statesman*, *Politico* and *Die Welt*, among others. Craigie is based in the UK.

Credits

by arrangement with the writer: *Don't Be a Stooge for the Regime – Iranians Reject State-Controlled Media* by Malu Halasa (15 December 2022), *Rebel Rebel, Exhibition Review* by Malu Halasa (30 January 2023) and *Seven Winters in Tehran, Q&A with Steffi Niederzoll* by Malu Halasa (10 April 2023).

Shokouh Moghimi
Big Laleh, Little Laleh (translated by Salar Abdoh) was originally published in *The Markaz Review*, 15 July 2022. Published here by arrangement with the writer and translator.

Kamin Mohammadi
'Jin Jîyan Azadî': The Kurdish Heart of Iran's Female-led Uprising was originally published in *Truthdig* (www.truthdig.com), 7 December 2022. Published here in arrangement with *Truthdig*.

Sara Mokhavat
On the Pain of Others, Once Again (translated by Salar Abdoh) was originally published in *The Markaz Review*, 24 October 2022. Published here by arrangement with the writer and translator.

trans magazin
Revolution of the Anonymous by Alexander Cyrus Poulikakos, Niloofar Rasooli; *Queering of a Revolution* by Alexander Cyrus Poulikakos and *In Her Voice, We Are All Together* by Niloofar Rasooli were first published in *trans magazin* by gta Verlag. Published here by arrangement with the writers.

.

Acknowledgements

The *Woman Life Freedom* anthology would not have been possible without the novelist and translator Salar Abdoh; *Jorat* co-curator Emilia Sandoghdar and editors in chief, Jordan Elgrably of *The Markaz Review* and Maziar Bahari of *IranWire*. Saqi Books publisher Lynn Gaspard came up with the original idea to produce an anthology and her team there, editorial director Elizabeth Briggs and designer Will Brady, were key in realising the book. Malu Halasa also thanks Fuchsia Hart, the Iran Heritage Foundation Curator for the Iranian Collections at the Victoria and Albert Museum, for an important early discussion about the art of the women's protests.

Woman Life Freedom is dedicated to the women and girls of Iran.

Index

References to images are in *italics*.

Saqi Books
Gable House, 18-24 Turnham Green Terrace, London W4 1QP
www.saqibooks.com

Published 2023 by Saqi Books

ISBN 978 0 86356 972 2
eISBN 978 0 86356 977 7

A full CIP record for this book is available from the British Library.

Printed and bound by PBtisk a.s.

'These writers and artists are real life heroes, writing in real time as history unfolds, letting the rest of us know how audacity is done. We need more of THIS!'
NEGIN FARSAD

Jina Mahsa Amini's death at the hands of Iran's Morality Police on 16 September 2022 sparked widespread protests across the country. Women took to the streets, uncovering their hair, burning headscarves and chanting 'Woman Life Freedom' – '*Zan Zendegi Azadi*' in Persian and '*Jin Jîyan Azadî*' in Kurdish – in mass demonstrations. An explosion of creative resistance followed as art and photography shared online went viral and people around the world saw what was really going on in the country.

Woman Life Freedom captures this historic moment in artwork and first-person accounts. This striking collection goes behind the scenes at forbidden fashion shows; records the sound of dissent in Iran where it is illegal for women to sing unaccompanied in public; and walks the streets of Tehran with 'The Smarties' – Gen Z women who colour and show their hair in defiance of the authorities, despite the potentially devastating consequences. Extolling the power of art, writing and body politics – both female and queer – this collection is a universal rallying call and a celebration of the women the regime has tried and failed to silence.

This is what protest looks like.

Art/Culture UK £14.99 US $19.95

51995>

9 780863 569722

www.saqibooks.com